INSTANT FILM
PHOTOGRAPHY

INSTANT FILM
PHOTOGRAPHY

A CREATIVE HANDBOOK
for Polaroid, Instant Film and Convertible Cameras

Michael Freeman

Salem
House

First published in the United States by Salem House, 1986
a member of the Merrimack Publishers' Circle,
Salem. New Hampshire 03079

ISBN: 0 88162 117 X

LIBRARY OF CONGRESS CATALOG CARD NUMBER: 85-50741

Designer: Sarah Jackson
Assistant Designer: Colin Lewis
Editor: Matthew Sturgis
Picture Researcher: Caroline Mitchell

Filmset by Tradespools Ltd.
Printed by Purnell & Sons (Book Production) Ltd

First published in Great Britain in 1985
by Macdonald & Co. (Publishers) Ltd
London & Sydney

Acknowledgments

The author and editor wish to express their warm
thanks to the following for their generous help: Hans
Gobez and Rose Procida of Polaroid Corporation, US;
Andrew Parkhouse and Pat Wallace of Polaroid
Corporation, UK; Peter Sutherst of Kodak, UK; Keith
Johnson Photographic, London; Contax; Konica.

CONTENTS

INTRODUCTION

Over the years the delay between taking a picture and seeing the final product has become an accepted and natural part of the process of photography. The photograph is taken and the film stored, often for up to several days or even a few weeks, until eventually it is processed. The more popular photography becomes, and the more people there are practising it, the *less* the proportion of home-processing. Most film is now processed by photo-finishing laboratories, which contributes to further delay.

The result of this has been the growth of certain assumptions and methods of working that both compensate for and acknowledge the division of photography into two components: the first ends when the shutter-release is pressed; the second involves editing, evaluating and displaying the picture. The most obvious effect is that the photographer's memory of the actual scene or event fades, so that he or she comes with at least some freshness to the newly developed image. There are some aesthetic advantages to this, particularly in that it gives the photographer a more objective 'second eye', but for the majority of people this is outweighed by the uncertainty of whether the original image idea has in fact been captured. Hence much of the technology and marketing in popular photography has been directed towards 'foolproof' automation: exposure control, focusing aids and reliable portable flash.

Aesthetically, the time gap between taking a picture and seeing the finished result has encouraged a linear method of working—that is, the process of creating a picture generally moves in a straight line from making the initial decisions and choices towards the end result: a finished photograph. There is, however, another method of working that allows time to alter and improve the photograph by evaluating first results. The rapid availability of a picture through the use of instant film makes this possible, and in professional photography it is standard practice to use instant film for a preview of what will finally be shot on conventional transparency film.

Using instant film for feedback information to improve an image can help the photographer both technically and aesthetically. The usual technical checks made with instant film are for exposure, lighting and colour balance. Rapid access to a print can help a photographer to judge the success of an idea, enabling him or her to step back from the process.

As a tool for testing and improving, the introduction of instant 35mm transparency film has broadened the applications of photography. In the kind of uncertain conditions for which 35mm cameras are often used on location, checking is now practical; underwater photography, for example, is one area that has benefitted.

As a finished product instant film has a wide number of applications, especially in documentary, industrial and medical photography; in television news reporting, stills frequently are used, and many television stations now use instant film transparencies. Uncertain, single-opportunity shots, such as in high-speed photography, can be judged to be satisfactory or not at the time of shooting.

Certain kinds of special effects and experimental photography are more practical with instant film. The artist David Hockney's exploration into composite print assemblies was made initially with integral instant film prints. By being able to lay out the assembly on the spot, he could develop and make use of ideas at that moment. Other creative uses of instant film include opening integral prints, stripping emulsion and retouching.

Such uses of instant film photography are by no means exclusive to professionals. For amateurs, instant film feedback has the same potential for improving picture results. In this case the finished product is likely to be an instant print, but the quality of modern materials, particularly the peel-apart films, is of a very high standard.

As a professional photographer my own introduction to instant film was rather prosaic, but typical in its way. From the beginning of my career I used instant film prints to test lighting, colour balance, exposure and even composition. I have always felt that instant film prints are the best solution ever devised to cope with the uncertainties involved in photography that is shot to a brief and to a deadline, a view shared by practically all professional photographers who work with medium- and large-format cameras; there are very few professional studio sessions today in which the waste bin or floor is not being filled with the discarded covers of instant prints.

What this meant, however, is that while I learned early about the serious, non-frivolous uses of instant photography, I came rather late to its pleasures. Simply making use of the material as a professional tool, it took me several years to see that this was just one of a number of unique uses. Indeed, although the prints were filed away regularly as a record of assignments, it was several years before I recognized that these instant pictures could have value in their own right, and be worth a little care. The technology of instant photography has improved to the extent that the print qualities of today's materials are excellent, and most have as much permanence as conventional materials. In fact, for sheer excellence of finish, colour, tone, sharpness and permanence, I can think of nothing finer than my own favourite, 4×5-inch Polacolor print. Perhaps a dye transfer might be better in some ways, but at such trouble and cost that it can only be reserved for special images; the entire action involved in turning out a very refined instant colour print is completed within the 60 seconds or so after it has been pulled from its pack or holder.

I write this with the enthusiasm of a convert, and this seems, in fact, to be the best way of treating an area of photography that has not yet received the serious attention it deserves from all of its users. The more I looked into the possibilities that instant film offers, of different ways of working and of different types of photograph, the more I became convinced that its full potential has yet to be explored.

Much of what follows is a result of my own piecemeal investigation, making easy discoveries here and there, struggling unexpectedly with other ideas that originally promised to be simple and neat. Using integral film out of the camera for photograms and enlargements could not have been simpler: technically, at least, it worked like a charm at the first attempt. Somehow, though, using the same film *in* the camera, a Polaroid SLR 680, was disappointing in several kinds of ordinary location situations. Eventually I put this down to an unwise attempt to use this camera and film in the same way as I would a regular 35mm SLR; not surprisingly, this just pointed out the lack of variety of lenses and the restrictions of a square format. Once I had accepted the inherent differences in picture-taking, results started to improve.

Each time something like this happened, it added to a growing feeling that instant film and its related cameras have distinct qualities that assert themselves in many ways. With integral prints in particular, trying to marshall them into the role of regular photography seems a less successful approach than looking for what they do best, and exploiting that. This book looks at what is unique in instant film photography: the different image qualities of instant film pictures, the way feedback can be used to improve the image, and the surprisingly open area of creative experiment.

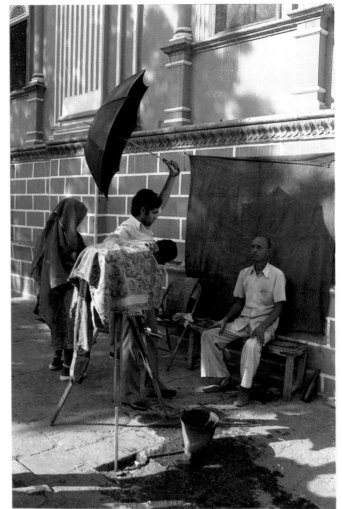

In February 1947 the first public demonstration of one-step photography took place at the Optical Society of America, when Dr Edwin H. Land exposed 8 × 10-inch negative in a view camera and peeled it off from the positive to reveal the finished image.

If instant film photography can be called a relatively new invention, a fair substitute has existed for decades—and still survives in parts of the world. In the Indian city of Jaipur, itinerant photographers fulfil a demand for rapid portraiture by the ingenious means of paper negatives. Regular black-and-white printing paper develops in less than 2 minutes; this is then re-photographed for the final print. From start to finish this takes less than 10 minutes.

Polaroid Type 55 positive/negative print

METRIC CONVERSIONS OF FILM FORMATS AND SIZES

Imperial (inches)	Metric (centimetres)
$2^7/_{16} \times 3^1/_4$	6.2×8.3
$2^5/_8 \times 3^9/_{16}$	6.6×9
$2^7/_8 \times 3^5/_8$	6.8×9.1
$2^3/_4 \times 2^7/_8$	7×7.3
$2^7/_8 \times 3^3/_4$	7.3×9.5
$2^7/_8 \times 4^1/_2$	7.3×11.5
$3^1/_8 \times 3^1/_8$	8×8
$3^1/_8 \times 4^1/_2$	8×11.5
$3^1/_4 \times 3^3/_8$	8.3×8.6
$3^1/_4 \times 4$	8.3×10.2
$3^1/_4 \times 4^1/_4$	8.3×10.8
$3^1/_2 \times 4^1/_2$	9×11.4
$3^1/_2 \times 4^5/_8$	9×11.7
$4 \times 3^3/_{16}$	10.5×8
4×5	10.5×13
$7^1/_2 \times 9^1/_2$	19×23
$8^7/_{16} \times 10^7/_8$	22×27

Polaroid SX-70 print

There are currently three basic types of instant film. Integral print films, made by both Polaroid and Kodak, retain all the chemicals and materials that are needed for processing in a sealed pack, and must be used in specific, automated cameras. Peel-apart print films, made only by Polaroid, are available in four different formats, and can be used, according to type, in special instant-film cameras or in holders that fit on to conventional cameras. Instant slide film is available from Polaroid in 35mm cassettes that can be used in conventional cameras, and from Kodak in a system that uses a special camera and produces one shot at a time.

THE INVENTORY

Choosing Instant Film and Equipment

Instant film photography is almost completely the province of one manufacturer—the Polaroid Corporation—and virtually everything there is to say about instant film involves Polaroid products. Fortunately, and perhaps unusually in a situation where a single corporation so dominates the market, Polaroid traditionally has seen itself as a patron of photography and has done a considerable amount to encourage its use as a means of personal expression and creative experiment. However, despite all the useful information on ways of using the different films, the range of equipment and materials is all but impenetrable. Polaroid's own product list is about as confusing as it could be, with approximately thirty types of film, some of them minor technical changes as one emulsion is gradually replaced by another, many of them varieties of format. Even the description of individual films occasionally changes. Simply unravelling what is generally available required some effort.

The thirty-odd instant film types available can be divided into three basic categories: peel-apart prints, integral prints, and 35mm transparencies (slides):

Peel-apart instant film is self-descriptive: the negative and chemicals used to produce the print are peeled off and discarded (positive/negative film is an exception). The basic range includes colour prints, a fine-grain black-and-white print, an equally fine-grain black-and-white print that has a permanent negative, and a high-speed black-and-white print.

Integral instant films are the mainstay of the amateur market and are designed for simple, no-frills use. At present Polaroid makes two basic types: a medium-speed (due to be phased out) and a high-speed. Kodak make two: one medium-speed, and one that is fairly fast, with a print that can be separated from its packet. *35mm instant slide film*, the latest innovation, could have a significant future if fully accepted by the single-lens reflex (SLR) camera user as being equal to conventional slides, although this will probably depend on further product development. As introduced, such slide films are aimed at the audio-visual market, where their advantages are most obvious. There are two black-and-white transparency films: one medium-speed, the other high-contrast; there is also a colour transparency film.

Equipment for instant film photography is divided between purpose-designed cameras for specific films, and the combination of various holders and the conventional camera systems they fit. One noticeable lack in the range of equipment is high-quality cameras specifically for peel-apart films.

Polaroid Polagraph HC 35mm slide

Polaroid Polapan CT 35mm slide

9

AN INVENTORY OF INSTANT FILMS
(specialist films not included)

PEEL-APART INSTANT PRINT FILMS

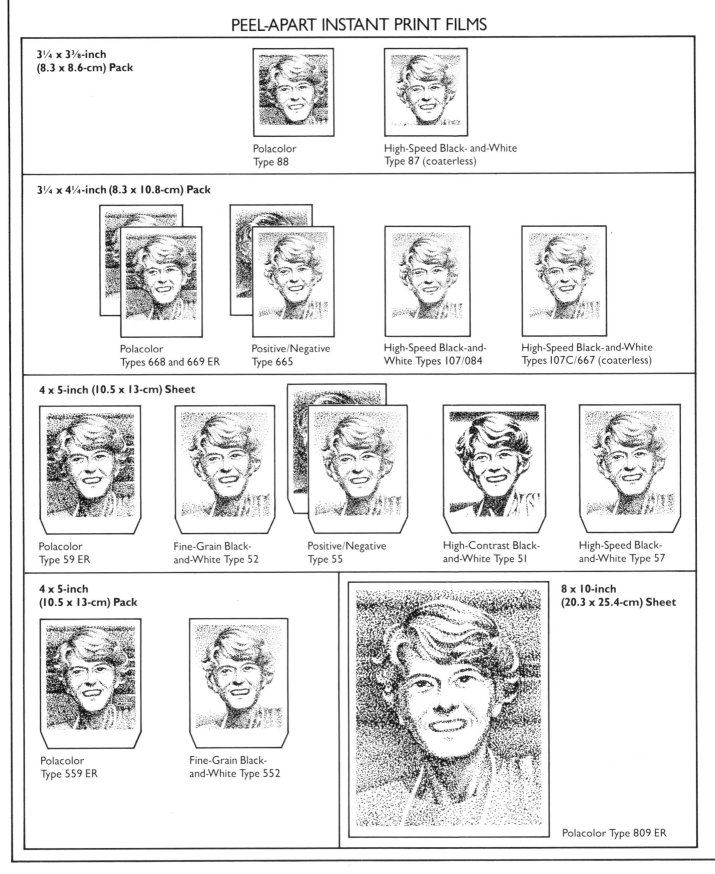

3¼ x 3⅜-inch (8.3 x 8.6-cm) Pack

Polacolor
Type 88

High-Speed Black- and-White
Type 87 (coaterless)

3¼ x 4¼-inch (8.3 x 10.8-cm) Pack

Polacolor
Types 668 and 669 ER

Positive/Negative
Type 665

High-Speed Black-and-
White Types 107/084

High-Speed Black- and-White
Types 107C/667 (coaterless)

4 x 5-inch (10.5 x 13-cm) Sheet

Polacolor
Type 59 ER

Fine-Grain Black-
and-White Type 52

Positive/Negative
Type 55

High-Contrast Black-
and-White Type 51

High-Speed Black-
and-White Type 57

4 x 5-inch (10.5 x 13-cm) Pack

Polacolor
Type 559 ER

Fine-Grain Black-
and-White Type 552

8 x 10-inch (20.3 x 25.4-cm) Sheet

Polacolor Type 809 ER

INTEGRAL INSTANT PRINT FILMS

POLAROID PACK

SX-70/778

600 Supercolor/779

KODAK PACK

PR144 Instant Colour
Print Film

HS144 Trimprint

35MM INSTANT SLIDES

35mm Rolls

Polachrome CS 35mm

Polapan CT 35mm

Polagraph HC 35mm

35mm Format Pack

Kodak Instagraphic

8 x 10-inch (20.3 x 25.4-cm)
Transparency for Overhead Projection

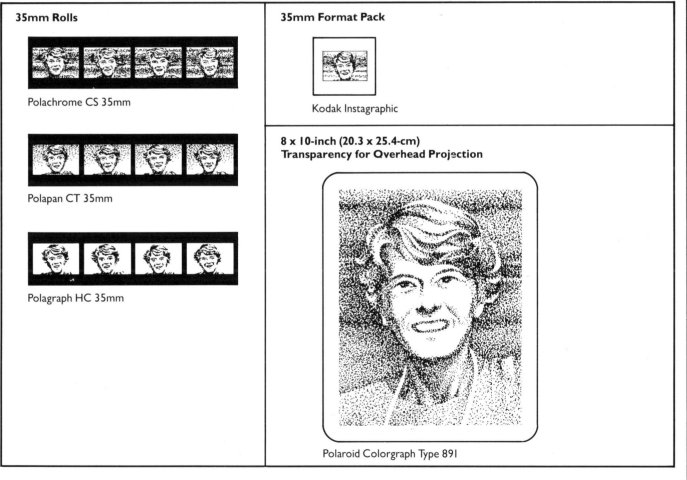

Polaroid Colorgraph Type 891

In the interest of simplicity, the specialized Polaroid products have been omitted from this chart, and the history of product innovation makes it likely that soon there will be additions and replacements. It is the availability of the camera equipment that determines the range of films that can be used, and they are subdivided accordingly. Polaroid rollfilms have been intentionally left out because rollfilm cameras were discontinued in 1963, and rollfilm backs in 1979. For a full description of each film type, see the individual entries that follow.

INTEGRAL FILM CAMERAS AND THEIR FILMS

Polaroid SX-70

Launched in 1972, Polaroid's SX-70 camera revolutionized instant film photography. A compact, folding SLR with sophisticated electronics and optics, the SX-70 was designed around a remarkable film in which everything—negative, positive and processing chemicals—was sealed in one pack. Not only could the film self-process in full daylight, but there was nothing to discard. The SX-70 was the first system to produce true one-step instant photography.

The SX-70 had to meet three essential specifications: first, it had to produce a right-way-round image in a film that is exposed through the *front*; second, it had to be compact yet fill a relatively large image area of 3⅛ × 3⅛ inches (8 × 8cm); third, it had to be fully automatic.

Most films are exposed through the side *opposite* the one they are viewed through, but SX-70 instant film, which develops with a base of white pigment against which the picture can be seen, had to be exposed and viewed from the *same* side. The problem was overcome by bouncing the image off a mirror during exposure (for focusing, the image is bounced off mirrors *four* times to give a right-way-round view through the eyepiece).

Compactness is a special problem for all instant print photography because the picture must be large enough to be seen without enlargement. To achieve the size of an SX-70 print, this ordinarily would require a focal length from lens to film of about 4½ inches (11.5cm). Polaroid managed to squeeze this into a camera that folds to a remarkably flat 1 × 4 × 7-inch (2.5 × 10 × 18-cm) slab (without the autofocus) by the use of an innovative, if odd, folding mechanism. Mainly, the SX-70 is the result of an extremely compact, four-element 116mm lens that measures less than ¾ inch (1.9cm) at its longest, most closely focused position, and an arrangement of mirrors that bounce the image to 'fold' the light path.

Automation extends to exposure measurement, monitoring of the two-in-one aperture/shutter blades, ejection of the film through motorized, pod-squeezing rollers, and, in current models, sonar-operated autofocusing. The power for this, and for the flash bar, comes from a flat, 6v battery inside each film pack.

1) Viewing With the camera opened up, all of its obvious lines are at different angles. At this stage the film pack (2) is protected from light by two mirrors. The image formed by the lens is projected first on to the viewing mirror (3), and reflected down on to a second, patterned, mirror (4). This acts as a flat condenser lens, concentrating the light rays and reflecting them up again to the first, viewing, mirror, but at a different angle. From here they pass through a small opening to the final, concave, viewfinder mirror (5), which projects the image out through the viewfinder lens (6) to the photographer's eye. Being bounced off the mirrors an even number of times—four—the image is viewed right-way-round.

For focusing, only the front element of the lens moves, requiring no mechanical changes inside the camera. The illustration shows the basic Alpha model, without the sonar autofocus; here a knurled wheel engages the lens. *With* autofocusing, a transducer senses the distance by the time-lag between ultrasonic pulses and their echoes from the subject as soon as the shutter release is half-pressed; a servo-motor then focuses the lens.

2) Shooting As the shutter-release is fully pressed, the shutter/aperture blades close to darken the inside of the camera. The patterned mirror is then raised by a motor (2) to reveal the top sheet of film (3); on the back of this mirror is another mirror, now ready to reflect the image straight on to the emulsion. Being reflected just once the image is reversed, but as the print will be both exposed and viewed from the same side, the effect will be normal. These actions take about 3/10 second—what at first seems to be a disconcerting delay in shooting.

The next step is when the twin shutter/aperture blades begin to open. Each blade contains a circular opening with a small kink in one side; as they slide across each other they form an aperture that increases in size. A smaller pair of openings cross to allow light to reach a meter, and when this senses that *half* the required exposure has been made, it signals the closing of the blades.

3) Processing Once the shutter has closed, the same motor that lifted the base mirror now turns gears to slide a 'pick' (1) that engages one rear corner of the film pack and pushes it forwards towards the rollers (2). The rollers, themselves run by gears, take hold of the film like an old-fashioned laundry mangle, and eject it through the front of the camera; in the process they rupture the film's pod and spread its contents evenly between the negative and the image-receiving layer. The processing sequence is completed outside the camera (4). Back inside, the base mirror has fallen back into position, a spring in the film-pack pushes the next sheet up into position (3), and the shutter blades are open once again for viewing.

SX-70 SUMMARY

SPECIAL FEATURES	LIMITATIONS
SLR	Combination of medium
Takes ISO 150 film	film speed and f8
Current version has	maximum
autofocus with manual	Aperture blurs
override	movement in dim light
Automatic exposure with	Limited exposure control
lighten/darken control	
Clip-on 10-bulb flash bar	
Variety of attachments	

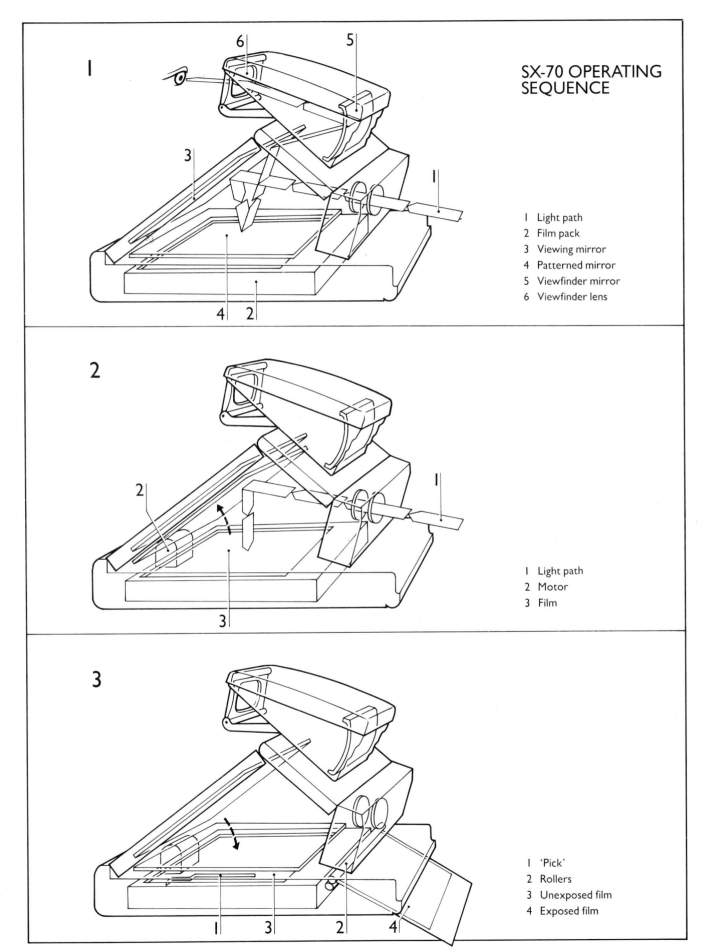

SX-70 OPERATING SEQUENCE

1

1 Light path
2 Film pack
3 Viewing mirror
4 Patterned mirror
5 Viewfinder mirror
6 Viewfinder lens

2

1 Light path
2 Motor
3 Film

3

1 'Pick'
2 Rollers
3 Unexposed film
4 Exposed film

13

Below and right: A tele-lens attachment, available for the SX-70 camera (unfortunately not for its SLR 680 successor), acts as a supplementary lens to give a 50% increase in magnification.

Below: **Discoloration with age** An unusual fault, much more evident in SX-70 film than in the later 600 Supercolor, is the discoloration of white areas in the print that comes with age. In certain cases this may have an aesthetic advantage, but it can be removed by exposure to ultraviolet light (see page 85).

Translucency of the image, particularly around highlight areas, is characteristic of SX-70 film.

Common faults Three of the most usual image faults with Polaroid integral film include: (below) a brown corner at the top indicates that the reagent has failed to spread evenly; (right) white blotches close to one edge are also spreading faults; (below right) a hazy yellowish bar running horizontally reveals uneven action of the rollers. If any of these faults persist, have the camera rollers serviced.

Below: Rich, well-saturated colour was one of the principal qualities of the new metallic dyes introduced in SX-70 film.

SX-70 Integral Film

Polaroid's SX-70 is what is called an integral print film, meaning that every part of the process, from negative to chemicals, remains sealed inside one pack. The development of the image is absolutely 'clean', with no covers or negatives to discard. The photograph is viewed through a tough transparent plastic window, and the negative, once it has served its purpose, remains hidden from view underneath.

This considerable achievement took several major innovations in film technology. One was a package of sixteen layers containing all the necessary dyes and dye developers, but thinner than the negative in Polacolor film. Another was the idea of spreading a brilliant white opaque layer between the positive image above and the negative below, to act as both a

backing for the picture and a screen to hide the used negative layers that remain permanently in the pack.

This white pigment is just one-third of the ingredients of the processing fluid contained in the film's pod. The other two are the alkaline developing agent, which stirs the film's dye developer molecules into action, and, perhaps most innovative of all, a substance called an opacifier. Like litmus paper, the opacifier changes colour with the level of alkalinity; because the fresh developing agent is alkaline, the opacifier spreads through the film as an opaque layer, allowing the chemical reactions to continue beneath in darkness, even though the film pack itself is exposed to light. As the development progresses, the level of alkalinity drops and the opacifier becomes transparent, until eventually the image is visible through the plastic window.

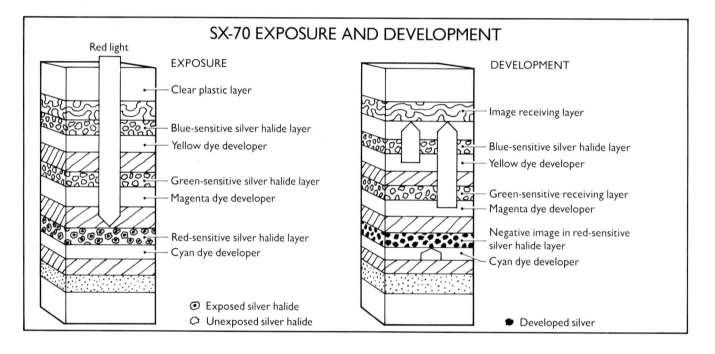

SX-70 EXPOSURE AND DEVELOPMENT

EXPOSURE

Red light

- Clear plastic layer
- Blue-sensitive silver halide layer
- Yellow dye developer
- Green-sensitive silver halide layer
- Magenta dye developer
- Red-sensitive silver halide layer
- Cyan dye developer

⊙ Exposed silver halide
◌ Unexposed silver halide

DEVELOPMENT

- Image receiving layer
- Blue-sensitive silver halide layer
- Yellow dye developer
- Green-sensitive·receiving layer
- Magenta dye developer
- Negative image in red-sensitive silver halide layer
- Cyan dye developer

⬤ Developed silver

1) Exposure As the camera's shutter opens, light strikes the film through the clear plastic window. The negative has three sections, each for one colour and each containing both an emulsion layer of regular silver halide grains and a dye developer layer. The top layer of the three is sensitive to blue light, and the grains exposed here serve as 'traps' for the yellow dye in the next layer. The same happens to the green and red-sensitive emulsions.

2) Development As the film is ejected, the camera's rollers burst the pod of fluid, which is squeezed between the negative and the image receiving layer. The alkalis in this fluid seep through the layers of the negative, activating the dye developers. The dye developer molecules move upwards, but whenever one meets a silver halide 'trap', it is stopped. Cyan dye is caught in the red-sensitive layer above wherever red light reached during exposure; the remaining cyan dye continues upwards to lodge in the image-receiving layer. The same thing happens with the magenta and yellow dyes as they, too, migrate upwards. So this chemical reaction can take place unaffected by light, an opacifier in the pod's fluid forms a lightproof layer above the negative, clearing only when development is complete and the alkalinity has gone. Finally, the positive image is viewed against white pigment, which effectively obscures the spent negative.

Although the first SX-70 film took about 6 minutes of development before the opacifier had cleared and the image could be seen fully, current Time Zero prints clear in about 2 minutes. Even so, about 15 minutes are needed for the image to achieve its full richness and final colour balance: the process of 'settling down' continues for a long time, but the effects become less and less noticeable.

Type 778 is designated by Polaroid 'for professional use', which means that it is selected from production runs for meeting specifications exactly. There may be, for instant, tiny differences of film speed. When a series of pictures is to be made, and all must match in their basic image values, Type 778 is the more reliable film; for most normal use, however, the differences between Type 778 and Time Zero are negligible.

SX-70 TIME ZERO (TYPE 778) DATA BOX

Format	$3\frac{1}{2} \times 4\frac{1}{4}$ in (9×11.5 cm)
Image size	$3\frac{1}{8} \times 3\frac{1}{8}$ in (8×8 cm)
Sensitivity	Colour
Speed	ISO 150
Contrast	Medium
Resolution	8–10 line pairs/mm
Normal processing	Self-processing
Reciprocity compensation	1 sec + 1 stop or + 1 sec 10 sec + 1⅔ stop or + 8 sec 100 sec + 2½ stop or + 500 sec

The restricted range of exposure control offered by the lighten/darken dial (top) can be extended by using a neutral density filter. To *darken* the image hold the filter over the lens only (above); to *lighten* the image, hold it over the sensor only (right).

Polaroid SLR 680

A decade after the launch of the SX-70, Polaroid introduced its greatly improved version, the SLR 680, which may eventually replace the original model. In appearance much the same as the SX-70, the main raison d'etre for the SLR 680 is the development of the excellent ISO 600 high-speed film, which makes low-light photography possible and gives better depth-of-field in most situations. At the same time Polaroid updated the camera's technology with sophisticated improvements. What has been lost is a certain amount of adaptability, such as tele-lens and close-up attachments, in favour of close-to-foolproof operation. There is no possibility of using the slower SX-70 film in the SLR 680; apart from not fitting, there would be no advantage.

The mechanics, optics and exposure system of the SLR 680 are essentially those of the SX-70, and the same sonar autofocus has been incorporated. Focusing with the f8 116mm lens is possible down to 10¼ inches (26.4cm), and the automatic exposure works within a range of shutter speeds (14 to ¹/₁₈₀ seconds).

It is the self-contained flash unit, stacked on top of the autofocus unit, that gives the SLR 680 its noticeable extra length—10 inches (25cm) when folded flat compared with 7 inches (38cm) for the original SX-70. Gone are the flash bars to clip in the top; instead there is a very small flash reflector, measuring only 1 × ¾ × ½ inches (2.5 × 2 × 1cm), positioned slightly to the left of the photographer's viewpoint.

When ejected from the camera, both SX-70 and 600 Supercolor films appear pale-green and featureless. The image appears gradually, becoming stronger and richer. Although the image can be judged within a minute, the print only achieves its final state after several minutes. The developing sequence shown is on 600 Supercolor film.

Not only is the flash small, but its output, if you watch it in operation, appears low compared with conventional camera-mounted flash units. The reason for this is the high speed of the film; even when the full discharge is needed (when photographing in darkness), the ISO 600 film needs much less light than the SX-70's ISO 150 film. There are no batteries in the camera; instead each film pack contains a 6v battery.

The two special features of the SLR 680's flash are that it automatically changes position to focus on the subject at whatever distance, and that its output adjusts to fill in shadows according to ambient lighting.

Articulating flash makes sure that the light is directed, sensibly enough, towards the subject, even when close (as the flash is about 3 inches [7.5cm] from the lens, this is actually necessary). In operation the flash tilts and is connected to the autofocus. Further than about 15 feet (4.5m) nothing happens, but when the sonar signal indicates a closer subject, the flash head tilts down, variably, to a maximum angle of 10° at the closest focusing distance of 10¼ inches (26.4cm). One advantage at such close shooting distance is that the downward tilt gives better modelling than head-on flat lighting.

Even more sophisticated is the continuous-fill flash system, in which the flash unit delivers a variable dose of light rather than blindly pumping out a fixed quantity. Micro-circuitry makes it possible to monitor both existing light and the distance to the subject, and *then* to use this information to alter flash output. If there is very little light, only the flash will be used for illumination; in bright sunlight with a light-toned subject, the flash effect will hardly be visible. In normal daylight, at distances of several feet, the shutter and aperture blades remain open for about 40% of the complete exposure, the remainder being filled by flash. In weaker lighting the ratio alters accordingly to give more flash effect.

Adjustments are also made to take into account the distance of the subject. The range of the flash unit's full power is 14 feet (4.2m), and at much greater distances it will not be noticeable in the picture. In the flash mode, the effective aperture can vary from f8 to f90.

The effect of all these permutations of available light, flash and distance is to produce, under a wide range of shooting conditions, adequately (that is, average) exposed pictures, and to do so with a minimum of attention from the photographer. (Significantly Polaroid recommend using the flash for *every* picture, whatever the conditions, even though the flash can be switched off. This is intentionally one step closer to Dr Land's ideal that 'the process should be concealed from–non-existent for–the photographer'.)

It is, however, not possible to please everyone, and for photographers who like to tinker with controls and settings, the price for all this automation is little versatility—less, in fact, than with the original SX-70. Gone, for example, is any provision for attachments to the lens, which means the demise of the tele-attachment and close-up kit. (Why, indeed, lose the latter? We could have had some fun with that later in the book.) It also means there is no simple way of using filters (but see page 68). There is, certainly, a manual override for the autofocus, and the flash can be switched off, but the lighten/darken control covers only ±1½ stops (not quite enough for a polarizing filter). The SLR 680 is definitely intended to be used as it is, without fooling around.

To an extent I have bowed to the inevitable and concentrated mainly on straightforward uses of the camera. For the few technical tricks that are still possible, despite the worthy efforts of Polaroid engineers, see 'Creative Experiments'.

SLR 680 SUMMARY

SPECIAL FEATURES	LIMITATIONS
SLR	No attachments possible
Takes ISO 600 integral film	Limited exposure control
Autofocus with manual override	
Automatic exposure with lighten/darken control	
Built-in articulated flash	
Continuous-fill flash	

The electronic flash head on the SLR 680 articulates in tandem with the focus. At normal focusing distances (below) it remains pointing straight ahead; when the sonar senses a close subject (below right), it automatically tilts forwards.

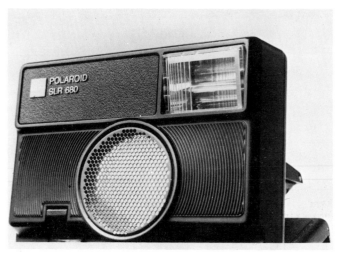

600 Supercolor Film

Since the introduction of the original SX-70 film, Polaroid have made a number of 'hidden' improvements to colour brightness and purity, and to the dye transfer and development time. Polaroid's main goal, however, was to produce a faster film that would allow photography in a greater variety of situations.

600 Supercolor is the result of these endeavours, and in appearance and use is essentially a version of SX-70 film that needs only one-quarter of the amount of light. With an ISO-equivalent speed rating of 600, it is four times—or two stops—faster. Structurally and chemically, however, there are more 'hidden' improvements. The net result is print quality that is, on balance, better for most uses than SX-70, despite being faster. With conventional films the benefits of a higher speed rating have to be paid for with more graininess, and this gives a noticeable difference to the image quality. However, 600 Supercolor does not suffer in this way, although it is the fastest instant colour print film available. This is partly because the extra sensitivity has been achieved in a sophisticated way, but more because, as an instant print film, it does not have to be enlarged—a simple but significant advantage.

The film's high speed has been achieved by a combination of technical advances, including new silver-halide emulsions; two new spacer layers that make the use of light inside the film more efficient; a small increase in grain size; a new spectral sensitizer; and a little more silver. At normal viewing distances the increase in graininess is not noticeable.

In addition, 600 Supercolor is less contrasty than SX-70—an improvement in most picture situations. It does, however, remain high by comparison with the normal peel-apart films, and this explains why Polaroid encourage users to take *all* pictures with the built-in flash: as fill-in, it reduces the difference in brightness between highlights and deep shadows.

As with other integral print films, the image begins to appear almost as soon as the print has been ejected. Tones and colours intensify steadily, and after about 90 seconds the image is fairly well developed. Nevertheless, as the sequence on page 19 shows, there continues to be an increase in saturation for several minutes. The initial colour background is pale green, but the image that forms is at first redder than it will become, an important point to note when you are judging the effect.

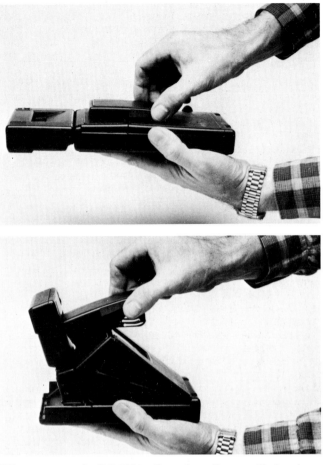

When not in use, the SLR 680 is a flat package. To open, lift the edges of the viewing head, pulling straight up until the metal bar at the side of the camera locks vertically into place.

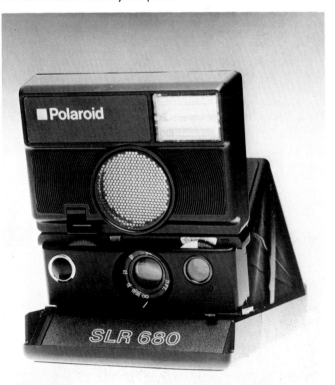

Right: Polaroid's SLR 680 has a built-in flash unit, sonar automatic focusing and automatic exposure. Each feature can be manually overridden to create special effects, or to achieve perfect results even in difficult photographic situations. It uses 600 Supercolor film.

Kodak Instant Cameras

After some major design changes over the last few years, the present range of Kodak instant film cameras all have basically the same appearance: a flat-folding design in which a panel at the front hinges open to swing the lens and shutter forward. By this means the light-path inside the camera is as conventional as could be, unlike the mirror-using design of Polaroid's SX-70, SLR 680 and some previous Kodak models. This model operates on the same principle as the Konica Instant Press—and indeed of a whole family of regular cameras, now mostly museum pieces—in which the lens concertinas forward to give the necessary focal length.

As with Polaroid's integral cameras, Kodamatic models are designed for simple, amateur use ('Instamatic' might seem a more appropriate name, but Kodak used this, perhaps unwisely, for a conventional camera years ago). As you might expect, they are easy to use for straightforward shooting, but do not lend themselves to technical adaptations. The names of the models differ according to where and how they are sold, but, basically, there are the four types:

Kodamatic 950 Instant Camera is a basic model, has a fixed-focus, 100mm f12.8 lens, for use between 4 feet (1.2m) and infinity.

Kodamatic 970L Instant Camera is fitted with a built-in close-up lens to extend the range down to 2 feet (0.6m). The flash is at the side of the body instead of on top.

Kodamatic 980L Instant Camera features automatic infrared focusing from 3 feet (0.9m) to infinity with a 100mm f11, three-element lens and an infrared emitting and receiving window. Like the 970L, the flash is at the side.

Kodamatic 930 Instant Camera is more basic than the 950; it is essentially the same, but with no electronic flash (a non-electronic flash array can be fitted, such as the Sylvana Super 10 Flipflash).

Kodamatic 950 Instant Camera is of a compact, fold-flat design. It has a built-in electronic flash, automatic exposure control and selection of lens aperture, and an electronically controlled shutter.

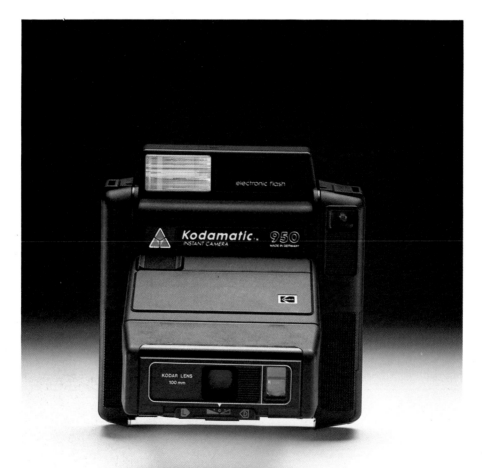

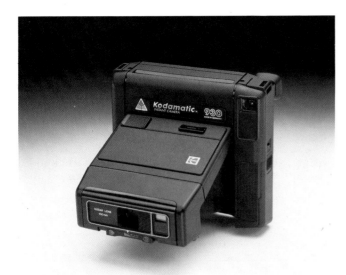

Kodamatic 930 Instant Camera has a fixed-focus lens, automatic exposure control and selection of lens aperture, and an electronically controlled shutter. Flash pictures use flipflash.

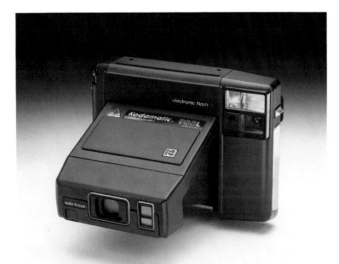

Kodamatic 980L Instant Camera has automatic infrared focusing electronic flash, automatic exposure and selection of lens aperture, and an electronically controlled shutter.

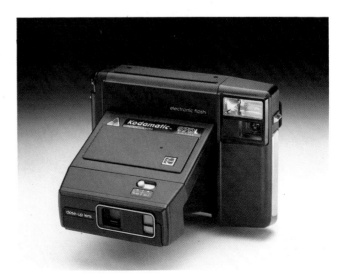

Kodamatic 970L Instant Camera has a fixed-focus lens plus a close-up lens. Its built-in flash fires automatically and switches itself on and off. The exposure control and selection of lens aperture are automatic, and a bright-line viewfinder has parallax correction.

All four cameras accept Kodamatic Trimprint HS144, which is the newer, higher speed improvement on the original Kodak Instant Colour Print Film PR144 (much as 600 Supercolor is to Polaroid's SX-70 film). The older, slower PR144 film is still available to fit earlier camera models.

Apart from the special-feature differences mentioned above, all Kodamatic Instant Cameras have in common automatic exposure control, automatic selection of lens aperture, an electronically controlled shutter and motorized print ejection. All of this requires batteries, which fit directly into the camera, unlike the Polaroid system with batteries in each film pack. Four 1.5v alkaline batteries are needed.

Although there is manual override, these cameras are clearly intended by Kodak to be used with flash, as is the SLR 680 by Polaroid. To save power the charging circuit switches on automatically when the camera is unfolded and gives an occasional boost to keep the charge full. Flash recycling time is about 5 seconds with fresh batteries. In the dark or in dim light exposures are made at the full aperture (f11 for the 980L, f12.8 for the others), but the three models that have electronic flash are designed to give a more realistic shadow-fill in daylight. If the lighting conditions are bright, the lens aperture closes down—to f22 in the 950 and 970L; f27 in the 980L—and the flash output is reduced (25% for the 950 and 980L; 31% for the 970L). If conditions are cloudy or overcast, the flash output is similarly reduced, but the lens aperture either stays wide open or closes down only slightly.

In final appearance, Kodak instant films differ from Polaroid's SX-70 and 600 Supercolor in their format—the more traditional rectangle—and in the semi-matt, lustrous finish, which gives less rich blacks, but also reduces distracting reflections when viewing the print.

The electronically controlled shutter has a range of speeds from about 1/250 second to 1/15 second—adequate for normal shooting with Trimprint film and flash, but not so adaptable as the Polaroid models. There is a lighten/darken control that allows manual override by ±1 stop, in half-stop increments.

As soon as the shutter button is released after making the exposure the motor takes over and drives the print out through the rollers. The print is ejected in about 3 seconds.

Cross-using Kodamatic Films The two varieties of Kodak film—PR144 and Trimprint HS144—are each intended to be used in specific cameras. Trimprint fits the current Kodamatic models; PR144 fits the remainder. Nevertheless, each can be used in the 'wrong' camera without mishap.

CROSS-USING KODAK INSTANT FILMS

TRIMPRINT HS144 IN OTHER CAMERAS	INSTANT COLOUR FILM PR144 IN KODAMATIC CAMERAS
Set lighten/darken control to full DARKEN (and also the electronic flash, if it has a control).	Set the lighten/darken control to full LIGHTEN.
Flash range will be increased by about 2ft (0.6m); pictures in dim light may be improved, but close-ups are likely to be over-exposed.	Flash range will be reduced by about 2ft (0.6m); pictures in dim light outdoors may appear too dark.

KODAMATIC INSTANT CAMERAS SUMMARY

SPECIAL FEATURES	LIMITATIONS
Compact, flat-folding design	Non-reflex
Takes Kodamatic Trimprint film	Limited control over exposure
Automated, simple to use	Long exposures not possible
Manual override for flash and a lighten/darken control	Limited control over focus and depth-of-field
Model choice of close-up lens or autofocus	No attachments possible

Kodamatic Films

Although superficially similar to Polaroid's integral products—being in the form of sealed packs that are ejected automatically from special cameras—Kodamatic instant prints use a different process. The main distinction is that they are exposed directly through the *back* of the film pack and are viewed from the front, whereas Polaroid's integral prints are both exposed and viewed through the front. The Kodamatic system allows a more conventional optical system for taking pictures.

The principle of Kodak's instant process is similar to Polaroid's, although the chemical components are different. A stack of layers makes up the negative,

and next to these is a thinner image-receiving section to which the dyes migrate. In the negative three layers that are sensitive to red, blue and green are each paired with a dye-release layer in either yellow, magenta or cyan. The basic description on page 16 serves for Kodamatic film as well, with the important difference that from the viewing side the order of the layers is reversed. In Polaroid prints the blue-sensitive layer is at the top, nearest the plastic window; in Kodamatic films it is at the bottom.

Having been exposed through the backing layers, the film self-develops in the usual way through an activator fluid squeezed out of a pod by rollers. The fluid—containing potassium hydroxide, a silver halide developing agent, an anti-foggant, sodium sulfite, carbon, water and a thickener—performs the same functions as the Polaroid version: it moves through the layers, developing the image, activating the dye-release and protecting the process from light until development is complete. Like Polaroid integral films, the finished print is enclosed in a pack.

In appearance the main differences are a more conventional rectangular format, and a silky textured finish so that fingermarks and light scratches are less obvious.

Film Development
Like Polaroid integral prints, Kodak instant prints begin to develop as soon as they are ejected from the camera. The image starts to form after about 30 seconds, at room temperature, and after about 10 minutes full saturation is reached. During this time pressure on the print or flexing the pack can spoil the image. The ideal temperatures for development are between 60°F (16°C) and 100°F (38°C). If cooler, the prints may be too light and have a colour cast; if hotter, they may be too dark. If extreme temperatures are unavoidable, use the lighten/darken control to compensate.

These integral prints contain moisture, and so it is better to allow air to circulate around them before putting them in an album or in an enclosed place. Allow two or three weeks for complete drying-out.

Trimprint
The Kodamatic Trimprint was introduced in 1983 to break away from the sealed pack appearance of Polaroid integral prints. While Polaroid deliberately made a film that would have no discardable bits, Kodak, having initially followed suit, now see a future in pictures that *can* be separated from their negatives and chemicals.

Kodamatic Trimprint develops in exactly the same way as basic Kodamatic film, and on ejection looks the same. Across the bottom border, however, is a slit where the positive print can be pulled away from the rest of the pack. The advantages are that the picture is thinner and looks more like a conventional colour print; the disadvantages are mainly environmental ones that Polaroid originally sought to overcome—discardable packs.

Trimprint film contains two black opacifier layers instead of the usual one, and in between is an adhesive, which, although strong enough to keep the packet sealed, also allows the print to be pulled away easily, leaving a dry back. Kodak recommend waiting for about an hour before making the separation (30 seconds at 65°F (18°C) and above).

Care and Storage of Integral Prints
No conventional photograph is as well protected as an integral print: the tough polyester window and sealed pack protect the image from almost any possible damage. The plastic *will* scratch, however, if treated roughly, and flexing the film pack can cause permanent marks if the image is still developing, or can cause the image layer to separate from the base. In other words, integral prints need only moderate care, but do not be fooled by their tough appearance into thinking they are invulnerable.

The moisture from the pod fluid eventually disappears, but the sealed pack ensures that this takes some weeks. It is as well to leave prints exposed to the air during this time; if they are to be framed, wait until they are thoroughly dry. Moist prints are more susceptible to the yellowing that can occur with age and dark storage (see page 14).

KODAK INSTANT PRINT DATA BOX

	Kodamatic/Kodamatic Trimprint HS144–10	Kodak Instant Colour Print Film PR144–10
Format	4 × 3³⁄₁₆ in (10.5 × 8 cm)	3⁷⁄₈ × 4 in (9.7 × 10.2 cm)
Image Size	2⁵⁄₈ × 3⁹⁄₁₆ in (6.6 × 9 cm)	2⁷⁄₈ × 3⁵⁄₈ in (6.8 × 9.1 cm)
Sensitivity	Colour	Colour
Speed	ISO 320	ISO 150
Contrast	Medium (5 stops)	Medium (5 stops)
Resolution*	12–16 c/mm	12–16 c/mm
Normal processing	35 sec at 72°F (22°C)	35 sec at 72°F (22°C)
Reciprocity 1 sec	−1 to −1½ stops	−1 to −1½ stops
compensation 10 sec	−1½ to −2 stops	−1½ to −2 stops

*Cycles-per-millimetre. (This is Kodak's terminology, and approximates line pairs/millimetre.)

PEEL-APART FILM CAMERAS

Unlike integral print films, which require the technology of special cameras, Polaroid's peel-apart films can be used with conventional camera systems. Although the films need to be held in a special area at the back of the camera, and to be pulled through a pair of rollers for processing, they are exposed just like ordinary film. This means that the different models of purpose-built camera for instant film prints are fairly conventional in design. They are quite large because of the print size and the correspondingly long focal lengths that are needed, but otherwise technically unremarkable.

There are, in fact, only a few such cameras made specially for peel-apart instant films; a surprisingly limited choice compared with the great range of films. For 'straight' photography, Polaroid make two cameras, the 600SE and the EE100S, and Konica make one, the Instant Press. More specialized cameras are available for close-up and copy work, notably Polaroid's CU-5 and MP-4 systems. An important alternative is the range of instant film backs now widely available for conventional camera systems (see page 30).

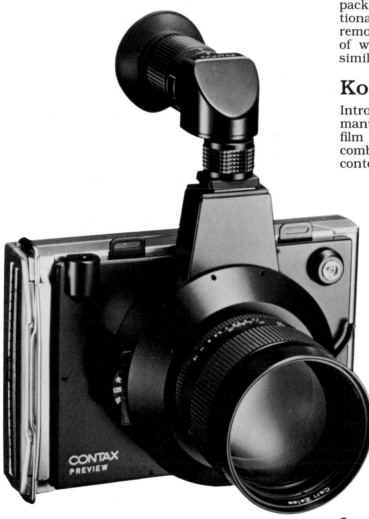

Contax Preview

In one sense a camera, in another a professional backup for testing before shooting on conventional film, the Contax Preview is an ingenious approach to using instant film prints in 35mm photography. In principle it is a highly simplified camera body attached to a Polaroid pack-film holder. Designed for professionals, it is intended to give the same checking facilities for 35mm photography that already exist for medium- and large-format cameras (hence the name Preview). The Polaroid pack-film holder forms the bulk of this camera, and attached to its front is a very slim combination of lens-mount, reflex-viewer and shutter. To keep matters simple, the viewer is right-angled (an eye-level finder is optional), and the shutter is cocked manually with a lever at the side of the lens.

The Preview takes all of the 3¼ × 4¼ pack films, including Types 107, 108, 665 and 668, and produces one full-frame 1 × 1½-inch picture on each print. In practice, having set up the shot with a conventional 35mm camera, the photographer transfers the lens to the Preview and takes a Polaroid test shot from the same camera position. The Preview accepts only Contax or Yashica bayonet-mount lenses. The practical advantage for a professional is that single Polaroid tests can be squeezed off at any time during a shoot; with the alternative system—a pack-film holder such as the ProBack—any conventional roll of 35mm film inside the camera must be removed before making an instant print. At the time of writing, no other 35mm manufacturer has a similar product.

Konica Instant Press

Introduced in 1984, and perhaps unusually by a manufacturer that has no association with instant film photography, the Konica Instant Press has a combination of advantages that make it a strong contender for the top instant pack-film camera. Like

Contax Preview

the Polaroid EE100S (or more strictly, like the earlier classic Polaroid models) it folds, but the quality of the lens, its close-focusing ability and manual exposure control make it worthy of serious professional use.

With built-in handgrip at the side, the Instant Press folds to 8⅜ × 5⅞ × 3½ inches (21.2 × 15 × 9cm). Open, it focuses by means of a large knorled knob on the folding cover. Because the bellows are used for focusing, just like a view camera, the Instant Press will focus down to 17½ inches (44.5cm)—much better than either of the two Polaroid models. The 110mm f4 Hexanon lens is a moderate wide-angle for the 3½ × 4¼-inch format, and at the closest focusing distance gives a magnification of one-third. The viewfinder has a couple rangefinder for parallax compensation at these close distances.

The exposure settings are all manual, with ranges from f4 to f64 on the aperture and T, B and 1 second to ¹⁄₅₀₀ second on the Copal 0 shutter. There is a tripod mount, cable-release socket, X-sync terminal and hot-shoe for electronic flash.

Accessories include a close-up attachment for life-size (1:1) photography, and a converter lens to give the effect of a 75mm lens.

KONICA INSTANT PRESS SUMMARY

SPECIAL FEATURES	LIMITATIONS
Compact	Fixed lens
High-quality lens	Non-reflex
Full exposure control	
Close focusing to	
17½in (44.5cm)	

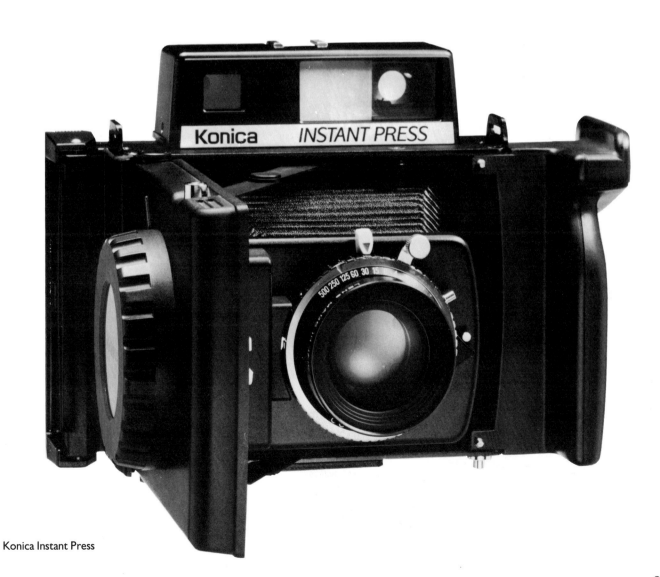

Konica Instant Press

Polaroid 600 SE

Any apparent similarity between this, Polaroid's 'professional' pack-film camera, and Mamiya's Universal press camera is no coincidence. It is essentially the Mamiya model with a pack-film back fitted, and accepts the 3¼ × 4¼-inch films (Type 107 for high-speed black-and-white prints; Type 665 positive/ negative for fine-grained prints and high-resolution negatives; and Types 669 and 668 Polacolor for colour prints).

Like most typical press cameras, the 600 SE is of a non-reflex rangefinder design (an instant-return reflex system would be too bulky for this large format), and has a pistol-grip for rapid handheld shooting (also useful for holding the camera firmly when pulling the film out through the rollers). It takes three interchangeable lenses: a 127mm standard lens with a maximum aperture of f4.7; a wide-angle 75mm f5.6 lens; and a very modest telephoto of 150mm and f5.6. The standard 127mm lens stops down to f64, the other two to f45 (these small apertures are actually necessary outdoors with high-speed film). The two shorter focal lengths focus down to 3½ feet (1.1m), which is normal for a camera of this design, but not so interesting for any photographer wishing to do close-ups.

The shutter opens from B and 1 second to ⅟₅₀₀ second, and there is a tripod socket for long exposures and carefully composed shots.

Conveniently, the film back is interchangeable, and there is a protective dark slide that allows film packs to be changed without losing a sheet of film.

600 SE SUMMARY

SPECIAL FEATURES	LIMITATIONS
High-quality interchangeable lenses	Non-reflex
Interchangeable film back	Limited close-focusing range
Full range of shutter and aperture settings	Bulky

Polaroid's 600 SE is constructed to withstand the rigours of the working environment. It is designed to meet demands for high-quality, versatile non-automatic pack cameras that use '100 Series' Polaroid colour and black-and-white films.

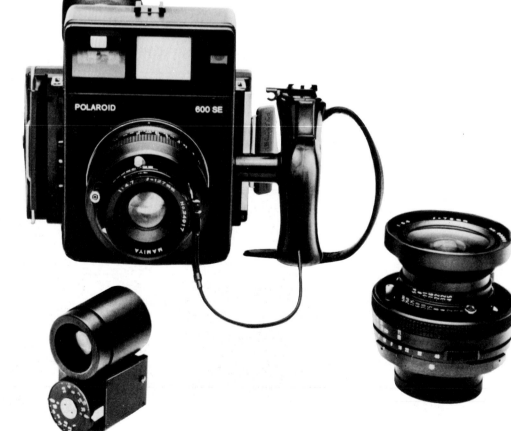

Polaroid EE100S

This is the basic pack-film camera made by Polaroid, the latest in a long line of folding, bellows-fitted cameras. In keeping with Polaroid's policy of making photography simple, the 114mm, f9 lens is fixed and the exposure is automatic via an electronic shutter and a separate photocell. A small lighten/darken control next to the lens allows a variation of four stops—2½ stops brighter and 1½ stops darker. A film selector covers the range of film speeds from ISO 75 to ISO 3000, and power is supplied by two 1.5v AA batteries.

There is no rangefinder, and the focus is set simply by turning the ring that surrounds the lens to the distance, which you must estimate. The viewfinder has two notches on the righthand side of the frame that mark the area of the image for the nearly square 3¼ × 3⅜-inch pack-films.

One of the main advantages of this lightweight, inexpensive camera is that it will accept both the 3¼ × 4¼- *and* the 3¼ × 3⅛-inch pack-films, which gives a useful choice.

The shutter is automatic and operates from 1 second to ⅕₀₀₀ second, and for longer exposures there is a tripod socket and cable-release.

EE100S SUMMARY

SPECIAL FEATURES	LIMITATIONS
Lightweight, very compact, and expensive	Fixed lens
	Non-reflex
	Small maximum aperture
Takes both 3¼ × 4¼in (8.3 × 10.8cm) and 3¼ × 3⅜ in (8.3 × 8.6cm) film packs	Limited close-focusing range
	Limited control over exposure settings
Simple to use	

Polaroid's EE100S is the company's smallest, lightest electronic exposure camera yet introduced. It has automatic exposure with 4-stop manual override, and focuses from infinity to 3½ feet (1m).

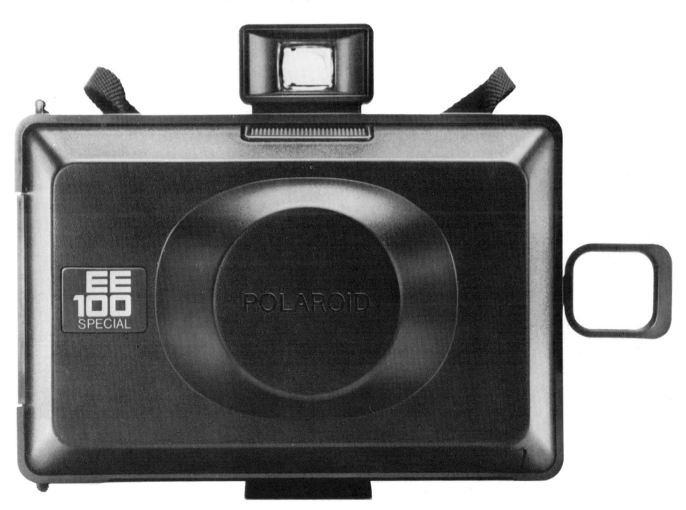

Peel-Apart Film Backs and Holders

Whereas users of Polaroid peel-apart films have a modest choice of purpose-built cameras, most owners of medium- and large-format cameras for conventional films are well served. Polaroid makes four varieties of holder to take its 8 × 10-, 4 × 5- and 3¼ × 4¼-inch formats of peel-apart film (but only to fit 8 × 10 and 4 × 5 equipment), while several major camera manufacturers, such as Hasselblad and Mamiya, produce their own versions to suit their various models of camera. As a result a number of conventional cameras can be used for instant film photography, either for making tests prior to shooting on conventional film, or for producing instant film prints, and negatives, as a final product. Cameras that use 120 rollfilm naturally make use of only a part of the picture area of the 3¼ × 4¼- or 3¼ × 3⅜-inch packfilms, but 4 × 5 and 8 × 10 camera users get the full benefit.

Using an instant film back with a conventional camera rather than an instant-film-only camera means that the full range of lenses and attachments can be used; the versatility of a system camera combined with a range of instant films is enormous. In practice, however, there is not a great choice between peel-apart instant film cameras and instant film backs: it would be an extremely expensive proposition to buy a conventional Polaroid-using system simply in order to shoot instant film.

Nevertheless, whether or not a camera system *can* accept an instant film back should be an important factor in deciding between brands; even if used only as a checking system, instant film can be invaluable.

Instant film backs are not of course limited to fitting conventional cameras. They can be used on copy cameras like the Polaroid MP-4 system, on video screen copiers, on various kinds of special instruments, and even loose, on an enlarger baseboard (see page 96. With a little handiwork most of these backs can be made to fit DIY systems: a basic high-magnification close-up camera, for instance, can be made without too much difficulty from any suitable enlarging or process lens, a long, dark tube and a light-tight fitting for the instant film back, replaced for viewing with a piece of ground glass.

Backs for 8 × 10-inch Polaroid Film

The only holder currently available is made by Polaroid, and closely resembles a normal sheet-film holder. The models 81-05 and 81-06 (the latter differs only in that it must be used with a special slide tray when processing) fit in the back of any normal 8 × 10 camera. Once in place, and when the camera shutter has been closed, the dark slide is withdrawn and the exposure made—just as when working with conventional sheet-film. The holder is then placed in Polaroid's film processor, which automatically feeds the film through pod-squeezing rollers and times the development.

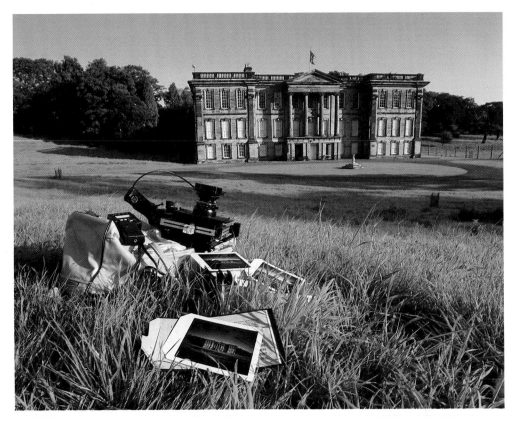

A Polaroid 545 film holder here converts a handheld 4 × 5 camera (a Sinar Handy with a wide-angle lens) into a large-format instant film camera, suitable for location work.

Opposite above: The Tekno back for 100 series 3¼ × 4¼-inch Polaroid film fits on to a Nikon SLR. By pulling the tab only an inch or two after the first exposure, a second shot can be made on the same sheet.

Opposite, below: The 545 holder (and the 550) fits into the spring-loaded back of any regular 4 × 5 view camera. The film pack's paper cover is withdrawn before exposure (at this point the shutter must be closed).

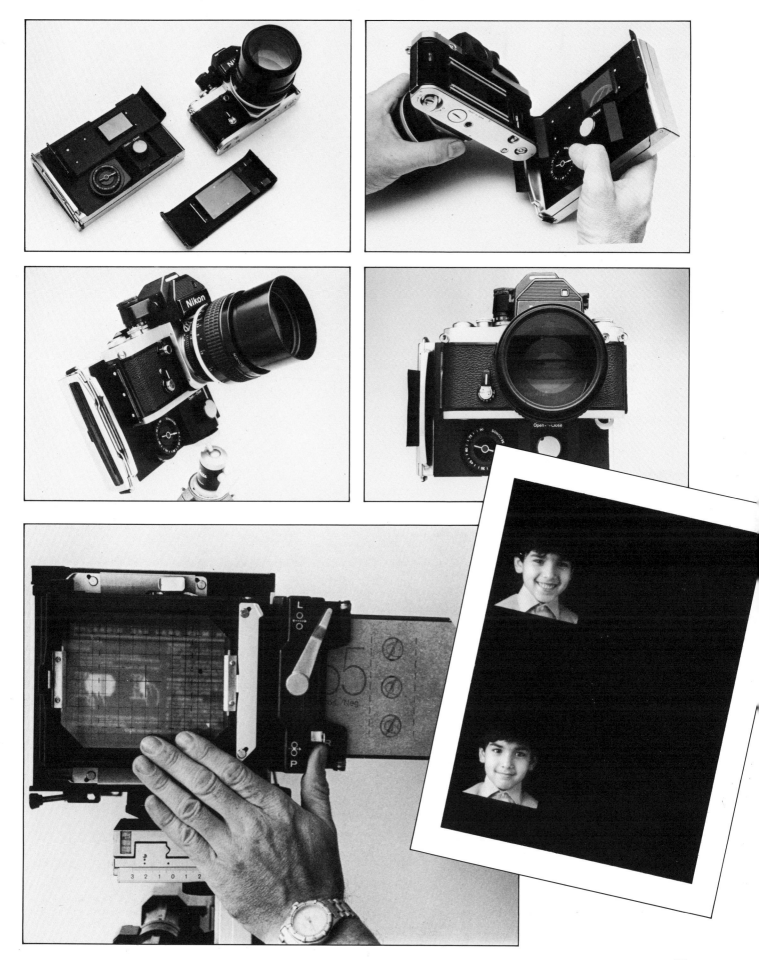

Backs for 4 × 5-inch Polaroid Film

There are two backs made by Polaroid: the Model 545, which accepts single sheets (film Types 51, 52, 55, 57, 58, 59), and the newer Model 550, for film packs (Types 552, 559). Both are designed to fit almost any 4 × 5 camera or instrument, although the extra bulk of the roller housing at one end occasionally prevents a good fit with certain older cameras. It is essential that the flat surround of the holder is flush with the camera back when seated, otherwise light will leak through to the film, and the image will also be out of focus. If there are obstructions on the camera back, they can usually be removed or machined down.

The image area on 4 × 5-inch peel-apart films is slightly less than that of conventional sheet films, and on the single-sheet packs is also slightly off-centre. The reason for this is that the cap at the bottom of the sheet takes up extra space; this can be important when an image is being composed exactly to the edges of the picture, and when the Polaroid film is used as a test for a conventional shot. On the pack films the image is cut off about ⅛ inch (3mm) all round from the normal 4 × 5-inch format; on the single pack films there is an *additional* ⅛ inch (3mm) lost at the cap end (the top of the picture in a vertically composed photograph).

Both of these holders are bulkier and much heavier than ordinary 4 × 5-inch film holders, and if the camera is not locked very firmly on the tripod head there may be risk of movement. Pull out the paper pack or tab with care, holding the body of the holder with the other hand, otherwise the camera may move. Loading the 545 and pulling the film pack out through its rollers usually are better performed with the holder off the camera.

Operating procedures are straightforward, but some precautions are necessary; always make sure the film in the 545 holder is loaded so that the side marked 'This side towards lens' does so; never touch the pod area; and listen for the slight 'click' during loading indicating that the cap has engaged.

A smooth pull through the rollers is important, otherwise there are likely to be blemishes of one kind or another. One aid with the 545 is to start by easing the pack out by about ½ inch (13mm), just until the pod touches the roller (with practice this can be felt), and then pulling out in one even movement. Start counting the processing time as soon as the pack is pulled.

Keep the rollers smooth and dust-free of particles by cleaning them regularly. The holder opens for this purpose. If a pod has broken open for any reason, clean the rollers with a damp cloth or paper, not by scraping. Have the holder serviced about every two years; the rollers need to be positioned precisely and can become slack with use.

Backs for 3¼ × 4¼- and 3¼ × 3⅜-inch Films

Although Polaroid manufactures a back to fit 4 × 5 view cameras (the 405 holder, which accepts 3¼ × 4¼-inch pack film), most of the backs for this size peel-apart film are designed for use on rollfilm cameras. Indeed, virtually every manufacturer of

Hasselblad holder for '100 Series' print film.

Polaroid 81-05 or 81-06 film holders function as any normal sheet film holder in a large-format view camera. To ensure even spreading of the reagent over the large print area, Polaroid's motorized film processor must be used.

medium-format camera has an instant film back in its range of equipment; each is, naturally, specific to that model. For some of these rollfilm cameras there is a choice between the two formats: the $3\frac{1}{4} \times 4\frac{1}{4}$ format (sometimes referred to as the '100 Series') has a greater variety of film types, while the $3\frac{1}{4} \times 3\frac{3}{8}$-inch format is slightly more economical.

Backs for Integral Film

Both Polaroid and Kodak make holders for their integral films (SX-70, 600 Supercolor and Trimprint). The Polaroid model CB-71, which has the same kind of motorized film development system as the SX-70 and SLR 680 cameras, is intended for use by other manufacturers of camera equipment and of equipment that needs an additional imaging system. The Kodak instant film back, on the other hand, will fit into any 4×5 view camera, or other instrument that has a Graflok-type fitting. Processing is motorized, and there is a dark slide so the back can be removed without fogging the film. Availability of both backs is restricted.

BACKS FOR INSTANT FILMS

	8 × 10 Peel-apart film (Types 809, 891)	4 × 5 Peel-apart film (Types 59, 559, 52, 552, 55, 51, 57)	3¼ × 4½ Peel-apart film (Types 669, 668, 665, 107, 084, 107C, 667; ['100 Series'])	3¼ × 3⅜ Peel-apart film (Types 88, 87; i.e. ['80 series'])
8 × 10 view cameras	Polaroid 81-05 and 81-06 film holder	Polaroid 545 film holder for single sheets, 550 film holder for pack films, both used in a reducing back.	Polaroid 405 film holder used in a reducing back	
4 × 5 view cameras		Polaroid 545 film holder for single sheets, 550 film holder for pack films	Polaroid 405 film holder	
Medium-format cameras				
Bronica ETRS, SQ GS1			Own back	Own back
Hasselblad 500C/M, SWC, ELM, FC/M			Own back/Arca back	
Mamiya RB67, RZ67, 645, Press Universal			Own back/Arca back*	Own back
Pentax 6 × 7			'Professional Camera Repair' (M. Forscher)	
Rollei 6006, SLX SL66, SL66E			Own back/Arca Back	
35 mm cameras				
Canon F1, F1N			'Professional Camera Repair' (M. Forscher) Tekno**	
Contax			See 'Contax Preview' page 000	
Nikon F2, F3			'Professional Camera Repair' (M. Forscher) Tekno**	

*Twin-shot capability
**Built-in darkslide for removal without losing any film

PEEL-APART FILMS

Polaroid Fine-Grain Black-and-White Film

Despite what would pass for a high speed in conventional photography, Polaroid's Polapan prints have none of the graininess associated with Tri-X and other fast black-and-white films. Quite the opposite in fact, for at a *paper* resolution of between 20 and 25 pairs of lines per millimetre, Polapan produces truly fine-grain pictures. The grain is too fine to be noticeable when viewed normally, so tonal differences are reproduced with delicacy and smooth gradations. For black-and-white photography, Polapan is an ideal general-purpose film.

Many of the characteristics of Polapan, and most of the techniques for using it, are typical of the general run of black-and-white peel-apart films. In terms of calculating exposure, sensitivity and filters, Polapan

is no different from any conventional black-and-white film, with two precautions: first, being a positive print it needs exposures that will hold the highlights accurately, showing just enough textural detail and avoiding the washed-out appearance of over-exposure. Second, like most instant films, Polapan is a little contrasty compared with most regular emulsions; its exposure range is rather narrow—1:48, or 5½ stops.

The Basic Process

Polaroid peel-apart films use silver halide grains, just like conventional films. Special innovations, however, include a positive receiving layer in the form of a separate sheet, and a sealed pod containing processing fluid, a viscous alkaline reagent. Part of the job of the different designs of camera back and film holder is to position the negative and positive sheets correctly. For shooting, the negative is exposed normally. For processing, the negative and positive sheets are pulled together through rollers that break the pod of fluid, squeezing it out as an even coating between the two sheets. This coating of reagent develops the exposed crystals in the negative, dissolves the rest and passes the solution of unexposed grains through to the positive receiving layer, where it precipitates to a dark silver—the finished image.

The mechanics of the processing vary according to the design of camera or film holder, but pod-squeezing rollers are common to all.

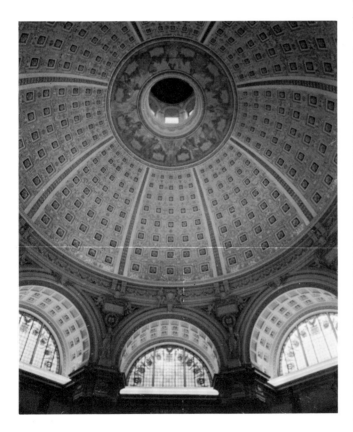

This detailed view of the interior of the Reading Room dome in the Library of Congress demonstrates the high resolution of a Polaroid Type 52 print.

The ability of fine-grain black-and-white film to handle a difficult range of tones is demonstrated here, where the overall contrast range is high (between the bright metal parts and the deep shadows); yet in the low range of the scale there is little real difference between the shades of black. The print copes well with these two extremes.

Long Exposures

All conventional camera films to some extent suffer from what is called reciprocity failure. While at normal exposures—typically between about $\frac{1}{10}$ and $\frac{1}{100}$ second—films behave as they should; at very short or very long exposures they behave as if they had a slower film speed. This is called reciprocity failure because the normal relationship between the brightness of the light and the exposure time breaks down at such unusual exposures. Practically, it is the long exposures of a few seconds and more that cause the most problems. Reciprocity failure is, however, predictable (the extra exposure needed is given in the Data Box on page 37.

Processing

While almost everything about using instant films is simple, the one point in the process that needs special care is when the exposed film is pulled out through the rollers. This is when the processing fluid is spread out between the negative and positive sheets, and any unevenness is likely to spoil the image. If the film is pulled too fast there may be spots left uncovered by the reagent; if too slow the pulling is likely to be unsmooth, causing bar-like marks. Ideally the film should be pulled in a steady, continuous movement at a moderate speed. This can really only be learned by example and practice, but what most people would consider a normal pulling action is in fact perfectly acceptable. To avoid unnecessary mechanical problems, clean and care for the camera or holder as suggested by the manufacturer.

Even though instant films will process adequately over a wider range of temperatures than conventional films, there are limits. Low temperatures slow down reactions, and longer processing time is needed to compensate. The temperature range covers most indoor conditions; it is outdoor use that usually needs special care. The ideal temperature for processing is up to 70°F (21°C), and for best results the temperature should be at least 60°F (16°C); for other temperatures with Polaroid fine-grain black-and-white, the recommended processing times are:

POLAROID FINE-GRAIN BLACK-AND-WHITE PROCESSING TIMES AND TEMPERATURES

	75–90°F (24–32°C)	70°F (21°C)	65°F (18°C)	60°F (16°C)	50°F (10°C)
Type 52	15 sec	20 sec	25 sec	30–35 sec	45–50 sec
Type 552	20 sec	25 sec	30 sec	35–40 sec	50–55 sec

Peeling apart the film For a clean separation of the print from its pack, first pull the two end flaps apart (right). Then, with moderate pressure, tear the envelope open down to the metal tab at the end (below). Finally, with one thumb holding down a corner of the negative and thin paper mask, use your other hand to lift off the print in one quick, smooth action (below right).

35

Clearly it is more reliable to keep the films warm than to calculate the adjustments for cooler temperatures. It is the temperature of the film pack that counts, not the air temperature, and the two will not be the same if, for example, the film has been stored somewhere cooler or hotter than the air temperature. In coolish conditions the easiest solution is to keep the film pack, or even the holder, next to your body for a few minutes *prior* to processing.

As it is only the temperature *at the time of processing* that is important, it is unnecessary to warm up the film before shooting. In fact, if immediate results are not important, with Type 52 Polaroid films (single 4 × 5-inch film packs) it may be safer to save the exposed sheets and process them later indoors. In very cold weather this is usually more sensible; the 545 Land film holder has printed instructions for removing the pack without breaking the pod. If you do use body warmth on a cold day, it is better to have the film pack at the right temperature *before* pulling it through the rollers than to process it cold. To do this, expose the film then remove the pack without processing and warm it next to your body. After a few minutes put it back in the holder and pull it out through the rollers, placing it once again next to your body. An alternative is to warm up the film pack before shooting, make the exposure quickly, and return it to the warmth.

Very high temperatures—over 90°F (32°C)—can also affect the image, therefore the film should be kept as cool as practical. Outdoors an insulated picnic box is one solution, but at the least the film should be kept in shade. In any event, processing one sheet will show if there are any problems; if there are, the film can be stored for later processing.

The processing times given in the table on page 35 are recommended but variable. At any given temperature longer or shorter processing will still work, but the amount of black silver deposited on the print will vary. The longer the processing time the more silver and so the darker the image; shorter processing times give a correspondingly weaker image. The effects are not spectacular, but certainly noticeable. More interesting in many ways is the fact that the *contrast* is altered, becoming higher with longer processing, lower with less. This can be a useful control over image values.

Coating and Keeping Films

Like most peel-apart films, fine-grain black-and-white prints need to be treated with a special coating solution for protection and to neutralize any traces of processing fluid. Each film pack contains just enough coater swabs (one for every five 4 × 5-inch prints, and one for every eight 3¼ × 4¼-inch prints). It is important not to over-use each coater.

The sticky coating fluid that impregnates the swab is an acidic solution of a basic polymer. It removes any residual reagent left on the surface of the print and neutralizes any alkalinity. Without this, highlights and pale tones will bleach out, and the stability of the whole image will be affected, (see page 25). The plastic coating hardens as it dries, sealing the print surface against contamination from the atmosphere and scratching.

The sooner the print is coated, the better—in all events within 30 minutes of processing. The coater must be used carefully because the fresh print surface is very delicate (peel-apart prints have an extremely thin layer of silver). Use about six or eight overlapping strokes and include the white borders (but not necessarily the perforated tab); finish off with two or three smooth, full-length strokes parallel to the longer edges. Coat the print on a flat, clean surface, otherwise the pressure may emboss irregularities into it, and the swab may pick up particles. Outdoor locations are often unsuitable, and if there is any wind there is a danger of the print blowing to the ground. If no other surface is available place the print on the discarded film pack and this on the film box. Cap the coater tube after use.

How quickly the coating dries depends on the humidity of the air. While it can take only a few minutes to dry in a dry place, it is safer to keep the print out of contact with anything else for at least an hour. Drying to a light touch is not adequate to stack the print with other prints. Indoors this may pose no

Two temporary storage methods for prints on location are in the top of the box and in a *dry* negative storage bucket. Either method keeps the print surface out of contact with anything else while the coating fluid dries.

A fault that sometimes occurs with film packs is the misalignment of the envelope and the metal cap. This happens particularly if the packs are pulled out roughly from their box. If it looks like this, tap the length of the cap against a flat surface; there may be a little light leak at this end.

problem, but outdoors it is often difficult to find a suitable temporary storage place. A single print can be put inside the film box or on top of unexposed sheets. For several prints made in quick succession, an empty negative storage bucket of the type used for clearing Type 55 and Type 665 negatives provides safe storage.

Fingerprints and embedded particles are likely to damage the coating. If either has occurred, the coating can be dissolved later by applying fresh coater fluid. To avoid scratching, however, do this by dabbing with a fresh coater, not by wiping. Once the coating is fluid again, remove particles carefully with a small brush or cotton bud, and then carefully wipe over in overlapping strokes. If this re-coating does not work properly, or if two newly coated prints have accidentally stuck together, it is possible to remove the coating entirely by dampening with a solution of 6% acetic acid or white vinegar. Then wash the print, dry it and re-coat.

FINE-GRAIN BLACK-AND-WHITE FILMS DATA BOX

	Type 52	Type 552
Format	4 × 5-in (10.5 × 13-cm) single packs	4 × 5 in (10.5 × 13 cm) pack
Image size	3½ × 4½ in (9 × 11.5 cm)	3½ × 4⅝ in (9 × 11.7 cm)
Sensitivity	Panchromatic	Panchromatic
Speed	ISO 400	ISO 400
Contrast	Medium (1:48 or 5½ stops)	Medium (1:48 or 5½ stops)
Resolution	Fine (20—25 line pairs/mm)	Fine (20—25 line pairs/mm)
Normal processing	15 sec at 70°F(21°C)+	20 sec at 75°F(24°C)+
Reciprocity compensation	1 sec+	None
	10 sec	+⅓ stop or +3 sec
	100 sec	+1 stop or +100 sec

An alternative to on-the-spot processing is to save the film pack until you are somewhere more convenient. This may be useful in windy or cold conditions. As a precaution, identify the shot by writing on the *tab* (not over the picture area or the pod).

Take care in coating each print. One coater contains sufficient liquid for five 4 × 5-inch prints, or eight 3¼ × 4½-inch prints.

Polacolor's colour fidelity is demonstrated here in a comparison between a Type 59 print (below) and an Ektachrome transparency (left). Both were shot under identical conditions with a diffused electronic flash. Indeed, the Polacolor was intended as a test for the Ektachrome. No filters were used for either.

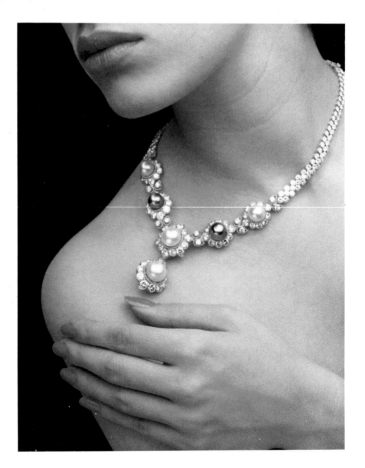

38

Reciprocity failure and correction The top print shows Polacolor's extreme reciprocity failure. At the meter-indicated exposure of 15 seconds at f45, and without any filtration, this interior view by diffuse daylight from a window is hopelessly dark and blue-green. To correct both of these, the second print (bottom) was made with 85B, 30 red and 81A filters, at an exposure time of 8 minutes. This is an extreme example.

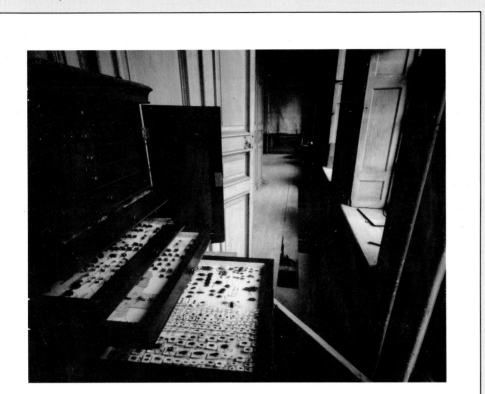

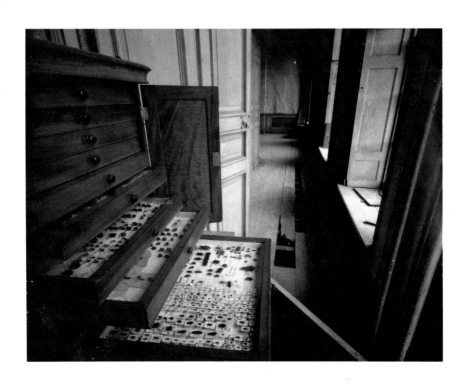

Polacolor

Used well, this colour peel-apart instant film rivals the best conventional colour printing processes. Traditionally Polacolor has been known as a contrasty film, making it difficult to use well in such conditions as bright sunlight with strong shadows. Now, with the introduction of what Polaroid calls its 'ER' Polacolor series (Types 59, 559, 669, 809), the situation has improved enormously. The 'ER' stands for 'extended range', and it can cope with brightness ranges in scenes up to 1:48, or about 5½ stops (the old films, Type 58 and its companions, could only handle 3½ stops, a fairly miserable range by the standards of normal colour films). At 5½ f-stops some care is still needed, both in choosing the subject and in arranging lighting (where this is possible), but for most conditions Polacolor ER performs excellently.

As with any positive film process, exposure decisions in high-contrast situations must normally be made to favour the highlights. In other words, when there are areas of brightness and deep shadows together, the result is usually more acceptable to most viewers if the bright areas look well-exposed and the shadows dark. The alternative—details revealed in the shadows at the expense of washed-out highlights—normally looks worse. This is a subjective area of decision-making, but convention goes against significant areas of over-exposure in most images.

Long Exposures

Like the other instant films, Polacolor becomes progressively *less* sensitive to light the longer it is exposed. This means essentially that there is a loss of speed when exposures are longer than ⅟₃₀ second. This reciprocity failure, however, is a rather more serious matter with colour film than with black-and-white because the three dyes in the emulsion each react differently. The combined effect is a pronounced overall colour shift towards blue-green—it becomes noticeable even at ⅟₃₀ second, and by 1 second is extreme. The Data Box on page 41 shows the degree of reciprocity failure at different long exposures; part of the reason for the considerable increase needed in exposure is that filter factors must be added.

Compared with most colour films—and they all suffer to some degree from colour shifts at long exposures—Polacolor is a heavy sufferer, and the blue-green tinge catches many first-time users by surprise. A common but mistaken reaction is to attribute it to batch differences in the film. Fiddling with filters is certainly something of a nuisance when working in natural light, but the compensations recommended by Polaroid, and listed on page 41 are consistent. To make things easier in picture situations where the exposure runs into seconds, standardize the shots at one exposure time—say, 10 seconds—and vary the aperture, so just one filter pack can be fitted to the lens.

Processing

The processing method for Polacolor is identical to that of other Polaroid peel-apart films, with the proviso that everything is that bit more critical. The temperature, time and pull-through must be just right, as any differences or defects will show up more noticeably in colour values.

The temperature during processing is important—even more so than with the black-and-white peel-apart films—because the richness of colour as well as tone is at stake. The best standard results are at about 75°F (24°C) and call for no adjustment to exposure.

POLACOLOR
PROCESSING TIMES AND TEMPERATURES

90°F (32°C)	75°F (24°C)	65°F (18°C)	55°F (13°C)
60 sec −⅓ stop	60 sec	75 sec +½ stop	90 sec +1 stop and ± CC10 yellow

The processing times mentioned are the standard recommendations by Polaroid, but extending them can improve colour saturation and the richness of blacks. It also, however, tends to cause a slight bias towards cyan. Practically this effect can be put to good use to give some individual control over the image quality. Increasing the time by about 50% produces noticeable results, but to keep the colour balance the same it is usually necessary to use red-yellow filtration when shooting.

FILTERING FOR TUNGSTEN LIGHTING

This table takes into account the combined effect of reciprocity failure and the warm colour of tungsten lamps: at very long exposures, they conveniently nearly cancel each other out.

Exposure	3200–3400K lamps (photofloods, halogen lamps etc.)	Meter setting	2800–2900K lamps (MP-4 copy lamps, etc)
⅛ sec	CC20 cyan + CC30 blue	ISO 25	80B
1 sec	CC30 blue	ISO 25	C50 blue + CC10 cyan
5 sec	CC20 magenta + CC10 blue	ISO 20	CC40 blue
10 sec	CC20 magenta	ISO 16	CC30 blue
30 sec	CC10 magenta + CC10 red	ISO 16	No filter

Viewing

The colour of the light by which a Polacolor print is viewed can make a surprising difference to the picture's colour values, and it is commonsense to judge it in the light under which it will finally be displayed. One odd effect that is not always predictable is an apparent shift towards red under certain types of fluorescent strip-lighting because the magenta dye layer is affected.

Safe-Keeping

Polacolor is a coaterless variety of Polaroid print, which means that as it dries the surface hardens, providing its own protection. Never apply coating fluid to a Polacolor print.

Until the surface dries to a hard gloss finish, be particularly careful with it. Keep prints separate and avoid stacking them. In any case, as with all prints, it is best never to touch the surface of the picture area.

Polacolor dyes are exceptionally stable—as far as colour materials go. While very fade-resistant, long exposure to strong light will weaken the image.

Studio back-lighting with electronic flash on Type 59 film. Polacolor is perfectly colour-balanced for flash.

POLACOLOR DATA BOX

	Type 809 in (cm)	Type 59 in (cm)	Type 559 in (cm)	Type 668 in (cm)	Type 669 in (cm)	Type 88 in (cm)
Format	8⁷⁄₁₆ × 10⁷⁄₈ (22 × 27) single pack	4 × 5 (10.5 × 13) single pack	4 × 5 (10.5 × 13) pack	3¼ × 4¼ (8.3 × 10.8) pack	3¼ × 4¼ (8.3 × 10.8) pack	3¼ × 3⅜ (8.3 × 8.6) pack
Image size	7½ × 9½ (18 × 23)	3½ × 4½ (9 × 11.4)	3½ × 4⅝ (9 × 11.7)	2⅞ × 3¾ (7.3 × 9.5)	2⅞ × 3¾ (7.3 × 9.5)	2¾ × 2⅞ (7 × 7.3)
Sensitivity	Colour	Colour	Colour	Colour	Colour	Colour
Speed	ISO 80	ISO 80	ISO 80	ISO 75	ISO 80	ISO 80
Contrast	Medium (1:48 or 5½ stops)	Medium (1:48 or 5½ stops)	Medium (1:48 or 5½ stops)	Medium-high (1:12 or 3½ stops)	Medium (1:48 or 5½ stops)	Medium (1:48 or 5½ stops)
Resolution	Moderate (11−14 line pairs/mm)	Moderate	Moderate	Moderate	Moderate	Moderate

Normal processing (all film types). 60 sec at 75°F (24°C) .

Reciprocity compensation (all film types):
⅓₀₀₀ sec (flash): −⅓ stop + CC10 cyan. ½₀₀₀ − ¹⁄₆₀ sec: None. ¹⁄₃₀ sec: None + CC05 red, ⅛ sec: +½ stop + CC20 red ¼ sec: +⅔ stop + CC20 red + CC10 yellow. 1 sec: +1½ stops + CC30 red + CC10 yellow. 10 sec: +2⅔ stops + CC50 red + CC10 yellow

Paradise Valley on the slopes of Mt Rainier, Washington, photographed on Type 59 film with a neutral graduated filter to lower the sky tone.

Enriching colour In this pair, the lefthand print was exposed and processed normally, allowing 60 seconds for development. Richer colours in the print below were achieved by developing for 90 seconds; to counter a tendency towards blue-green with extended development, CC05 red and CC05 yellow filters were added during the exposure.

Even with its 'extended range', the latest Polacolor prints can still be too contrasty for some lighting situations. In this sequence, the shaft of sunlight through the trees offered two alternatives: exposing for the sunlit area and allowing the shaded parts of the scene to go dark (above), or exposing for the shade and allowing the over-exposure of the highlights (right). In this type of situation it may well be better to wait until clouds cover the sun, reducing the overall contrast (below).

Positive/Negative Black-and-White Films

For black-and-white photography, Polaroid positive/negative film, in two formats, is one of the most exciting and versatile films available anywhere. Although the speed—ISO 50 for the 4 × 5-inch sheets and ISO 75 for 3¼ × 4¼-inch prints—does not compare with Polapan fine-grain, the resolution is at least as high. In addition to a high-quality positive print, however, this film delivers an equally high-quality permanent negative that can be used for conventional enlargements and wet-process darkroom printing.

With this two-in-one end-product, positive/negative film straddles both instant and conventional photography in a way that makes it possible to check results on the spot, produce an excellent small original print, *and* make multiple, controlled large prints. In quality, virtually nothing has been compromised: the tonal rendering and detail in the print is extremely fine, while the resolution of the negative, at around 160 line pairs per millimetre, compares with fine-grain conventional films—and the Polaroid film is large-format (one reason for this is that the emulsion is thin, and many photographers who work with medium-to-large format cameras use the film for regular shooting).

Apart from the security of knowing that the finished negative is safe and accurate, the self-contained process has another important advantage for a large-format film: it is absolutely free of dust or lint (a very real problem when loading conventional sheet film into holders on location and with a changing bag). The speed of delivery of the negative—30 seconds processing, a few minutes clearing and washing, and a drying time shortened by the thinness of the film—can also be useful in studio shooting when an immediate enlargement is needed.

The contrast of the two positive/negative formats differs slightly. The 4 × 5-inch prints are the same as fine-grain black-and-white, but the 3¼ × 4¼-inch prints are rather more contrasty. The negatives of each, however, have a considerably greater exposure range, and print easily.

Positive/negative film, in either of its formats—the 4 × 5-inch in Type 55 shown here, or the smaller Type 665—delivers an immediate positive and negative *and* the opportunity to tailor the image values in a later enlargement. In this example, the narrow range of tones within the surface of this Egg Cowrie was treated in the enlargement with an eye on brilliance, giving a different sensation to the original print.

Long Exposures

The extra exposure needed at several seconds and longer compares with fine-grain black-and-white. The 4 × 5-inch format has a film speed that is very similar to Ektachrome 6118 (Kodak's tungsten-rated sheet film), and so is very useful as an exposure check. More than this, however, by a lucky coincidence the long exposure compensation is also the same, and even at exposure times of several minutes the comparison holds. As tungsten-rated films are the ones most commonly used for long exposures (their reciprocity failure is less severe than that of most daylight films), this can be very valuable.

Processing

The basic procedure for positive/negative film processing is the same as for fine-grain black-and-white, although the processing time after the print has been pulled through the rollers is rather longer (20 seconds for the 4 × 5-inch sheets, 30 seconds for 3¼ × 4¼-inch prints).

One difference in the positive/negative films is that extended processing does *not* increase the density or contrast. Although this restricts the control that is possible over image values in other black-and-white films, in another way it makes processing simpler: there is no danger of over-processing, and all that is necessary is to give the film *at least* its minimum time (see below).

The temperature, however, is slightly more important than for fine-grain black-and-white films. An added effect of low temperature is that the speed of the *negative* is reduced even more. When warm—more than about 70°F (21°C)—the negative develops slightly more slowly than the print, by about one-third of a stop, but when cool, even at the processing times recommended, the negative can be as much as two-thirds, or one stop, slower than the positive. What this means is that a well-exposed print is accompanied by a thin negative, and while the difference may be too small to matter in a warm environment, when cool (particularly in outdoor shooting) the film will have to be exposed for *either* the print *or* the negative. It may even be necessary to make one exposure for a print check and then a second, longer, exposure to make a useful negative.

Coating

As with fine-grain black-and-white prints, these also must be coated for protection. Follow the recommendations on page 36. There is little opportunity to play with the contrast of a positive print as there is with other black-and-white peel-apart films: extra development creates no more density. However, coating can be delayed to brighten the highlights.

Treating the Negative

Peeling apart the film pack after processing reveals a

POSITIVE/NEGATIVE FILMS
PROCESSING TIMES AND TEMPERATURES

	85–90°F (29–32°C)	75°F (24°C)	70°F (21°C)	65°F (18°C)	60°F (16°C)	50°F (10°C)
Type 55	20 sec	20 sec	20 sec	30–35 sec	40 sec	60 sec
Type 665	20 sec	25 sec	30 sec	35 sec	40 sec	60 sec

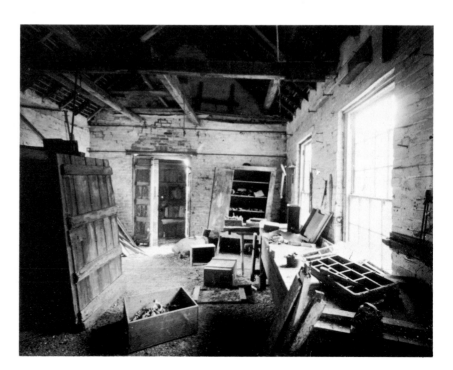

positive print and a negative. The latter is fully developed, but needs treatment to clear away any traces of the processing fluid and antihalation backing. Even the action of peeling off the negative is important: it should be separated cleanly without allowing the emulsion surface to touch anything that might damage it physically. A safe procedure is to peel off each layer completely one at a time to avoid the risk of the print or the thin paper 'frame' falling back on to the negative.

The negative is then pulled away from the strip metal cap along its perforations and immersed in a clearing solution. The solution is of sodium sulfite—an 18% concentration for 4 × 5-inch sheets and a 12% concentration for 3¼ × 4¼-inch films. If both formats are being used a single 18% solution can serve for both, although the backcoat on the Type 665 negatives will take longer to dissolve.

The negative must be treated quickly, certainly within 3 minutes. If there is no sodium sulfite solution available on the spot, however, the negative can simply be immersed and stored in plain water and then given the sodium sulfite treatment.

If everything is immediately to hand, including coater and solution, the order of coating the print and clearing the negative is not important. If this cannot be performed quickly, however, as may be the case outdoors on location, it is probably better to treat the negative first and then to coat the print.

Exposing for the print or the negative In most circumstances, a well-exposed print (left) will be accompanied by a too-thin negative. For an adequate negative it is usually necessary to 'over-expose', as far as the print is concerned (below).

The paper tab can be left on the negative—it makes holding easier—but the thin black perforated strip at the base needs watching: it separates easily after a few minutes soaking, but if it comes away and rests against the emulsion it can stain the negative.

In fact, nothing should be allowed to touch the emulsion surface, and negatives should be cleared either separately in a dish, or held apart from each other. A sheet-film developing tank or clip film hangers are useful, and Polaroid manufactures a special bucket with space for eight 4 × 5-inch negatives and a smaller version to hold 3¼ × 4¼-inch negatives. A removeable holder has curved frames for each negative; the emulsion side should face inwards so that it does not touch the plastic. Press the lead to seal it; the bucket is then portable for location use. After several immersions of film the liquid will turn a reddish-brown, but is still useable. Check the bottom of the bucket occasionally, however, for signs of the sodium sulfite precipitating into a solid block.

Agitate the negative continuously; it should clear in only a few minutes. In any case you can check the progress by inspection. Once the negative is cleared, wash it, although no harm will come if it is left for a day or so in the solution. Ideally, wash in running water that is cooler than about 75°F (24°C); if warmer it will soften the emulsion and make it very prone to scratching. Wash for no more than 5 minutes. For added protection give the negative a hardener bath before washing. Use either a proprietary solution, or mix 28% acetic acid (250cc) and potassium alum (16gm) with warm water (500cc), making up with more water to 1 quart (1 litre) once the chemicals have dissolved. Harden for about 2 minutes.

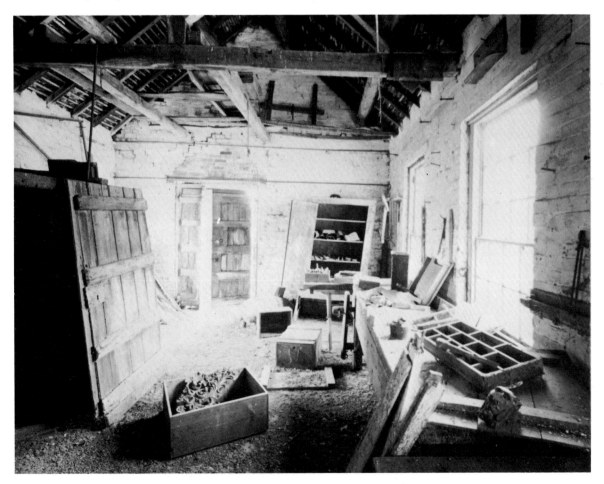

Above: A fresh, negative emulsion is delicate and can suffer from local conditions. Heat in particular can cause the emulsion to lift off the base, as in this example shot in the Anza Borrego Desert in southern California, where the temperature was 120°F (49°C).

Below: Because the film base is thin and very flexible, it is important to take care when loading and withdrawing the paper cover. Here, the negative was slightly buckled when exposed, causing distortion to the fireplace.

POSITIVE/NEGATIVE FILMS DATA BOX

	Type 55 in(cm)		Type 665 in(cm)
Format	4 × 5 (10.5 × 13) packs		3¼ × 3¼ (8.3 × 10.8) pack
Image size	3½ × 4½ (9 × 11.4)		2⅞ × 3¾ (7.3 × 9.5)
Sensitivity	Panchromatic		Panchromatic
Speed	Print: ISO 50		Print: ISO 75
	Negative: ISO 32		Negative: ISO 50
	(varies with		(varies with
	temperature)		temperature)
Contrast	Medium (print 1:24		Medium (print 1:16
	or 4½ stops;		or 4 stops;
	negative		negative
	1:128 or 7 stops)		1:48 or 5½ stops)
Resolution	Fine (print 22–25		Good (print 14–20
	line pairs/mm;		line pairs/mm;
	negative 150–160		negative 160–180
	line pairs/mm)		line pairs/mm)
Normal processing	20 sec at 70°F(21°C)+		30 sec at 70°F(21°C)+
Reciprocity compensation	1 sec	None	None
	10 sec	+⅓ stop or +3 sec	+½ stop or +5 sec
			+1⅓ stop or +150 sec
	100 sec	+1 stop or +100 sec	

Developing instant film negatives out of doors or in unusual situations need not be a problem. With the right equipment and care, it can be as simple as working in your own home.

Location tips for instant negatives To save weight and prevent spillage, travel with a Polaroid bucket, empty until you are ready to begin shooting. Take a measured quantity of sodium sulfite in a plastic screwtop container, possibly with a second amount if the trip is to be broken by, say, an aeroplane flight. Wash negatives in a washbasin with the tap opened just enough to allow a steady change of water down the overflow. Alternatively, use any container and change the water every few minutes.

Alternatively, for large numbers of negatives to be dried overnight, or in an emergency, use clothes pegs or safety pins, clipped to one corner of each negative.

High-Contrast Films

Type 51's high contrast can be used for graphic effect with lighting and subject matter that already have high contrast, as in this back-lit, silhouetted studio shot.

Available only in 4 × 5-inch sheets, Polaroid high-contrast black-and-white film has such a narrow exposure range that any subject that is already contrasty will be reproduced in just two tones: black and white. Lettering on a page, for example, photographs just as it should: dense black on a white background. This, in fact, is the basic use for which high-contrast film was designed: in graphic arts and the copying of line and half-tone originals. It will produce realistic, technically correct pictures of any subject that has the same narrow exposure range.

There is, however, nothing to prevent high-contrast film from being used for other, pictorial, subjects, and for a scene that has a typical range of tones, high-contrast film gives a more unusual treatment than any other instant film print (only Polaroid's 35mm slide film Polagraph HC gives similar results). The creative possibilities in photographing ordinary subjects with high-contrast film are on page 72.

Side-effects of this high contrast are excellent deep blacks and the highest resolution of any instant film print. This high resolution of course applies to the *edges* of tones, and as these tend to run together into dark and white blocks in the image, the *quantity* of sharp detail depends very much on the subject. In other words, if the fine detail in a scene is of more or less the same tone, it may simply run together in a high-contrast print, and effectively disappear. If, however, the detail itself is contrasty, such as a texture in relief, lit strongly with hard, angled lighting, then high-contrast film will give the sharpest, finest image of any.

Like many conventional high-contrast films, Type 51 is blue-sensitive or, to put it another way, does not respond to red. Although this is rather less useful with an instant film than with regular emulsions (the latter can be processed by inspection under a red safelight), it does mean that Type 51 can be used for different kinds of experiment outside the camera in a red-illuminated darkroom. With non-graphic subjects it means anything red will appear almost black, while blue things will appear white.

Exposure

The narrow exposure range of high-contrast film gives it very little latitude so that, in theory at least, the exposure must be accurate. A little less, or more, light alters the extent, and shape, of the dark areas of the image. This narrow latitude, however, only applies if the results need to be exact. Used pictorially high-contrast film gives unrealistic results in any case, so that any of several different exposures may be acceptable. Basically, the less technical the use the more room there is for exposure 'error'.

The blue-sensitivity of Type 51 high-contrast film has a noticeable effect on film speed. In average daylight or with flash the film speed is ISO 320, only one-quarter stop slower than fine-grain. Under photographic tungsten lamps rated at 3200K, however, the film speed is ISO 125, more than twice as slow. Essentially, the more red there is in the light the *slower* the response of the film, and under ordinary tungsten indoor lights the speed is even

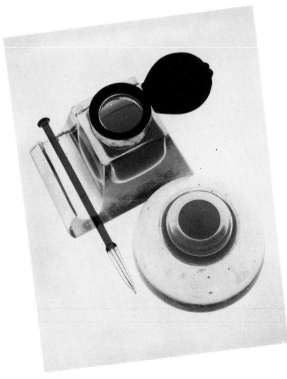

Colour response Type 51 film has an 'orthochromatic response', well illustrated here in comparison with the colour version of a still-life. The film overreacts to blue, so it virtually 'disappears' in a positive print, and is insensitive to red, which consequently appears black in positive.

slower than ISO 125. By the same token, under bluish light, such as shade under a clear blue sky, the film has a *higher* speed than ISO 320. Although this sounds an added complication, in practice the first shot, ready in 15 seconds, shows up any errors.

Long exposures follow the same pattern as Type 52 fine-grain and most other instant films, and the compensation needed for reciprocity failure is in the same order, as shown in the Data Box below.

Processing

High-contrast film is processed as Type 52 fine-grain and most others. Coating is necessary. Altering the processing time affects the density of the blacks and the contrast (see below), while the temperature differences call for the following adjustments:

HIGH-CONTRAST FILMS PROCESSING TIMES AND TEMPERATURES

	65–90°F (18–32°C)	40–60°F (4–16°C)
For high-contrast originals (e.g. line artwork)	15–20 sec	20–25 sec
For average-contrast originals	10 sec	10 sec

Contrast Control

As described above the image on Type 51 high-contrast also can be manipulated by changing the processing time. However, as the density of the developed areas is high to begin with, there is less change to the overall contrast than to the *extent* of the dark areas. For example, if the subject being

photographed has only four tones—black, dark grey, grey and white—normal processing may give an image in which only the black and dark grey tones are recorded. Extended processing will darken the dark grey a little, but may also include the original's grey tones in the picture. A wide range of images is possible by varying both exposure and processing with high-contrast film, but predictable and consistent results are difficult.

HIGH-CONTRAST FILM (TYPE 51) DATA BOX

Format	4 × 5-in (10.5 × 13 cm) single packs
Image size	3½ × 4½ in (9 × 11.4 cm)
Sensitivity	Blue-sensitive
Speed	Daylight (5500K): ISO 320
	Tungsten (3200K): ISO 125
Contrast	High (1:4 or 2 stops)
Resolution	Very high (28–32 line pairs/mm)
Normal processing	High-contrast originals: 15–20 sec at 65°F(18°C)+
	Average-contrast originals: 10 sec at 65°F(18°C)+
Reciprocity compensation	1/10 sec None
	1 sec +⅓ stop
	10 sec +⅔ stop or +6 sec
	100 sec +1⅓ stop or +150 sec

The sensitivity of Type 51 high-contrast film is only towards the blue end of the spectrum. Any longer wavelengths—that is, reds—are simply not recorded on the negative layer. With no red image registering on the negative, the equivalent area on the positive receiving layer develops to a full, rich black. Conversely, blues record strongly on the negative, leaving blank white areas on the positive print.

The most valuable pictorial use of Type 51's high contrast is to enliven flat scenes, as this comparison between a Type 52 fine-grain print (left) and a Type 51 print (right), taken at the same time, shows.

High-Speed and Special Films

Despite a film speed of ISO 3000—three stops faster than the basic fine-grain Types 52 and 552–Polaroid high-speed films have surprisingly good resolution and medium contrast. The range of formats is the greatest of any single kind of instant film, and includes 3¼ × 4¼-inch packs in both normal and coaterless versions, and professional versions of these, a square 3¼ × 3⅜-inch pack, and 4 × 5-inch sheets.

The ISO 3000 film speed is much higher even than fast conventional black-and-white films, and is intended for photographing fast-action events and in dim light. When compared with 35mm high-speed and low-light photography, some of this speed advantage is lost because lenses for these larger instant formats are usually slower (around f4 for instant cameras and most medium-to-large conventional cameras that take instant film holders).

Polaroid Types 107C, 667 and 87 are known as coaterless prints because they need no treatment once they have been processed. Ordinary Polaroid black-and-white prints that need to be swabbed with a coater fluid for protection use silica in the positive sheet that receives the image; coaterless prints use cellulose instead, and the silver image forms deep inside this layer for natural protection. Any traces of the processing fluid are automatically neutralized by a layer of polymeric acid underneath.

Coaterless prints like these are fast and convenient to use, but because the image forms *within* the image-receiving layer, the resolution is not as good.

Types 667 and 084 are professional varieties of Types 107C and 107, respectively. These are generally sold for medical use, particularly for recording ultrasonic images and body- and brain-scans.

Long Exposures
The differences between the formats, as shown below is very small. In general the reciprocity failure for high-speed films is only a little more than for fine-grain. In practice, however, the very high film speed means there are few occasions when a long exposure is actually necessary.

Processing
This is as straightforward as for other black-and-white films; simpler, in fact, with the coaterless Types 107C, 667 and 87, which need no further treatment after the print has been separated from its

HIGH-SPEED FILMS
PROCESSING TIMES AND TEMPERATURES

	75–90°F (24–32°C)	70°F (21°C)	65°F (18°C)	60°F (16°C)	50°F (10°C)	40°F (4°C)
Coated						
Type 107 (084)	15 sec	15 sec	20 sec	25 sec	30–45 sec	45–55 sec
Type 57	15 sec	15 sec	20 sec	25 sec	30–45 sec	45–55 sec
Coaterless						
Type 107C (664)	30 sec	45 sec	60 sec	75 sec	90 sec	Not recommended
Type 87	30 sec	45 sec	60 sec	75 sec	90 sec	Not recommended

HIGH-SPEED BLACK-AND-WHITE FILMS DATA BOX

	Type 107C(667) Coaterless in (cm)	Type 107(084) in (cm)	Type 87 Coaterless in (cm)	Type 57 in (cm)
Format	3¼ × 4¼ (8.3 × 10.8) pack	3¼ × 4¼ (8.3 × 10.8) pack	3¼ × 3⅜ (8.3 × 8.6) pack	4 × 5 (10.5 × 13) pack
Image size	2⅞ × 3¾ (7.3 × 9.5)	2⅞ × 3¾ (7.3 × 9.5)	2¾ × 2⅞ (7 × 7.3)	3½ × 4½ (9 × 11.5)
Sensitivity	Panchromatic	Panchromatic	Panchromatic	Panchromatic
Speed	ISO 3000	ISO 3000	ISO 3000	ISO 3000
Contrast	Medium high (1:16 or 3 stops)	Medium high (1:16 or 3 stops)	Medium high (1:16 or 3 stops)	Medium high (1:16 or 3 stops)
Resolution	Moderate (11–14 line pairs/mm)	Good (16–22 line pairs/mm)	Good (16–20 line pairs/mm)	Good (18–22 line pairs/mm)
Reciprocity compensation				
1/100 sec+	None	None	None	None
1/10 sec	None	None	+⅓ stop	None
1 sec	+⅓ stop	+½ stop or ½ sec	+1 stop or +10 sec	+1 stop or +1 sec
10 sec	+⅔ stop or +8 sec	+1 stop or +10 sec	+1 stop or +10 sec	+1 stop or +10 sec
100 sec	+1 stop or +220 sec	+1½ stop or +180 sec	+1⅔ stop or +220 sec	+1½ stop or +180 sec

pack. As with several other black-and-white peel-apart films, including Type 52, shortening or lengthening the processing time affects the contrast.

Coaterless films take twice as long to process as those that need coating (30 seconds at normal temperatures, against 15 seconds). Variations with temperature are in the same league as for fine-grain black-and-white (see below).

Contrast Control
The high-speed films are ideal for contrast controls (see page 72).

Special Black-and-White Films
In addition to the general-purpose films already described, Polaroid manufactures special films, mainly for scientific applications. Being specialized they are less widely distributed, and regular photographic dealers are unlikely to stock them. If available, however, some have interesting non-specialist uses.

Ultra High-Speed Films
Polaroid Type 612 is available only in 3¼ × 4¼-inch packs, and weighs in at the astonishingly high rating of ISO 20 000. At five-and-a-half stops faster than Type 52 fine-grain—itself not slow—this is definitely *not* a film for ordinary outdoor daylight use. In fact it is intended for oscilloscope trace recordings, but it can produce passable images, even under low-light conditions.

The following adjustments need to be made when processing at different temperatures (the film needs coating):

ULTRA-HIGH-SPEED FILM PROCESSING TIMES AND TEMPERATURES

79–90°F (21–32°C)	65°F (18°C)	60°F (16°C)	55°F (13°C)
30 sec	45 sec	50 sec	60 sec

Low-Contrast Films
Another film designed for photographing cathode ray tubes, low-contrast Type 611 is also available only in 3¼ × 4¼-inch packs. Its special feature is a very flat rendering to cope with the high contrast in images on video monitors and similar screen displays. As such it will produce an image of an ordinary scene that runs from dark to light grey (if under-exposed, black to grey; if over-exposed, grey to white). Type 611 can be processed for up to 3 minutes. It is coaterless.

Rollfilms
For the time being Polaroid continue to manufacture the old-fashioned '40 Series' rollfilms as a service to those who have the discontinued rollfilm cameras and backs. There are rollfilm versions of fine-grain (Type 42) and high-speed (Type 47) films, as well as a high-contrast black-and-white transparency (Type 146), and a medium-speed, average contrast black-and-white transparency (Type 46). The two transparency films must be hardened and stabilized in a special solution known as Polaroid 'Dippit'. A 'Dippit' tank is supplied with each six rolls.

ULTRA HIGH-SPEED FILM (TYPE 612) DATA BOX

Format	3¼ × 4¼-in (8.3 × 10.8-cm) pack
Image size	2⅞ × 3¾ in (7.3 × 9.5 cm)
Sensitivity	Panchromatic
Speed	ISO 20 000
Contrast	High
Resolution	Moderate (15–18 line pairs/mm)
Normal processing	30 sec at 70°F(21°C)
Reciprocity compensation	Not available (too fast to matter)

LOW-CONTRAST FILM (TYPE 611 COATERLESS) DATA BOX

Format	3¼ × 4¼-in (8.3 × 10.8-cm) pack
Image size	2⅞ × 3¾ in (7.3 × 9.5 cm)
Sensitivity	Panchromatic
Speed	200 ASA
Contrast	Low
Resolution	Good (2 line pairs/mm at peak high contrast)
Normal processing	45 sec at 65°F (80°C)
Reciprocity compensation	1/100 sec+ None
	1/10 sec +1/3 stop
	1 sec +2/3 stop or +1 secW
	10 sec +1 stop or +10 secW
	100 sec +1 2/3 stop or +220 secW

This picture of a spark-plug, taken with Type 667 high-speed film, 3000 ASA, shows how even with such a fast shutter speed and in low-light conditions, fine tonal quality and detail are not lost.

35mm INSTANT SLIDES

The most recent major development in instant film photography has again come from Polaroid: instant film in the form of regular 35mm cassettes. Although instant black-and-white transparencies are not a new idea (an early rollfilm format from Polaroid was available in 1948), the new cassettes are the first that are easy and convenient to use. Colour slide film is a real breakthrough, not the least because it can be used in any 35mm camera. There are, of course, a few limitations that Polaroid is working on to improve, but even in their present state these films offer remarkable opportunities.

There are at the moment three types of 35mm slide film, all with the same method of image formation:

Polapan CT is a 35mm instant black-and-white slide film, rated at ISO 125 and available in 36-exposure cassettes. Like most conventional black-and-white films its response to colours is panchromatic, and the image is formed in metallic silver. The film is developed in a separate piece of equipment—a portable darkroom called the Autoprocessor—by inserting a processing pack that is supplied with the film cassette.

Polachrome CS is a 35mm instant colour slide film, rated at ISO 40 and available in both 36- and 12-exposure cassettes. The image is also in metallic silver, but exposed and viewed through an extremely fine screen of a repeating pattern of red, green and blue transparent bands. Quite unlike conventional colour slide film, Pola-

chrome is an additive colour slide film. Development is the same as for Polapan.

Polagraph HC is a 35mm instant black-and-white slide film of very high contrast, similar in appearance to a line of lith film. Rated at ISO 400, with an image in dense metallic silver, Polagraph is available in 12-exposure cassettes. Unlike many conventional high-contrast films it is panchromatic, and so fully sensitive to red as well as other colours. Development procedure is as for Polapan.

Image Formation

All three films work on the same principle. It helps to think of Polachrome as Polapan with the addition of a colour screen. The chemistry is sophisticated, but the principle is actually easy to understand.

In all three films there is an emulsion layer of silver halide grains that is exposed to record the latent image, just as in any conventional film. In order to produce a positive image, however, a second layer is needed. Called the positive image-receiving layer, this layer will carry the final image when the processing is complete. The originally exposed emulsion is then stripped away with used chemical agents.

Slides on location Polaroid's Autoprocessor, a self-contained unit operated by hand-cranking, can be used as easily on location as indoors.

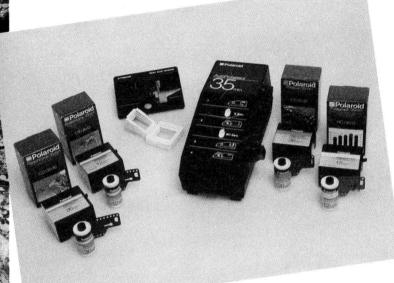

Each roll comes supplied with its own pack of chemicals. The Autoprocessor is separate.

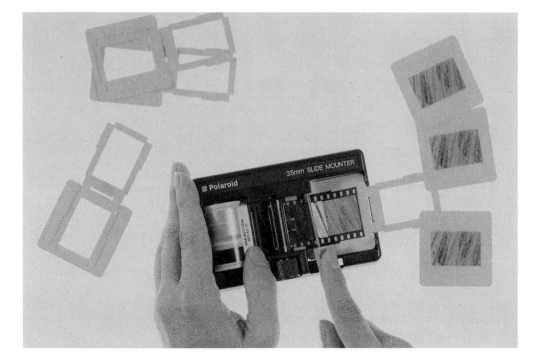

After exposure and rewinding, the film is loaded into the Autoprocessor with its chemical pack. Illustrations printed on the inside of the processor show the sequence of loading.

Polapan CT

This basic black-and-white transparency film has few idiosyncracies. For accurate exposure it is better to treat it as a colour slide film rather than a black-and-white negative: there is naturally less latitude, and of the possible errors, over-exposure is usually *less* acceptable than under-exposure.

As the Data Box on page 58 shows, graininess is moderately fine and has a tight, attractive pattern at magnification; resolution is quite good and contrast fairly high. Compared with the usual way of looking at black-and-white images—as prints—a transparency makes a refreshing change.

Polapan, as Polagraph and Polachrome, is noticeably thinner than conventional films: the polyester base is actually 0.074mm thick rather than the normal 0.125mm. One occasional problem is that in some cameras the thin film can curl, causing soft-focus near the edges. Whenever possible it is safer to close the lens down by two or three stops.

Another hidden problem exists for cameras that have off-the-film (OTF) metering. This normally highly accurate method, in which the brightness of the image is measured directly off the film at the moment of exposure, relies on a matt-finish emulsion, as most are. Because Polapan is exposed through the shiny film base, however, readings are sometimes affected and over-exposure is typical if this *does* happen. The problem is most acute with dedicated flash, and it is safest to set the flash unit for use with its own built-in sensor. Manual settings cause no difficulties. For non-flash OTF photography, use a shutter speed no slower than 1/60 second. Any doubts about exposure can be overcome within minutes by processing the film on the spot.

Processing is straightforward (see below). The range of temperatures is quite generous, and it is impossible to over-develop. Simply make sure that the minimum recommended times are maintained.

35 mm SLIDES PROCESSING TIMES AND TEMPERATURES		
	60–85°F (15–29°C)	60–85°F (15–29°C)
Developing time	60 sec	120 sec
Total processing time	± 5 min	± 6 min

One final caution: Polapan and its two companion films have a built-in protective layer to prevent damage to the image, but in the field, scratching is a real danger. Processing involves winding the film forwards and backwards, and the Autoprocessor must be kept spotless. If there is any risk, expose extra frames for safety.

Because the image is formed with conventional silver, various chemical treatments are possible, including reducing and toning. In particular gold-toning helps to increase the stability of the slides in high heat and humidity (although under normal storage conditions stability is excellent).

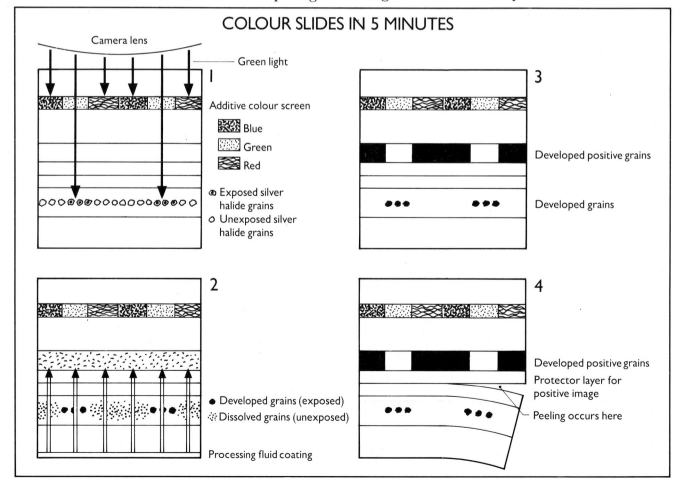

COLOUR SLIDES IN 5 MINUTES

Camera lens

Green light

1

Additive colour screen

Blue
Green
Red

Exposed silver halide grains
Unexposed silver halide grains

2

Developed grains (exposed)
Dissolved grains (unexposed)

Processing fluid coating

3

Developed positive grains

Developed grains

4

Developed positive grains
Protector layer for positive image
Peeling occurs here

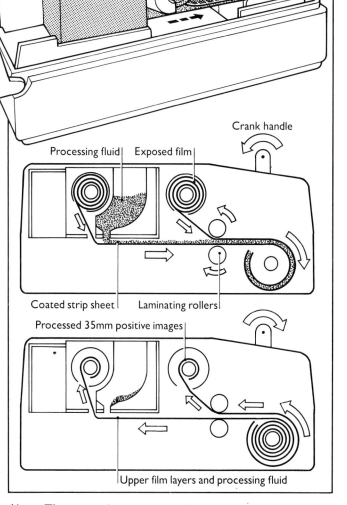

Crank handle

Processing fluid | Exposed film

Coated strip sheet | Laminating rollers

Processed 35mm positive images

Upper film layers and processing fluid

Left: **Colour slides in 5 minutes** From shooting to finished slides ready for projection, the Polachrome process can be completed in 5 minutes, including loading the cassette, a development time of 60 seconds, and stripping away the top layers of the film. The sequence illustrated for Polachrome is the same as for the two black-and-white slide films; the sole difference is the extra colour screen for Polachrome.

1) Exposure From the point of view of conventional films, Polachrome, Polapan and Polagraph are back-to-front: the exposure is made through the clear film base. The grains of silver halide that occupy the emulsion layer in the middle of the film are exposed according to the image. In Polachrome the light passes first through a screen made of a repeating pattern of red, blue and green filters (1 000 triplets per inch). In this example the exposure of only green light from the subject is shown; the green stripes pass this light, but are blocked by the red and blue stripes alongside.

2) Development In the Autoprocessor, a thin coating of processing fluid is applied to the surface of the film and soaks through the upper layers. Within a few seconds the exposed silver grains are reduced to silver. This is a negative image, and it is the remaining *unexposed* grains that will form the final image. These are dissolved by the processing fluid and move down towards the receiving layer.

3) End of development After about 1 minute, all of the silver halide has been converted to metallic silver, but it is divided between the emulsion layer and the receiving layer. The former carries the original negative image, the latter the positive image (the dissolved silver halide grains that migrated down have been reduced to a dense silver). The areas where the green light was able to pass through are now clear and transparent.

4) Stripping the emulsion layer The final stage, which also takes place in the Autoprocessor, strips off the layers containing the weak negative image. What remains is a transparency made up of a clear film base, additive colour screen, silver positive image and protective coating. The parts of the image *exposed* through the green filter strips can now be *viewed* through the same filter. Other colours behave in the same way.

Above: **The processing sequence** All three 35mm films are processed in the same way, with a processing pack supplied with the film and an Autoprocessor. Shown here is the basic hand-cranked version, although there is also a powered model. All of the instructions are printed on the Autoprocessor; the only error possible is to load the wrong processing pack with the film.

The film and processing pack are first loaded with their respective leaders attached to the take-up spool; diagrams on the inside show how everything should fit (top). A lever is then pressed to break the pod of processing fluid inside the pack. After a pause of 5 seconds, the crank handle is turned until it will go no further (centre). It then takes 60 seconds for the development to complete (2 minutes for Polagraph), after which the lever is returned, and the crank handle turned once more in the same direction to rewind the film. The developed film can now be removed (below).

Polachrome CS

Technically Polachrome is a black-and-white film with the addition of a colour screen. There are no dyes involved, just ordinary silver grains. Under high-power magnification, however, parallel stripes of red, blue and green can be seen, similar in appearance to the bands on a colour television set. They work on the additive principle. To the unaided eye they are so close together that they blend and appear colourless against a plain white background. By filtering the light that reaches the film during exposure (they each favour their own colour), and even though these are recorded in black-and-white, when viewed after development through the same colour screen the appearance is an extremely accurate colour rendering. This is the same principle as using strong-coloured filters with black-and-white film to change the tones.

Much of the information already given for Polapan applies to Polachrome, but the colour element needs special comment. In some ways a Polachrome slide is quite unlike a conventional colour transparency. The most noticeable feature is that the highlights do not appear to be very brilliant, and seem to the eye to have a kind of veil over them. This is in fact true because the colour screen has some tone, even when there is no silver behind it. Technically speaking the base density is rather high. This looks worst when the slides are held up to the light or viewed on a lightbox, and is the cause of some disappointment for people using Polachrome for the first time. When projected on to a screen in a darkened room, or in an illuminated slide viewer, however, the slides look excellent, particularly if the light-source is bright.

A slightly odd consequence of having a microscopically striped screen in the film is that under certain conditions it can create an interference pattern. One such condition is when copying Polachrome slides *on to* Polachrome; another is when using a lenticular projection screen; a third is when straight lines in the image *nearly* coincide with the lines of the colour stripes. In most cases the resulting moiré patterns and slightly jagged edges are unwelcome, but can be avoided simply by being aware of the possibility.

If these are the drawbacks of the Polachrome process, the good news is a remarkable colour accuracy and a complete absence of colour shift at long exposures. The reasons for this accuracy are that the colour dyes used are in the striped screen to start with, and undergo no changes. Also, by being arranged side by side, rather than on top of one another as with conventional films, the reaction of one dye has no effect on the others. A special bonus is that the sickly greens of fluorescent strip-lighting, the bane of available-light photography, are banished; Polachrome does not need the normal magenta correction filter. For true colours, even with the longest of exposure times (all night under the stars, if necessary), the credit goes to the fact that Polachrome is actually a black-and-white film— reciprocity failure affects only one layer of silver, not three layers of dye.

The warning about OTF metering given for Polapan also holds true for Polachrome. In addition, any photographer planning to have Polachrome slides reproduced in a book or magazine should be aware that the colours and tones are likely to appear wrong unless the printer uses different scanner settings.

POLAROID 35 mm SLIDE DATA BOX

		Polapan CT	Polagraph HC	Polachrome CS
Film speed		Medium (ISO 125)	Fast (ISO 400)	Slow (ISO 40)
Sensitivity		Panchromatic	Panchromatic	Panchromatic
Exposure latitude		Medium (±1 stop)	Narrow (±⅓ stop)	Medium-narrow (+1, −½ stop)
Graininess		Fine	Fine	Medium
Resolution		Good (90 line pairs/mm)	Good (90 line pairs/mm)	Good (90 line pairs/mm)
Colour accuracy		—	—	Good
Contrast		Quite high (gamma 2.0)	Very high (gamma 4.0)	Quite high (gamma 2.0)
Reciprocity	1 sec	+⅔ stop	+⅔ stop	+⅔ stop, no filter
compensation	10 sec	+1 stop	+1 stop	+1 stop, no filter

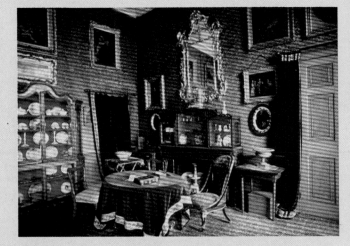
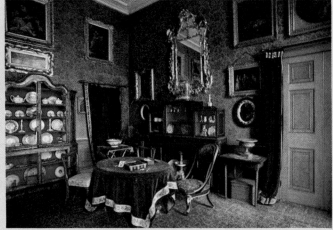

Above and right: Accurate, well-saturated colours are a feature of Polachrome's additive process, but to be seen to their best effect the slides should be viewed either in a handviewer that excludes ambient lighting, or by means of a projector in a darkened room.

Below: A hidden advantage of the additive colour process used in Polachrome is that interiors lit by fluorescent illumination, which would normally appear distinctly green on conventional film (the picture on the right was shot on Kodachrome) are close to normal on Polachrome (left), even without filtration.

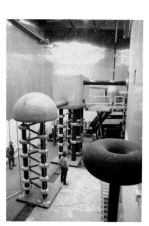

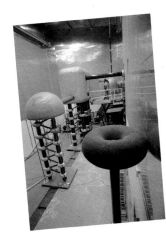

Opposite: Because the overlying colour screen in Polachrome film is in a pattern of parallel stripes, any duplicate transparencies made from Polachrome on to Polachrome will exhibit an odd moiré effect (left).

Polagraph HC

Much of what has been said about Polapan applies to Polagraph as well, although the high-contrast image is pictorially very different. The high contrast, which has obvious uses in copying line artwork and for making clean, sharp titles for audio-visual shows, is achieved by a very narrow exposure latitude and an especially dense silver image. The transparent film base gives extremely bright highlights, and the dense silver in the developed areas gives a high maximum density. This calls for rather longer development—about 2 minutes, as opposed to 60 seconds for the other two films.

As might be expected, the narrow latitude gives very little room for exposure error—only one-third of

a stop over or under. This needs some qualification, however, as the high-contrast result is in any case an unnatural treatment for any normal scene. If artwork has to be produced to a particular density then bracketing is recommended, but for pictorial use the range of acceptable results depends almost entirely on the photographer's opinion. Without experience it is not always easy to predict how a high-contrast version of a scene will appear at different exposures, and as more than one may well look satisfactory, it is often useful to bracket when shooting and then choose which looks best later.

Although many conventional high-contrast emulsions (line and lith films) are insensitive to red, Polagraph is panchromatic and responds well to all colours in the same way as regular black-and-white films.

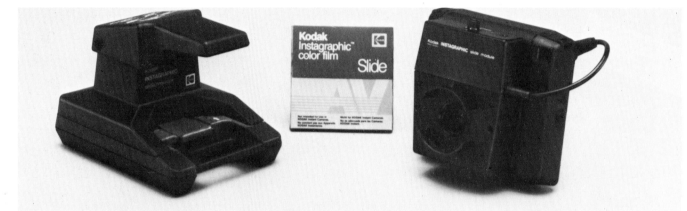

Left to right: Kodak Instagraphic slide mounter, a package of Kodak Instagraphic colour slide film, and Kodak Instagraphic slide module with attached camera back.

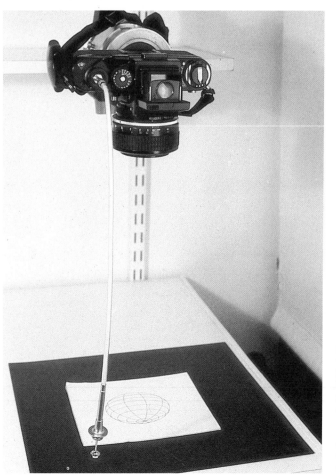

Left: **Artwork for audio-visual shows** The conventional use for Polagraph is as a line copy film for titling and the presentation of flat artwork on a projection screen. For a simple, no-frills copying set-up, clamp the camera as shown, aimed vertically down to any level surface, such as a desk top. A right-angled viewfinder is more useful and convenient than the normal pentaprism in this configuration. As a precaution against the effects of flare, place a black sheet under the artwork to be copied. Measure the exposure with a handheld incident-reading meter, or by taking a direct TTL reading off a mid-grey card or sheet.

Sharpening low contrast Flat scenes, such as the view of gallery ferns in a rain forest (opposite, above), can be given more life with Polagraph, much as described for Type 51 print film on pages 50–1 Note that while the high contrast theoretically makes exposure accuracy more crucial, in practice exposure differences often simply create different images, equally acceptable.

Emphasizing outline Used in shots that rely for their effect on outline created by contrast, Polagraph exaggerates the effect. As in the photographs of ferns, the choice of exposure is surprisingly open to personal taste, as the pair demonstrates (opposite, below).

DIFFERENT IMAGES

Getting the Best From Instant Film

The first section of this book, 'The Inventory', is something of a technical primer, covering the specifications of the films and cameras, how they work, and how to use them. However, while the spectacular achievement of all this technology is to deliver pictures quickly, these films also have special image qualities. In instant prints and slides, tone, texture and several other values are distinctly different from those found in conventional photographs. By knowing about these special qualities, and by knowing how to control them, you can use instant film for fine photographs in their own right, not just as throw-away snapshots or for quick tests.

While there are improvements still to be made—in the exposure range of prints, for example, and the base density of Polachrome slides—it would definitely be a mistake to think of instant films as poor cousins of the real thing. The unconventional chemistry, format and display of these films is necessary to make them instantaneous, and also gives unique picture qualities. Far from being shortcomings, the so-called unusual characteristics of instant films can be highly desirable, particularly if pictures are taken with these image values in mind.

The delicacy of tone in a Polaroid fine-grain print, for example, or the combination of sharp detail and diffuse haze in an integral print are unique; they have no exact equivalent in conventional films, and where such effects can be put to good use instant film is in fact superior to conventional. While differences of this order are certainly subtle, the fine control of image values has always been, and remains, important in serious photography. In the craft of photographic printing, instant films have a valuable place.

In this section of the book we look at how to make the most of the instant image, irrespective of the type of photography, and avoiding, for the time being, unusual experiments. This means identifying how and why instant film pictures of different types look the way they do, and then going a little further—to suggest types of subject, composition, treatment and display that use these qualities to their full. In part this is a matter of being sensitive to such values as graininess, tonal separation and colour saturation; in part knowing how to alter some of the values in a system of photography that is, by and large, not designed to be tampered with.

Orchids, back-lit in the studio with diffused electronic flash. 150mm lens, no filters, f45.

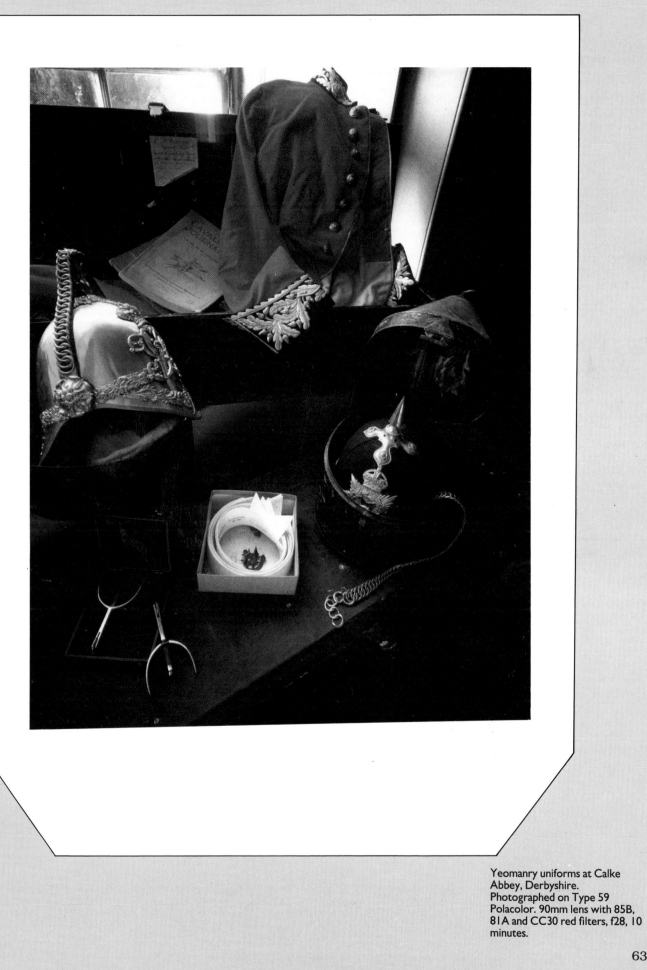

Yeomanry uniforms at Calke Abbey, Derbyshire. Photographed on Type 59 Polacolor. 90mm lens with 85B, 81A and CC30 red filters, f28, 10 minutes.

Integral Films

Even at first glance integral instant prints have a distinctive character and could hardly be mistaken for any other kind of print. Defining what makes an integral print different from a conventional print, however, is not always easy, because at times integral print images appear sharp and bold, while at others they are delicate and subtle.

This variability is not quite as paradoxical as it may seem, because some of the image qualities of these prints are actually at slight odds with each other. On the one hand, contrast is definitely high and detail is recorded sharply (like other instant film pictures, integral prints are essentially contact prints, and nothing is lost through enlarging with another lens); together, these two qualities give a definite, bold appearance. On the other hand, many colours tend to be rendered in pastel shades, and the high resolution is overlaid with a diffuse haze, which is most obvious in highlights and at the edges between very light and very dark areas. A bright object, for instance, often has a 'glowing' effect in a print. The closest analogy of these effects is a softening filter used over a very sharp lens. These qualities account for the delicate character of some prints.

In fact, this mixture of qualities is part of the charm of integral prints, and a different emphasis can be given to each one according to the style of shooting and the type of subject. For example, underexposure, flash and hard lighting, such as a high sun on a clear day, tend to favour a strong, obvious image. By contrast, a quite different, delicate flavour can often be created by over-exposing; using soft lighting; back-lit subjects; highlights and bright subjects against a dark background; finely detailed subjects, with an intricate rather than a bold composition; and haze.

Modern Miniatures

One of the most easily overlooked qualities of integral instant prints concerns not the image values, but the form of the complete picture. Small, individually unique, and presented as a framed, plastic-sealed pack, these prints have many of the qualities of both miniature paintings and daguerreotypes.

If this seems a bit fanciful, consider the appeal of these two types of picture-making. The miniaturist schools of painting flourished from the seventeenth century until the nineteenth. Miniature artists were influenced by the traditions of the Rennaissance portrait medal and medieval illuminated manuscripts, and the paintings became popular because of their jewel-like delicacy and refinement; there is intimacy and charm in a tiny image that is lost in a full-scale painting.

Miniature paintings, which were mainly portraits worn as lockets, disappeared when photography arrived, and it was the daguerreotype that became the replacement. Interestingly, it was not just that a photograph was a simpler and less costly way of producing a picture that made this replacement natural, but that a daguerreotype had many of the same qualities as a miniature. The detail and tones of the daguerreotype were exquisite, and the glass backed with metal, like a painting, had solidity. Although daguerreotypes are now an extinct species of photograph, having been superseded by faster and more convenient processes, they are still very attractive. The shifting of tones when the photograph is held at different angles to the light, and the ornate, clasped frames that the Victorians used for display make them very tactile objects.

Integral instant prints, sealed in a similar way behind a protective window in their own small, bordered pack, have—or at least can have—some of these associations. If displayed and presented to suggest that the picture is worth looking *into*, and not just an off-the-cuff snapshot, integral prints acquire physical presence. Different display and presentation techniques are described on page 98.

October morning, the Cotswolds. SX-70. An enlarged section of an integral print shows the distinctive delicacy in reproductions of soft, misty views.

Old Pathan, Northwest Frontier. SX-70, natural daylight. The high contrast of integral film can help the definition of pictures that use side- or back-lighting to outline the subject. The lighten/darken control needs to be turned to full darken for such a low-key effect.

Room interior, Jaipur, India. Although the SLR 680's built-in flash inevitably changes the atmosphere of the local lighting, it is essential for moving subjects; it also allows rapid, and even candid, shooting.

A daguerreotype of 1858
(right) and Polaroid integral
prints of 1985. Both can be
appreciated as physical objects,
as well as for their images.

Polacolor

Polacolor is, quite simply, one of the finest colour print processes currently available in photography. Since Polaroid introduced the ER ('extended range') version in 1980, the traditional problem of high contrast, which tended to wash out lighter colours, has been largely overcome. The combination of well-saturated, accurate colours and a fine, semi-glossy finish gives a very high print quality that makes Polacolor rewarding to shoot as finished photography. Getting the most from Polacolor is largely a matter of controlling the colour values—their balance, accuracy, richness and so on. This is easy enough to do by using filters and by manipulating Polacolor's special behaviour at long exposures and at different development times.

Varying the Richness of Colour

The processing time makes a noticeable difference to a Polacolor print (see page 40). Just as a longer processing time for a black-and-white instant print enables a richer deposit of silver to be transferred from the negative, so the colour hues in a Polacolor print become more saturated. The amount of extra time depends on personal taste (and by no means do all pictures benefit from being more intense). The change starts to become noticeable when the processing goes on for about one-third longer than recommended—for example, 80 seconds rather than 60 seconds at normal temperatures. In appearance,

the mid-tone colours are those that seem to intensify the most; the highlights and shadows, which have less colour, hardly change.

Using Filters to Change Mood and Balance

Most modern colour films are capable of considerable subtlety in the hues they produce through one simple device—filters. These are much easier and more precise to use with instant film; selecting a filter when a conventional film is in the camera involves a certain amount of guesswork and experience because its effects will only become apparent later, but with instant film the results are immediate.

While many amateurs go for the special-effects filters that add strong colours or create starbursts and the like, the filters that most professionals use are only very gently tinted, creating slight alterations that can affect the atmosphere of a photograph without being stridently obvious. The cool, grey cast of an outdoor scene under a cloudy sky can be made more inviting by using just an 81A or 81B straw-coloured filter—actually a small change, as the weakness of the filter suggests, but one that makes a surprising difference to the mood of the shot. Or, with a forest view of leaves, mosses and ferns, adding

a yellow tint will give a fresher, more spring-like effect, while a bluish filter will give a more mysterious feeling (of all the colours, green is the most susceptible to such small changes).

Such fine-tuning of colour is often neglected in conventional photography because of the uncertainty of the effect, and any delicate manipulations are usually reserved for the printing of colour negatives. By then, however, it is too late to compare the results with the original scene. With instant film, and in particular Polachrome slides and Polacolor peel-apart prints, a small pack of filters on location will give the photographer professional control over the nuance of colour. Effects such as those shown here can be rated for success at the time, something that has never been possible with colour slides before now.

Kodak's series of light-balancing filters—which range from blue to orange—and correction filters—which include red, green, blue, cyan, magenta and yellow—offer the finest control. Although a full set would be impractical, a selection covers most situations.

Neutral graduated filters are especially useful with Polacolor, giving a substantial range of control over contrast. Usually available in rotating mounts, these filters can be positioned at different angles.

Opposite: One of the most useful filters for location shooting is a neutral graduated type. For outdoor use, the transitional zone between light and dark can be aligned with the horizon, so that the sky tones can be lowered to bring them within the range of the film. In other situations the filter can be angled to coincide with, say, the tonal division in an interior. The best use is usually the most subtle, with the filter used to balance tones. In the paired example, a graduated filter rotated so that the division is vertical corrects the left-right tonal distribution.

Antique yellow An 81B straw-coloured filter, added to the filter pack to correct reciprocity failure, enhances the old, dusty associations of this 19th-century butterfly collection.

Cool purple In deliberate contrast to the expected orange rendering of a sunset view along the northwest Pacific coast, a filter pack of CC35 magenta and CC10 red was used with a 4-second exposure. The combination of the filters and Polacolor's own reciprocity colour-shift produces a refreshingly cool sunset.

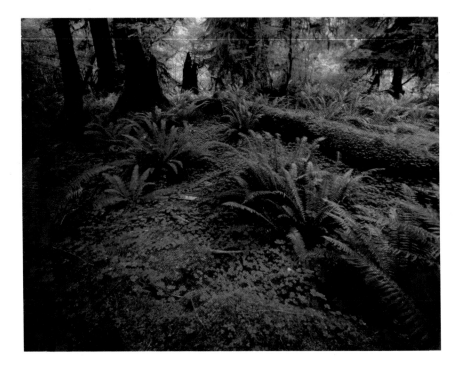

Blue-green gloom The silent, gothic atmosphere of a wet rainforest is enhanced by allowing the natural shift of Polacolor towards blue-green in a long exposure to remain uncorrected.

Subtle variations in contrast and colour intensity are possible by varying the time that the print is allowed to develop. In the bottom version the print was developed for the recommended 60 seconds for 75°F (24°C). The top print was allowed to develop for 90 seconds. The result: slightly more intense colours and dark tones, and a small shift towards blue-green. This colour shift can be compensated for by using light-yellow and red filters when shooting.

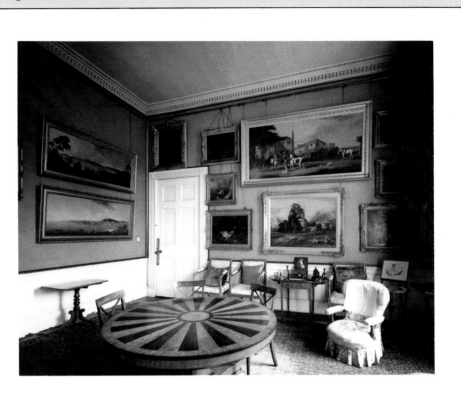

Fine-Grain Black-and-White Films

As a group, Polaroid's black-and-white peel-apart films offer the monochrome photographer outstanding image quality and a useful variety of treatments—including fine grain, high sensitivity and high contrast. Not only do all these print films hold their own against conventional emulsions, but some are even superior in certain respects. All have in common the advantages of being contact prints made directly from their companion instant negatives, and of having a very fine, thin silver layer that forms the image. These advantages become obvious when comparisons are made with conventional prints: high resolution and good separation of tones. All of these films also have the practical benefit of being made under sealed conditions, and dust-specks are rare.

There are, in addition, subtler advantages in the quality of the black-and-white image. Ansel Adams, the master of the fine print, saw two unique aesthetic values in fine-grain Polaroid prints. One is the combination of high resolution and a diffuse silver haze—what he called 'an acceptable degree of perceived sharpness accompanied by a subtle "glow" in the print that is often of great aesthetic advantage'. The other is the tonal distribution from black to white. Again, to quote Adams, 'Within its exposure range Type 52 has a rare quality—its value scale is quite "linear", which the eye seems to appreciate favourably. Indeed, it is practically impossible to make a conventional print that equals the unique quality of a fine Polaroid Type 52 original'. The same applies to Type 552, and to Types 55 and 665 positive/negative.

Contrast Control

In most black-and-white photography the film is negative, leaving the photographer with a wide choice of results achieved by using different printing techniques. A variety of paper grades and the usual printing controls, such as shading and printing-in, make it fairly easy to change the contrast and to decide how much shadow and highlight detail will appear. Instant film prints, on the other hand, are positive, and in ordinary use do not have the same latitude. However, by juggling the exposure, processing, and the time of coating the print, the contrast *can* be controlled to a surprising degree.

The normal rule-of-thumb for all positive films, whether colour slides or instant film prints, is to expose for the highlights and let the shadows take care of themselves. This is only more than common-sense, as shadow areas can be dense black or pale grey and still look acceptable, whereas washed-out, bright areas nearly always look wrong. Most instant films, however, have a higher contrast than conventional films, and if the scene being photographed is contrasty, too much detail may be lost. By a fortunate coincidence there are two steps in the processing of Polapan fine-grain (and some of the other black-and-white Polaroid films) that each affect different tones in the picture: the processing time affects how much silver is deposited (and so the darkness of the shadow areas), while one of the effects of coating is to prevent bleaching of the bright areas. Used together, development time and the time of coating can alter the contrast. The exposure is used to balance the effects. By choosing the right combination of processing time, coating time and exposure, you can have useful and simple control over the contrast of an instant print or slide.

Extending the processing time deposits more silver on the print, and this naturally has most effect on the darkest areas (making the blacks deeper) and least on the highlights. This in itself heightens contrast, although it also makes average pictures darker overall, so that the actual exposure may have to be a little greater. Extending the development for a long time—around 60 seconds or more—can deposit so much silver on fine-grain film that very dark shadow areas acquire a metallic sheen, known as gilding. This may or may not be desirable.

Shortening the processing time gives weaker blacks —again having virtually no effect on the light areas— so reducing contrast. Shortening the processing time should only be fractional because evenly toned areas may appear blotchy or streaked due to poor development.

If coating is delayed, the lightest areas in the print will bleach slightly, so increasing contrast at this end of the tone-scale. Dark areas are affected least.

Pre-exposure is another technique that can help, although rather fussy and dependent on the type of camera. This is a fairly old-fashioned trick, which involves giving a very slight, overall dose of light to the entire film before shooting. For example, an extremely short exposure (about two stops less than normal) of an evenly lit sheet of white paper or a white wall, out of focus, has the effect of lightening shadows in the second, 'real' exposure. Highlights are least affected, and so the overall contrast is reduced. Although this is a useable technique, it is less convenient than altering the processing and coating times.

RAISING CONTRAST

	Exposure*	Processing time	Coating
Deepen shadows	Normal	Longer	Normal
Brighten highlights	Normal	Normal	Delayed
Deepen shadows *and* brighten highlights	Normal	Longer	Delayed
Lighten mid-to-light tones	Slightly more	Longer	Normal

*This will depend on how much shadow area there is. If the overall tone of the image is light, for example, no increase in exposure may be necessary.

REDUCING CONTRAST

	Exposure*	Processing time
Lighten shadows	Normal	Shorter
Lower highlights	Less	Shorter
Lighten shadows *and* lower highlights	Slightly less	Shorter

*This will depend, as with raising contrast, on the type of image.

Both the delicacy of tonal separation and the fine resolution of Type 52 film are evident in this natural-light shot of a bronze door on the Library of Congress, Washington D.C.

Contrast control Using Type 52 fine-grain film, this pair of prints shows the tonal control that is possible by altering the processing time. The print directly below was developed as recommended for 15 seconds at about 75°F (24°C); the richer print at the bottom was allowed to develop for 60 seconds before the film pack was opened.

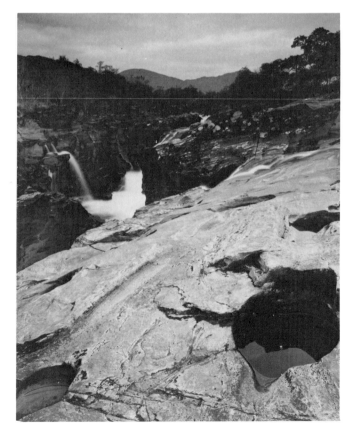

Using solarization effects By opening the film pack in full daylight and allowing it to clear in the open, some of the deepest shadow areas in this Scottish landscape have started to reverse (the area around the waterfall). Technically a fault, such solarization can give an interesting tonal effect, as the reversal is halted by adjacent developed areas. The effect is obvious in both the Polaroid print and in later conventional enlargements from the negative.

Positive/Negative Films

The two Polaroid positive/negative films, Types 55 and 665, are probably the most interesting of any black-and-white material available. The instant film print has the same fine grain and delicate tonal distribution as Types 52 and 552 fine-grain black-and-white (although the film speed is quite a bit slower), and in addition there is the exceptional negative. In this way, one single pack can produce an immediate proof print and the means of making a conventional enlargement of high quality.

As mentioned in 'Feedback', the film speed and reciprocity characteristics of Types 55 and 665 prints make them useful as testing vehicles for some colour films, but their main use is for the negatives. To make the best use of this negative material, the first important step is to expose the film correctly. This requires a little thought because the negative is 'slower' than the print, particularly in cold weather. If you want a good instant print *and* a well-exposed negative, you will probably need to make two exposures. To judge the negative on the spot, first clear it for a minute or two in the sodium sulfite solution using the Polaroid bucket. Then hold it up to the light, remembering that the minimum density (the density of the highlights) is rather higher than that of a conventional negative. Remember also, when examining the print and negative together, that the negative will cover a scale of tonal separation that is about two stops greater than the print.

Printing the Negative

One good reason for keeping instant film prints as proof prints is that their quality of tonal separation sets a very high standard. It is, in fact, very difficult to match an instant print's scale of values exactly when making a conventional enlargement.

When enlarging, the noticeable qualities of these negatives are the fineness of detail (they lack the distinct grain structure of, say, Tri-X) and the physical thinness of the emulsion. Because the emulsion layer is so thin, there is no great difference between the effects of a condenser enlarger and a diffusion enlarger. Traditionally a diffusion enlarger produces a softer print with less contrast, and reveals less of the film's structure (grain and defects). Such differences do exist for Types 55 and 665, but they are by no means as marked. A normally exposed negative of a subject with an average tonal range is likely to print best on Grade 2 paper in a condenser enlarger, or Grade 3 in a diffusion enlarger.

When using Type 55—which is larger and has a thinner film base than Type 665—beware of buckling in the enlarger; as the film heats up under the lamp it may 'pop' slightly, causing an area of softness on the print. There may be some advantage in placing the negative in a glass carrier.

Even if full control over the lighting is not possible when shooting, and the contrast is not quite right, later enlargements from the instant negative allows all the normal techniques of printing control to be exercised. These include printing-in and shading with the hands or pieces of card. The result of the printing-in illustrated here is shown in the print of the old newspaper press on page 76.

The Type 55 negative base is particularly thin and liable to buckling. To avoid this happening, load into the negative carrier between two sheets of glass.

Extra
3 seconds.

Basic overall
exposure of
8 seconds.

Extra
8 seconds.

10 × 12-inch print,
Grade 2 paper, f16.

A 19th-century printing press, lit by one
overhead, moderately diffused light. To
hold both the shades of black in the cast
iron and the much brighter white of the
newspaper, printing controls were used
when enlarging the Type 55 negative on to
Grade 2 paper. A printing plan was roughed
out as shown.

Extra
6 seconds.

Basic overall
exposure of
6 seconds.

Extra
12 seconds.

Negative
cropped here.

10 × 12-inch print,
Grade 1 paper, f19.

In this picture, to have added photographic
lighting in order to balance the contrast
would have required an enormous light
output, and would also have changed the
atmosphere of the scene. The result was a
Type 55 negative with a high contrast range
and some imbalance in the top left of the
image. The printing plan shown was the
solution.

Polachrome CS

In some ways Polachrome is one of the most problematical of instant films to handle well. As a transparency it has no surface qualities, as do the instant print films, and as a colour material it invites direct comparison with conventional slide films, many of which have measurably better qualities of resolution, tonal separation and colour saturation. There may be one or two occasions in which Polachrome could be said to give a more suitable picture than, say, Kodachrome, but for the most part Polachrome's advantage lies in its immediacy rather than in its image quality. Reading between the lines of Polaroid's published literature, there still seems to be some way to go in improving this emulsion. Still, image values are in the end a personal judgment, and the distinctly different look of Polachrome slides does at least broaden the choice of films.

One noticeable feature of Polachrome CS is its grain. For most purposes this is rather too prominent, and Polaroid has already made some product changes to reduce the film's graininess. Nevertheless, there *are* occasions when the resultant pattern is desirable—again it is principally a matter of taste. In terms of this graininess, one of the advantages of Polachrome CS is that the grain *texture* is tight, distinct and regular. Ordinary colour transparency film does not have actual grains when developed; instead the original crystals of silver halide are replaced by soft-edged 'clouds' of colour dyes.

As a result, in fast films that seem grainy the structure is rather fuzzy. Because Polachrome CS grains are the original black silver ones, they appear crisp and can, under the right circumstances, give the picture an attractive texture. This grain texture is most apparent in medium-toned areas of the picture, particularly those areas with little detail. Its appearance is also affected by the exposure: underexposing is likely to produce a higher grain effect, which can be useful for certain special effects. Generally, however, under-exposure should be avoided for conventional images.

Probably the best way to deal with the high base density is to avoid prominent highlight areas wherever possible, because it is here that the effect shows through most strongly as a kind of 'veil' over the picture. Equally, however, there are picture situations where the high base density of the highlights gives the appearance of less contrast, so that in some high-contrast images, the overall effect can appear to be more satisfactory. Polachrome CS has a longer toe shape to its characteristic curve (this means brighter highlights), and a longer exposure range on the light end of the scale. Therefore, if there is any uncertainty about the exposure level to give, it is usually safer to over-expose slightly rather than to under-expose. This takes some getting used to, as underexposing to intensify colours has long been a standard practice among professionals.

The method of projection also has an effect on the use of Polachrome slides. Polaroid recommend that the projection room be darkened, and that a clean, glass-beaded screen be used in preference to a lenticular screen, which can create a moiré effect. Also, a brighter projected image helps to compensate for the high base density of the film, and to this end it is best to use fast, high-quality projector lenses with fixed focal lengths.

Above: Polachrome's additive colour system works differently from conventional film processes and requires a different approach to exposure. If you are used to under-exposing colour transparency film slightly in order to get more saturated hues, you will need to un-learn this trick. Under-exposing Polachrome, as the example above shows, simply makes the image darker and less easy to 'read'.

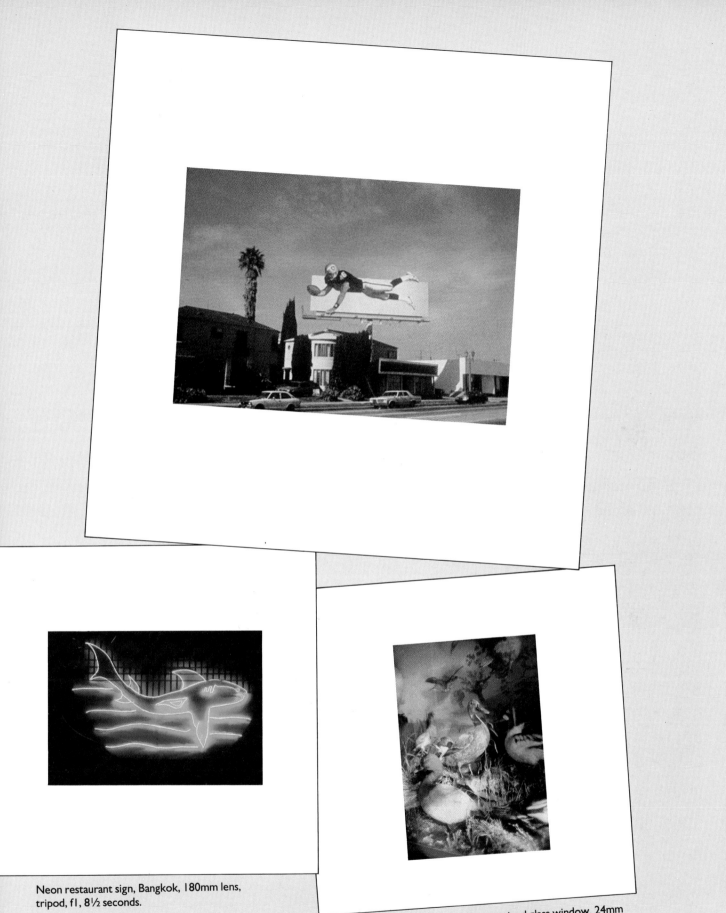

Neon restaurant sign, Bangkok, 180mm lens, tripod, f1, 8½ seconds.

A case of stuffed birds illuminated by a stained glass window. 24mm lens, f2, 1/125 second.

Opposite: Temple, Chiangmai, 20mm lens, f16, 1/60 second.

Polapan Slides

Different types of film encourage different approaches to photography, and the three major groups—black-and-white negative, colour negative and colour transparency—each have their own ethos. For most photographers who enjoy working in black-and-white, the negative is the raw material from which a print can be crafted— 'the score', in Ansel Adams' words, with the print as 'the performance'.

Most colour negative photography tends to be of the straightforward, wallet-sized print variety, but for photographers who take it seriously, printing is as important as in black-and-white photography, although with fewer opportunities for expressing individual printing style. Colour transparencies are shot mainly for projection—that is, for a slide show. Professionally, they are used for reproduction.

Polaroid's Polapan 35mm offers something new: black-and-white photographs with the brilliance and sparkle of a projected slide. Put another way, it offers the one-step, no-messing-about advantages of slide shooting in the more graphic and restrained medium of monochrome. One of the strong appeals of black-and-white photography is that its limited palette actually allows the photographer more opportunities to have control over the image. As the production of colour photographs has become simpler and faster, however, conventional black-and-white photography has come to seem complicated by comparison; naturally enough, most photographers today are too impatient for results to want to fiddle about with an enlarger and developing trays.

Opposite, above: Tree-lined driveway, Calke Abbey, Derbyshire.

Below: Second Beach, Olympic National Park, Washington.

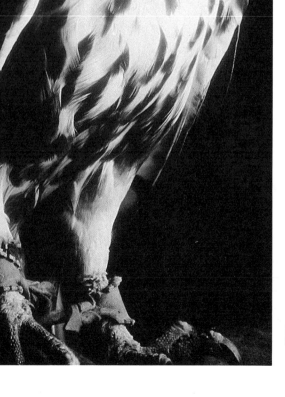

Left: Changeable Hawk-Eagle. Electronic flash in studio.

Polagraph Slides

Intended for graphic arts use, Polagraph's high contrast and high silver density give it special qualities in photographing normal three-dimensional scenes. Because it is *not* designed to produce conventional, realistic images, it is extremely valuable.

Polagraph seems to work best with subjects that have very low contrast under flat, diffuse lighting, and those with very high contrast. Although this may seem a bit odd—that the most suitable subjects are extreme opposites—the reason is straightforward: high-contrast film can bring a flat scene to life by giving it a normal range of tones, and can also exaggerate the already abstract appearance of a high-contrast scene. In the one, it performs a useful service to straight photography, in the other, it is a creative design tool.

Enlivening Flat Scenes

Polagraph is not quite the same as conventional line films, such as Kodalith or its more recent companion Polalith. Its contrast, while high, is not absolute. Like the 4 × 5-inch, high-contrast peel-apart film Type 51, this actually makes it *more* useful in straight photography because the results are more natural.

Whatever the subject, a conventional line film produces an image made up of only two tones: solid black and clear white. Polagraph, on the other hand, simply increases the contrast, so the effect depends very much on the original subject. A flat-toned scene on a dull day—say, a group of green plants in forest shade—may cover a range of only a few greys, possibly no more than three stops. Photographed straight on regular film, the result may be too flat to have much interest; Polagraph, however, will sharpen the entire image, giving it the appearance of normal contrast. With this kind of subject and treatment there is often no way for a viewer to tell that a high-contrast film has even been used.

The types of subject that can benefit from Polagraph are many. These include, among the more distinctive:

- small details of nature, such as plants, that are in shade or under a cloudy sky;

- many scenes on heavily overcast days;

- long-distance telephoto shots through haze;

- foggy and misty scenes (this depends, of course, on how extreme the conditions are, and on the effect sought);

- some flat, frontally lit scenes, such as a room interior with a window behind the camera;

- many close-ups (lighting that would give normal contrast at regular distances appears more diffuse for small-scale views).

The narrow latitude of Polagraph makes it advisable to bracket exposures, preferably in half-stop increments from −1 to +1.

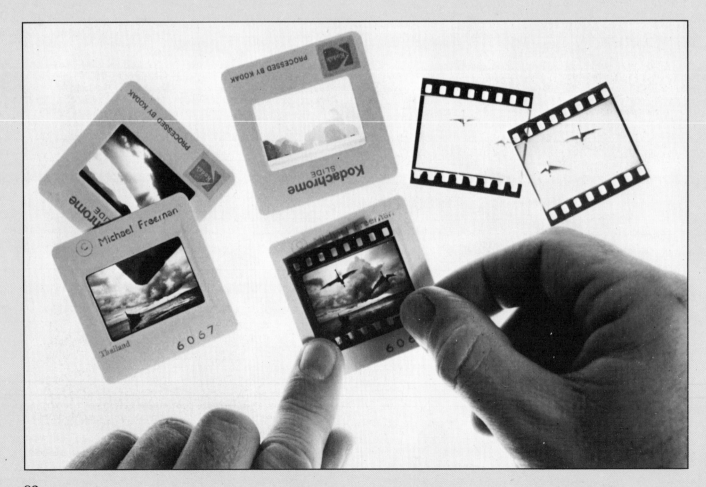

Making Stark, Graphic Images
At the other end of the scale are scenes that already have a limited range of tones, such as back-lit views. For these Polagraph can simplify the image even further and so strengthen the effect. Silhouettes are probably the most common type of high-contrast shot, and at their most effective rely on two qualities: graphically simple shapes, and a minimum of tones (preferably just black and white). As most silhouettes are chosen by photographers for having basic, recognizeable outlines, high-contrast film can only help by cutting out distracting mid-tone details and areas.

Because dark and light tones are widely separated to begin with, accurate exposure is not quite so important as it is with low-contrast subjects, but bracketing is still a sensible precaution.

Audio-Visual Effects
Polagraph really shines when put to graphic use in slide shows, and for lettering and charts in particular. While a great deal of this work is obvious, involving little more than the copying of line artwork (which can include typesetting, transfer lettering and hand-drawn artwork in ink), as with any graphic technique, it can be used with imagination. For reversed out titles, use Polalith.

'Type-Over' Titles
An alternative to displaying a single title before the photographs are shown is to sandwich the title with a background slide. If the title is short, it can be in bold type and will read prominently against virtually any photograph. If the type is fine, the most suitable backgrounds are plain and evenly toned.

Shooting Lettering for Titles
The simplest and easiest of all lettering is type from an ordinary typewriter. Type out the title on a clean white sheet of paper, leaving ample space for adjustments to the framing. Then, laying it flat on a desk top or the floor, fit the camera and macro-lens (or an ordinary lens with either a thin extension ring or supplementary close-up lens) on a tripod, or clamp directly above. Check that the camera back is absolutely horizontal by eye, or with a spirit level. For completely even lighting, use two lamps on either side, although a single light and a piece of bright foil held opposite for reflection will often suffice. As Polagrah is panchromatic, its film speed remains the same under domestic tungsten lamps, and ordinary desk lights can be used. Measure the exposure either with a hand-held incident light meter, or by taking a reading directly off the white paper and then adding one or two stops to the exposure.

Ink-Black Skies
Because Polagraph is sensitive to all colours, including red (most high-contrast films are sensitive only to blue), clear blue skies can be turned to deep black by using a red filter. This is normal practice to darken skies in conventional black-and-white photography, but Polagraph's high contrast gives dramatic results.

Opposite: **Slide sandwiches** Because Polagraph is so useful for making silhouettes with clean, clear backgrounds, it gives ample room for experiment in combining images. Here, the silhouette of flying birds (copied from an existing conventional transparency on a slide duplicating machine) is positioned on a stock-shot against a sunset sky. This kind of silhouette works best against backgrounds photographed into the light.

Left and centre: **Tone control with filters** Unlike most high-contrast films, Polagraph is as panchromatic as any conventional black-and-white emulsion. Usefully, a red filter (here a Wratten 25) will turn a rich, blue sky to black.

Right: Mt Rainier, Washington. 400mm. This hazy, telephoto view was sharpened by Polagraph's high contrast.

Protecting Prints

The special qualities of instant film prints means that their care and preservation is of more than usual importance. Unlike conventional negative film, it is not so easy to run off another print or two. While it is possible to make a copy by re-photographing (see page 92, or even to make a permanent colour record in the form of inter-negatives, proper storage and handling of the original print is simpler.

Potential Problems

To some extent instant film prints are susceptible to the normal cause of deterioration that affect all photographs. Light, chemicals, humidity, heat and rough handling are the main reasons for the loss of image quality over the years. All, however, can be guarded against:

Light: Colour prints suffer much more from long exposure to light than do black-and-white prints. The image tends to fade in time, particularly if the light has a high ultraviolet component (daylight and fluorescent lamps). The dyes in the latest instant films, especially Polacolor ER and integral print films, are much more stable than earlier ones, but a sensible precaution is to display prints away from windows and under moderate lighting, preferably not fluorescent. Ultraviolet filters can be fitted to fluorescent lights, and the glass in a frame will give additional protection. For extended display, a protective spray developed by Polaroid laboratories is useful.

Chemicals: Properly handled, instant film prints actually have an advantage over conventional prints in protection from chemical attack. First, because processing is largely automatic, the usual precautions of efficient fixing and hypo-clearing do not apply. Second, the tough polyester sheets that seal integral prints offer excellent protection. Basic precautions are, with peel-apart films, to process long enough at the recommended temperature, and to apply sufficient coating fluid; with all prints, to store away from any materials that contain acids or give off fumes. Avoid all papers or cards except acid-free or archival, and wood. Keep instant film prints away from regular photographic prints, which may have traces of chemicals left over from processing.

Humidity and heat: Light and chemical action work faster in warm, moist conditions, and mould is also a possibility. Coolish room conditions are best: ideally 60–70°F (16–21°C) and a relative humidity of 30–50%. Very dry air (less than 30% relative humidity) can cause surface cracking and curling of the print. If this happens move the prints to an environment with higher humidity, or install a humidifier.

Rough handling: Scratching is the obvious danger, but can easily be guarded against. If prints are to be stacked, interleave them with archival tissue paper. Store flat, and without heavy pressure. Write only on the margins of prints, never on the back of the image area because in time the words will show through.

All instant films need very delicate handling immediately after processing. Allow time for both peel-apart and integral prints to dry before packing or stacking. The time this takes depends on the humidity and temperature, but even prints that do not need coating, such as Polacolor ER, need at least a few minutes to harden.

Never write on the front or back of the picture area of a print; even writing on the back will eventually show through. Instead, use either the front or back of the tab.

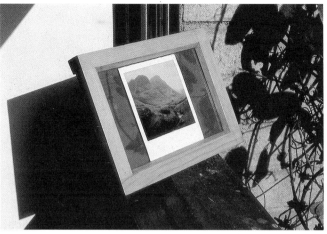

If a print has discoloured due to dark storage, the highlights can be cleaned up by exposure to any ultraviolent source, such as the sun. In this case, a print is being treated by being left at an open window. Monitor the effects carefully to avoid fading; leave only for a few hours at a time.

Even integral prints need a week or so to dry thoroughly. To speed the process, store loosely in a drawer with a container of desiccant (silica gel). Do not stack tightly.

Protect individual prints from scratching by using 4 × 5-inch negative bags.

Special Precautions

Certain instant films need particular care. Integral prints, while in many ways the best protected of all, have a special long-term discolouration problem. While storage in the dark is the normal recommendation for all photographs, with integral prints this causes yellowing of the white areas. If this has happened, the print can be restored somewhat by leaving it by a window for a few days. Yellowing can be reduced by allowing freshly processed integral prints to dry out thoroughly. This can take several weeks, during which time it is best not to enclose them in frames or sealed wraps.

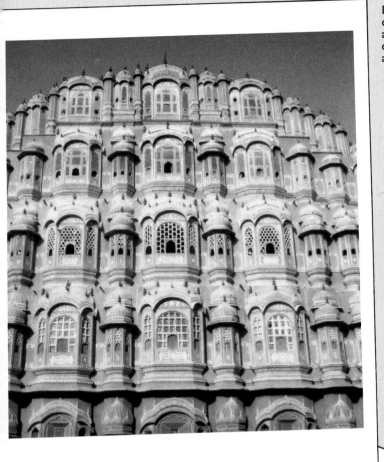

Detail of a Thai temple decoration. Close-ups often allow bold, simple shapes and colours that 'read' very clearly in a small print.

Neon sign in Bangkok. One simple, frame-filling shape in only two colours.

The Palace of Winds, Jaipur. In contrast to the use of simple shape and outline, this intricate view encourages minute examination of fine detail.

Symbolic sculptures in a northern Thai temple. Here, the miniaturist treatment works through a combination of sharply rendered, fine detail and a regularly divided picture.

Even large-scale subjects can be given simple composition by using shadow areas as part of the design. Monochromatic colour also helps to simplify.

Small-Format Composition

Compared to most conventional photographs, instant film prints are quite small, which has an important bearing on the successful design of the photographs. While instant film prints can be copied and enlarged (see page 92), for most of the available instant films, and for integral prints in particular, this is impractical as a regular procedure. Some images need to be seen large to be appreciated, particularly those that rely on a wealth of detail for their effect. Most instant film prints do *not* offer this opportunity; to make the most of them, some re-thinking of design and choice of subject is called for.

Thinking small is not the only change in attitude that integral films and their cameras encourage. To any photographer brought up on modern SLRs, with interchangeable lenses and a variety of controls, instant film cameras seem rather spartan. The SX-70 and its successor the SLR 680 are sophisticated technologically, but intentionally limited in operation. Essentially they are nearly foolproof visual notebooks without frills. As these 'frills' normally include the versatility of different lens focal lengths, which most photographers now take for granted, the instant film camera compels the photographer to think in a visually 'straight' way. This means seeing pictures in 'normal' perspective and from a 'normal' angle of view. If you have a problem with composition, it is no good reaching for a more extreme lens focal length to help you out; nor is there any point assessing the possibilities of a scene at different angles of view.

Moreover, for reasons that are a little difficult to understand on aesthetic grounds, the format of Polaroid's integral film is square (Kodak's is in the proportions 4:3). While a square format suits some image designs, for most it is awkward, and in general one of the least versatile.

This requires some explanation. In all two-dimensional art forms, from painting to photography, the picture frame is more than just a convenience: it is part of the overall design. In an obvious way it literally frames the viewer's field of attention. Beyond this, however, the sides and corners of a frame have a visual relationship with the elements within the picture. For example, a subject that fills half of the picture area will be surrounded by space that is defined by the picture frame. As well, prominent lines within the picture will form angles with the closest edges of the frame.

Through a combination of convention and the arrangement of the human eyes, the 'natural' picture format is a horizontal rectangle of fairly modest proportions. The theory behind this is less important than the fact that in visual forms that offer complete freedom of choice in picture shape, such as painting and illustration, this happens to be the most common shape; it is what most people choose. A square, however, is *not* common, and while it is always possible to improve the composition of a subject within a set format, it is in general more difficult when that format is square.

Therefore, integral instant film photography with a camera such as the SX-70 has definite limits in size, variety of view and shape. While it would be possible to see all these factors as being unsatisfactory and problematic, adopting this attitude would mean to overlook some special opportunities in design. A better approach is to see what *types* of image work well in small, square formats, with standard lenses, and to look for these when you are using an instant film camera.

The marvellous versatility of 35mm SLR cameras, particularly in the choice of lenses, can certainly be used to solve design problems and to extend the range of visual expression, but it can as easily lead to creative laziness. A streamlined photographic system, such as an SLR 680 and integral film, can encourage a more self-reliant approach to composition. For example, if a photographer is confronted with a scene that does not seem exciting with a standard lens, the simple answer with a conventional camera is to use a different focal length—perhaps a very wide-angle lens. This, however is not the only answer; it can be much more rewarding to keep the standard lens and apply some thought and design sense instead.

Small Images

Small pictures tend to inhabit wallets rather than gallery walls. This is mainly a reflection of the different uses of photographs—private rather than public pictures in this case—but what is not always appreciated is that size affects design. Certain photographs work best when hand-sized; others deliver their punch only when they fill the field of view. When enlargements are made from conventional negatives and slides, such decisions can be left until later (or more usually, not taken at all); the fixed format of an instant film print, however, has advantages for images that are intended to be seen in a small frame and at a short distance.

How small prints are viewed is an important influence, and there are two mildly conflicting tendencies. One is to hold the print at a comfortable viewing distance of a foot or two so that it really *does* appear small, and to look at it for a few seconds for its immediate impact. If you watch someone flicking through family or holiday snapshots, this is the normal viewing procedure of 'wallet' photographs. A less common tendency, but one that can be encouraged by the manner of display and presentation, is to look at a small photographic print as a miniature. There are two straightforward lessons here: first, most small photographs benefit from having the instant appeal of strong, simple designs; second, some can work well by being intricate and delicate, provided they are displayed appropriately.

The natural scale for a photograph is one that nearly fills the eyes' field of view: the borders are visible at a glance, but the viewer's attention is in fact concentrated inside, and moves around as the picture is studied. Most instant film prints, however, take up such a small area of the field of view that the overall composition can be seen at a glance. Therefore, if shapes, lines, colours and the number of elements are kept simple (or even bold), a small print is likely to work well. Generally, too, the tighter the composition the better; in a large print, breathing space between the main subject and the picture's borders is helpful for the viewer, but tends to look wasted in a small picture (to reinforce this point, most of the prints reproduced in this book are their actual size).

One incidental effect of the smallness of an instant film print is that the frame edges are much more important graphically than they would be in an

enlargement. Looking into a large print, the eyes tend to ignore spaces in the corners and close to the sides; in a small picture, the frame edges can be used to create angles and shapes.

If, on the other hand, the viewer can be persuaded to peer into and study the picture for more than a few seconds, even though it is small, a different set of values takes over. Although an instant film print is not hand-crafted, in the same way as a small painting or engraving, the fineness of detail can still have a powerful appeal. Instant film prints are *the* most directly made of any photograph—indeed, the majority of them are contact prints and so have high resolution, unspoiled by darkroom processing. Concentrating on intricate detail exploits this, especially if special display techniques are used (see page 98).

Square Images
The most prominent feature of a square picture frame is its air of formality, suggesting regularity and order. Despite its equal sides and lack of either vertical or horizontal suggestion, however, it is *not* a neutral frame shape. A horizontal, moderately proportioned rectangle is more natural, and so less influential on the picture. A square frame, however, tends to make itself noticed.

Any naturally square subject or arrangement of shapes will, of course, fit ideally into a square frame, but the same thing can be said of any frame and subject shape. It is always worth looking out for images that mimic the borders of the frame, but this is not an especially interesting exercise in composition.

If we take the premise that a square border is by nature formal and disciplined, there should be design techniques that make use of these qualities. For example, the centre of a square-frame picture is a particularly loaded part, simply because the shape is so symmetrical. In most circumstances, composing a picture so the focus of attention is right in the middle tends to be tedious, but the very formality of a square format has the effect of justifying this. This does not necessarily mean placing a single object in the centre of the frame every time. It is more often a case of finding images that *surround* a centre-point and are held together by it. Anything bilateral or radial makes easily 'centred' pictures.

While these examples have identifiable centre-points, a very similar effect occurs when two or three elements are more or less evenly spaced, so there is an *implied* centre.

'Pictures with centres' are one obvious way of exploiting the symmetry of a square frame, but to a certain extent this format suits a variety of geometric designs. If the lines within the picture are distinct and relate to the corners or sides of the frame, the chances are good for a strong, coherent composition. In a sense, the symmetry of a square sets the tone for simple subdivision, particularly if this is done either parallel to the sides or from corner to corner.

Another type of picture that goes well with a square frame is a pattern. Patterns—which can include deliberate, regular designs, such as the arrangement of windows on a high-rise building; and disorganized, irregular ones, such as a mass of flowers in a field or a crowd of people—are essentially rhythmical forms. Their visual strength lies in repetition, and because most lack an overall shape, a formal, symmetrical frame is an ideal counterpoint. Moreover, as a boundary marker for a continuous pattern, a square offers no suggestion of direction.

For fear of suggesting that these few techniques of square composition are the only valid ones, I hurry to add that there are all kinds of much more subtle compositions that can work perfectly well if handled by someone with a good sense of design. 'Empty' spaces, for example, can be made to work usefully in a composition, and the balance of a picture can be used to direct attention towards certain subjects rather than to fit an abstract pattern. These examples are intended as suggestions that are known to work, for use on occasions when pleasing or effective compositions seem elusive.

Freshly painted bicycle seats drying on the wall of a Jaipur workshop. More strong colours, in repetitive shapes on a plain background. Another example of bold, basic design.

Although spires such as these would normally sit uncomfortably in a square frame, stepping back and treating them as a diagonal outline gives a coherent result.

This strong geometric composition uses the edges and corners of the square frame to unify the design.

Organizing the elements of a picture into a regular, frontal design nearly always suits a square format.

Pay-binoculars in the San Diego Zoo. Symmetrical subjects are a natural for square composition.

Even if the subject alone cannot naturally be 'squared', a change of camera position and careful angling can divide the scene into sections.

Copying Instant Prints

Although one of the special characteristics of instant film prints is that each one is a unique image, there are occasions when a copy will be wanted. Usually it is simplest to make another exposure or two at the time of shooting, but if the moment itself cannot be repeated, or if the need for more prints arises later, the answer is to make a copy. This can even be an emergency procedure: in the photograph of the copying set-up, a Polacolor print was all that survived of a location assignment. It had been shot as a test exposure for some 4 × 5-inch transparencies, but these had been lost. By copying directly from the print, new transparencies were made.

The basic requirements for making any kind of photographic copy are that:

- the camera and original print must both be level;

- the camera must be capable of life-size magnification (the lens can be extended);

- the lighting must be even across the print;

- there should be no reflections from the print's surface;

- the exposure must be accurate;

- the contrast range in the copy should be the same as that in the original;

- the colour of the copy must be balanced with that of the original.

Although it is possible to construct an elaborate copy arrangement, this is not really necessary, and quite good quality copies can be made with ordinary equipment. The Polaroid MP-4 camera is a special case—ideal if you have access to one, but justifiable only if you put it to regular use. For occasional copying, the only likely extra expense is a means of giving your instant film camera life-size magnification (supplementary close-up lenses, for example).

Shown here is a 4 × 5-inch view camera (only because it is my regular working equipment and accepts a 4 × 5-inch Polaroid film holder). Although an elaborate piece of equipment, it can be substituted with practically any other camera, such as a 35mm SLR.

The simplest copying system that does not involve buying special equipment is as follows:

The print is copied flat on the floor. A thick, black plastic card cut with a rectangle prevents the print from curling up, at the edges. A spirit level is used for aligning the back of the camera.

The camera shown extends for 1:1 reproduction without additions. Otherwise, a close-up lens or extension can be used. A process lens might be marginally sharper across a flat field, but a regular lens does the job. The aperture is set for optimum sharpness (two or three stops down from its widest).

The classic lighting arrangement for copying consists of two identical lights positioned at the same distance from the original and diagonally at 45°. For black-and-white copies virtually any type of lamp will do, including ordinary desk lamps, but for colour accuracy with Type 59 film, flash is perfectly balanced. Two small portable units with guide numbers of only 56 (ISO 100) are quite adequate. Otherwise, tungsten *can* be used with Polacolor, either by using an 80B light-balancing filter over the lens, or by making such a long exposure that this film's notorious reciprocity failure compensates for the orange cast to tungsten light. Whatever the lights, they can be mounted on pocket tripods. In this set-up, each is 13 inches (33cm) from the centre of the print. The black plastic frame reduces the risk of flare.

The shiny surface of instant prints is a potential problem, particularly if the original has solid areas of black or dark tones. One answer is to use a lens with a longer focal length; another is to photograph through a hole cut in a black card held below the camera. In most cases, however, no special precautions are necessary, provided the front of the camera and lens are mainly black (use a black cable-release, and not your hand).

Exposure problems are naturally solved by using instant film. Also, a standardized set-up allows you to predict accurately once you have tried it out. With the arrangement shown, the exposure on Polacolor Type 59 is f14.

In practice, contrast tends to increase; the contrast-controlling techniques described on page 72 are useful.

A set of Kodak Wratten filters can be used to balance colour. A first test shot should indicate which corrective filter, if any, is needed.

With appropriate filters and contrast control, it is even possible to make corrections to an imperfect original. Copying can also be used as a way of experimenting with special effects—producing, for example, double-exposures (see page 148). In the end, however, same-size copying from an instant film print will lose some of the finer picture qualities, such as sharpness and shadow detail.

A 4 × 5 view camera set up to make a vertical same-size copy of a 4 × 5-inch Polaroid print. The camera shown extends for 1:1 reproduction without additions, otherwise, a close-up lens or extension could be used.

Using the contrast control methods described on page 72 high quality same-size copies are straightforward.

Here, a negative had been lost and all that remained was one conventional print. Copying on positive/negative film was the solution.

Slide Printing

One extremely useful function of instant print film is the production of immediate copies from slides for reference and for pleasure. It has proved so popular that a number of manufacturers, including Polaroid, now make compact slide copiers. All are designed to be extremely simple and consistent in use, and with most it is simply a matter of loading the instant print film, placing a 35mm slide in a holder, pressing a button and pulling out the print. The exposure measurement is automatic. Extra refinements include exposure control, filtration, and some limited arrangements for cropping the image, all depending on the model.

Because slide printers are designed for uncomplicated operation, such controls as selective enlargements and multiple exposure are not possible. If you are interested in these, a regular enlarger is better.

Polaprinter

This is one of the best models available, and image quality is high. It accepts two types of peel-apart film: Type 665 positive/negative for high-quality black-and-white prints and negatives, and Type 669 for Polacolor prints. The print format of 3¼ × 4¼ inches does not correspond with the 2:3 proportions of a 35mm slide, so some of the image is lost in the copying. By moving a slider below the preview screen, you can choose which part of the picture to lose; the slide, in other words, can be cropped lengthways.

In use, the slide is pressed into an illuminated preview screen and moved until it is cropped as wanted (there is no provision, as in one or two other machines, for printing the entire 1 × 1½-inch image area). The slider that determines this cropping remains in position when the slide is removed and placed in the machine. Pressing one button delivers an automatically measured dose of flash and trips a timer that warns when the print is developed (there is a choice of 60 seconds for colour prints and 30 seconds for black-and-white). The print is an enlargement in the proportions 3:4.

The exposure control dial has a range of four stops with twelve graduated steps (each one-third of a stop); the print can be lightened two stops or darkened two stops. The contrast control has five graduated steps from 'normal' to reduced contrast. The lenticular screen used in the contrast control system is at the base of the machine next to the film pack. Sometimes the lenticular pattern is reproduced in Type 665 negatives; if this is a persistent problem the screen can be removed by unscrewing (not recommended by Polaroid), although the contrast control will then be lost.

To avoid specks of dust, keep the machine spotless; in particular clean the screen at the base of the machine regularly, as dust that collects here will appear sharply on the print.

Polaroid's 8 × 10-inch Slide Printer

In a different league from the other slide printers by virtue of the print size, this machine makes extremely high-quality colour prints or colour slides from 35mm transparencies. It must be used in conjunction with the Polaroid 8 × 10-inch film processor and film holder. Cost, unfortunately, puts this excellent system in the professional category of equipment. Nevertheless, expensive though it is, the results are magnificent. A more affordable alternative is to use an ordinary darkroom enlarger, exposing the film in its holder and then processing it in the film processor (see page 57).

As with the smaller Polaprinter, the slide is previewed on a small screen, but there is a choice between a full-frame print (showing the entire 1 × 1½-inch image and some of the black borders of the longer slides), and a cropped print that covers almost the full width of the transparency. Instead of removing the slide, it is pushed in its mount under the central flash housing. The exposure control covers a range of four stops in twelve ⅓-stop increments. Contrast, however, is not adjustable. There is a filter holder for colour balancing or special effects.

Eight-by-ten-inch colour prints are produced on Type 809 Polacolor film; 8 × 10-inch transparencies for overhead projection on Type 891 Colorgraph film. Type 891 film is a little contrasty for continuous-tone reproduction; its processing time is 4 minutes.

Slide Printing with an Enlarger

Proprietary slide printers are simple and trouble-free, and an ideal investment for any photographer or organization with a regular need for straightforward copying. If you already have an enlarger, however, it can also be used with very little preparation—indeed the opportunities for selective enlargement and all kinds of experiment are much greater. Compared with conventional printing, the speed of development and the complete freedom from having to prepare and use chemicals makes instant film a delight in the darkroom, even if it is a slightly unconventional material.

There are a number of non-Polaroid printers available, and most take 3¼ × 4¼-inch pack film (exposures are usually calibrated for the Polacolor and positive/negative film types). The Swiss-made machine shown here, the Rapid Image 205, is typical. It is designed to accept a standard Polaroid 405 holder (which must be bought separately), works by means of a lens and mirror system, has a variable aperture control from f3.5 to f16, and prints the entire picture area of a 35mm slide.

High-contrast originals Although low-contrast slides will reproduce well without any contrast adjustment, a contrasty original, such as the Kodachrome shown, will nearly always look better if the Polaprinter's contrast control is used. However, be advised that the adjustment will also darken the picture slightly. In the first print the slide was copied with the exposure and contrast controls normal. The result: accurate highlights but shadows completely lost. In the last print the contrast control dial was turned the full 5 steps for maximum flattening effect, but the overall exposure was too dark. The second, and best, version was made with the contrast control at the same full setting, but the exposure control turned 2 steps towards 'lighten'.

Keeping colours rich As with normal slide photography, over-exposure washes out colours. In this view of a tropical storm over rooftops, the important colours are the reds and yellows on the horizon and in the lit windows. The first attempt is well-exposed overall, but too light in the bright areas. By reducing the contrast 3 steps and the exposure 1 (1/3 of a stop), these colours are darkened and so more saturated.

The basic procedure is extremely simple: the sheet or pack of instant film is placed under the enlarger just as if it were regular printing paper; it is then processed in its holder, or by returning it to the camera. With integral film the entire pack is laid flat on the enlarger baseboard. Although it lies at a small angle, this is unimportant if a small lens aperture is used, and as instant films are much more sensitive than ordinary printing paper, this is unavoidable.

The first essential is to calibrate the exposure and filtration; once set up they will need little alteration. Trial and error is the only method, but this is fairly easy. To get consistent results for one size of film, my standardized settings, using a De Vere enlarger and a 150mm lens, were as in the chart below.

This table is simply to give an approximate idea. The model of enlarger, its lamp, condensers, lens focal length and so on make a considerable difference. However, more detailed information is not actually necessary—the beauty of instant film copying is that the results can be assessed and compensated for immediately.

As the examples show, even integral film—distinctly contrasty in normal shooting—gives good results. Copying slides on to any kind of conventional (unmasked) emulsion is usually an open invitation to fierce contrast, with black shadows and washed-out highlights, but with instant film prints there appears to be very little increase. What undoubtedly helps is the small size of the print—the areas of shadow and highlight are just not large enough to be prominent. This applies also to the excellent sharpness—one more benefit of working with a small format.

Selective enlargement is a natural extension of simple slide printing. To avoid wasting film in future enlargements, make a note of the exposure setting *and* the positions of the lamp housing and lens. Different heights affect the amount of light reaching the baseboard and so the exposure, but a list of settings and their results compiled as you go will help to predict future exposures. From straight enlargement it is a short step to experimentation, such as multiple exposure, filtration (coloured, diffused, graduated), and even to putting objects, rather than slides, in the carrier (see page 142).

Enlarging on to 8 × 10-inch Polacolor

While the slide copiers already described and the enlarger techniques detailed on the last few pages give good *small* prints, Polaroid's Type 809 opens up a new range of possibilities—full-scale, high-quality enlarging. Although more costly than conventional darkroom materials such as Cibachrome, in quality and sheer convenience it can lay claim to being the colour printing paper of choice.

Slide printing with an enlarger The procedure shown is for integral print film, which must be re-inserted in the camera for processing. Peel-apart films are even easier to use.
1) With a transparency loaded normally in the enlarger's film-carrier, use a discarded pack containing a white (over-exposed) instant print as a focusing and framing guide. Use the corner of an enlarging easel as a locator for the instant film pack, or else tape down any two raised edges.
2) Either dial in the appropriate filters or, as shown here with a black-and-white enlarger, insert gelatin filters. The filtration needed is likely to be the equivalent of an 80B when using instant colour prints. Adjust the lens aperture and timer.
3) In complete darkness, open the camera and pull out the film pack.
4) By touch, position the pack, film upwards, under the enlarger. Make the exposure.
5) Still in complete darkness, return the pack to the camera. Closing the film door will activate the processing sequence, so keep fingers away from the picture exit-slot.

SLIDE PRINTING WITH AN ENLARGER

Original transparency	Instant film Type 779	Filtration	Exposure
Ektachrome 4 × 5in (10.5 × 13cm)	Full square format	80B + 82A	¼ sec f32
Ektachrome 120	Full square format	80B + 82A	¼ sec f27
Ektachrome 35mm	Full square format	80B + 82A	¼ sec f19
Kodachrome 35mm	Full square format		
Ektachrome 35mm	Entire original		
Kodachrome 35mm	Entire original		

2

4

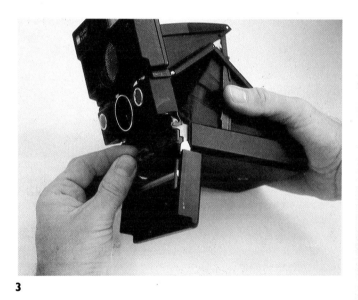

3

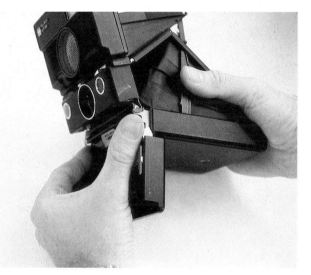

5

Mounting and Displaying

Prints need to be displayed to be enjoyed, and attention to the way they are presented is an important but commonly neglected part of photography. The worst thing that can happen to instant film prints is for them to be wrapped up and packed away; the second worst is for them to be shuffled together in a loose pile. A more sensible, and sensitive, approach is to devise a system of display that shows off the particular print qualities to best advantage. With an elegant and attractive set of frames or mounts, the photographs can be changed regularly to keep pace with new work being shot.

The traditional choices for displaying prints are in an album, in a mount and in a frame. If this sounds rather limited, the variety of display techniques possible within each of these more than compensates; there is nearly as much scope for creative presentation as there is for creative photography.

Albums, mounts and frames have two functions: to protect the prints, and to set them off visually. In practice this means taking certain physical precautions that are standard, and being sensitive to the conditions under which photographs are viewed, particularly to the visual effect of the surroundings.

All of this naturally applies to conventional photographic prints as well as instant film prints, but the latter have certain special qualities that affect their display. The most important of these is their small size and regular format. The vast majority of instant film prints are essentially miniatures, and as such they need special displaying. Just as the design of the picture needs to take into account the size of the print, so the conditions of display should allow for the fact that people will want to peer closely at the image rather than stand back.

There are, in fact, considerable advantages in working with miniature pictures, both aesthetically and practically. Properly displayed, a small print can actually draw closer attention than can a large picture, while the size and regularity of format make possible interesting experiments with multiples. Also, small instant film prints are less liable to buckle than large bromide prints, and so in many ways are easier to mount.

Antique photo albums are often ideal for hand-sized instant prints.

The simplest mount of all for integral instant prints is an empty plastic film pack. A card or plastic prop can be taped to the back so it will stand on a desk or tabletop.

Above: Even if the originally composed print looks fine, there may be opportunities for making the design more interesting. Using the mount to do this gives the chance to experiment without making irrevocable changes.

Below: If, despite best attempts to compose within the instant film format, the design is a bit loose, cropping in with the mount is the answer. In this example, masking out extraneous elements at either side improves the composition.

Albums

Although print albums have connotations of page after page of dreary snapshots, they are extremely convenient to use and have the potential to be elegant and interesting. In particular they can display and store large sequences of prints efficiently.

Albums of all types are available commercially, but by no means are all safe for preservation. Black and coloured paper is especially likely to contain contaminants that can eventually stain prints; it is safer to buy albums that are made with acid-free paper or board (photographic galleries or reputable photographic dealers are good sources for these). Each page should have some protective covering for the print surfaces—interleaves, for instance, of clear plastic or archival tissue.

This said, there is great variety among albums, and the majority are designed to take prints of about the same size as most instant film photographs. One interesting type worth examining is the antique Victorian photographic album; some of these are particularly elegant and well made, often with hand-carved card frames for each picture.

Albums can also be made from almost any loose-leaf binder, with punched holes or a spring-back spine. Buy acid-free paper, and mount the prints either by cutting diagonal slits for the corners, or with corner mounts that are stuck to the paper. Interleave with sheets of acid-free tissue or plastic. An alternative to a bound album for such sheets of mounted prints is a photographic print box of the type used for selling portfolios in galleries.

Mounts

Possibly the simplest and cleanest display design for prints is a board mount. Each one can be prepared to suit an individual photograph and, if carefully prepared, is as professional a means of display as a fully glassed frame. It also offers good storage protection.

A mount consists of two main parts: a mounting board, to which the print is attached and which forms the backing, and an overmat, which fits over and around the print, protecting it and providing an attractive surround.

The board should be acid-free, which restricts the choice of tone and colour. Museum board is ideal, but usually is available only in white and occasionally in grey. The two safest methods of attaching the print to the mounting board are by means of a separate sheet of acid-free paper cut with four diagonal slits for the print's corners, and by means of corner mounts. In both cases the print itself is not stuck directly on to the board, so avoiding any problems of contamination from the adhesive and allowing the print to be removed easily.

Because most instant film prints are small, there is normally no difficulty in making them lie flat. For this reason dry-mounting, although possible with peel-apart prints, is rarely necessary. If dry-mounting *is* undertaken, it is best to use a proper dry-mounting press rather than an ordinary iron. The dry-mounting tissue needs a precise temperature for an exact length of time if it is to adhere properly to both the print and the board, and Polaroid prints should not be heated above 180°F (82°C) for more than 30 seconds. Integral prints should never be dry-mounted—the heat will melt them.

The overmat frame can be cut with an ordinary craft blade and a metal ruler, but for a professional finish use a mat-cutter, which holds the blade at an angle so that the borders of the finished frame slope inwards towards the picture. Some practice is needed, but the results are definitely worthwhile. A mat-cutter is a modest investment, and attempting a similar effect with a hand-held knife is likely to be a waste of time without considerable practice—the finish must be accurate to be effective. The thicker the overmat board, the more pronounced the effect; a rather grander version uses two over mats, the upper one a little larger, for a double step. At some risk to the long life of the print, the sloping edges of the overmat frame can even be painted.

The size of most instant film prints gives limited opportunities for cropping, but there are occasions when it can be useful. One is to hide small edge blemishes, such as the flower-like pattern that occurs when the film's pod is broken a fraction too early. Another is to elongate or compress the shape of the picture to improve the composition (something that would ordinarily be done during enlargement with conventional printing). When cropping is not needed, it may look better if a small width of the instant film print's white border is left showing.

These are the basic considerations in mounting prints, but there are all kinds of possibilities for varying presentation. The size of the surrounding mount, for example, can be varied, making it considerably larger, such as 8 × 10 inches for a 4 × 5-inch print. This can have the effect of concentrating the viewer's attention, and of adding a sense of importance to the image. The position of the frame within the mount need not be exactly centred; slight off-centring with a broader surround below rather than above often appears to be better balanced. Vertical shots tend to suit a vertical format of mount, as do horizontal pictures a horizontal mount, but this is by no means a set rule.

Some of the most interesting opportunities for display are in mounting prints in groups and sequences. This calls for careful planning and cutting of the overmats, all in one sheet of board, but allows the prints to be seen in precise relationship with each other. The small print size and regular format suit multiple mounting particularly well.

Board mounts can be pinned or suspended on a wall, so that the picture is displayed in a manner similar to a framed photograph; they can be enclosed in a glassed frame; they can also be stored in an archival print box, as mentioned above.

Framing

Many of the techniques described for mounting prints apply to framing as well. Although the actual frame can be made with a saw and mitre box, the wide availability of ready-made frames makes this hardly worth the effort, particularly as wood is not recommended for close contact with photographs. The safest materials are stainless steel, aluminium and other metals with a baked enamel finish. When buying a frame, check that the backing is acid-free (avoid hardboard, for instance); otherwise, replace it with museum board. Either acrylic or glass is suitable for the front covering, although acrylic offers better screening against ultraviolet light.

An overmat, as described above, is essential for a framed mount to separate the surface of the print from the glass. Only seal the print in the frame once it is dry.

MOUNTING AND DISPLAYING

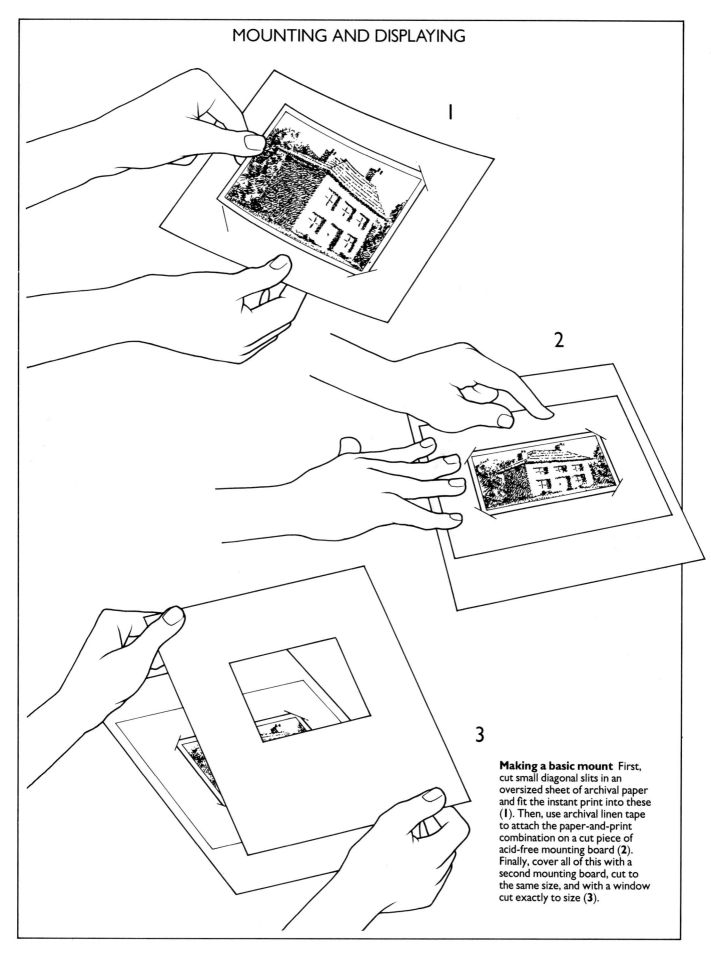

Making a basic mount First, cut small diagonal slits in an oversized sheet of archival paper and fit the instant print into these (**1**). Then, use archival linen tape to attach the paper-and-print combination on a cut piece of acid-free mounting board (**2**). Finally, cover all of this with a second mounting board, cut to the same size, and with a window cut exactly to size (**3**).

Improving Images on the Spot

Possibly the most valuable of all the special qualities of instant photography is rapid feedback—the ability to see, more or less immediately, the finished product and then to take action on the results. However experienced and painstaking the photographer, a fixed image that is available at the time of the photography and in front of the subject helps to crystallize decisions. Even under the most controlled conditions, a feedback picture usually delivers some surprises, even mild ones, such as the relationship between tones or small coincidences of composition. The time between making the photograph and seeing the processed version is, with conventional emulsions, too long to allow for adjustments and reshooting.

Not so instant film photography. The first instant film print can be thought of as a test shot, and it often helps to take a little time to study it carefully, as objectively as possible. This first print has the considerable advantage of helping to focus whatever decisions the photographer was taking at the time of shooting. As a means of refining the composition it is invaluable, as the sequences on the following pages show. This is not to say that continued adjustment to the layout of the subject, viewpoint or camera settings guarantees improvement—sometimes the best picture is seen retrospectively to have been the first—but using instant film in this way delivers the information when it is most needed: on the spot.

Cultured pearls seen normally, as a micro-section, under X-ray, back-lit, and fluorescing. A difficult photo-composite of several individual shots that could only be checked in stages with the help of instant film. A Type 59 Polacolor print.

Technical Checks

The prime professional use of instant film has been to eliminate the uncertainties in pictures where accuracy and detail count. An immediate preview of a planned or staged photograph is a kind of guarantee in a situation where mistakes would be costly, and if used carefully can be treated as an extra technical process that improves the craftmanship. Just as automatic metering or automatic focus, for example, make it possible to work with more confidence in certain conditions (mainly those that cannot be controlled by the photographer), so in a different way the instant film checking process makes it possible to tackle pictures that might otherwise be too complicated or contain too much risk of something going wrong. This use of instant film for technical checks is by no means confined to professional work; it is just as useful for personal photography.

To get the most out of making technical checks, and to waste the least amount of film, it is important to follow some kind of procedure. Although the ease of using instant film makes it tempting to run tests as soon as the camera is set up, the shot-in-the-dark approach is usually self-defeating. For example, in checking exposure, instant film reveals the subtle differences best—of around one-third or one-half a stop. Large differences, of two or more stops, are difficult to make adjustments from, and for basic measurements an exposure meter is more useful. A better method is to delay using the instant film until later stages, when all elements are as exact as possible.

As a test for shots that will finally be taken on conventional film, the most convenient instant films are those that can be used in a normal camera. It is for this reason that all camera systems that are sold at least partly for studio photography—rollfilm cameras such as the Mamiya and Hasselblad, and all view cameras—have some provision for taking Polaroid packs or sheets. In this way an instant film holder can replace the normal film back without disturbing the camera's position or any of its settings. With 35mm cameras, the 12-exposure cassettes of Polachrome are both convenient and call for no extra equipment. Alternatively, separate cameras with instant film can be used close to the main camera position, although this is less convenient and is useful for checking general conditions, such as the output from flash heads, rather than camera and lens settings. As a test for photographs that will be on the same instant film, the procedures are, naturally, much easier.

Exposure and Lighting

The most common technical uncertainty in photography is the exposure: how much, and whether the contrast will be too little or too great. However, just because this is such a common worry does not necessarily mean that instant film will provide all the answers; there is no substitute for an exposure meter for making basic readings. Where an instant film check *is* useful is in situations that have a complex arrangements of lights, and in those that are difficult to visualize—mainly where flash is used. An instant film check can then be used to finalize exposure, or to suggest changes in lighting.

The first essential is to find an instant film that is

Above: The only practical method of photographing and reproducing this rolled parchment was in sections. To make sure that the final transparencies (on 4 × 5-inch Ektachrome) would all fit together, black-and-white Polaroid prints of each step were laid out and matched on the spot.

Right: Resolution, the ability of a film to record fine detail, is usually measured by examining the film under a loupe. The smallest parallel lines that still appear separated distinctly indicate the line pairs per millimetre.

Far right: With studio photography, technical accuracy is often important, and it may be necessary to reproduce a particular lighting set-up for later shots. One of the most useful note-keeping methods is simply to take a quick snapshot of the set. This can identify exact light and camera positions better than any sketch.

reasonably similar in speed and contrast to the conventional film you will be using. Although it helps if they match exactly, if they do not it is usually a simple matter to convert from one to the other. In order to keep the same camera and lens settings, it is often better to use a neutral density filter; for example, if the Polaroid film is, say, one stop faster than the conventional film, use a 0.30 neutral density filter when making the test. Not only does this preserve the same depth-of-field, but it helps to prevent the easy mistake of forgetting to change back the aperture or shutter speed. The contrast of the instant film will nearly always be higher than that of the conventional film, but this is usually a slight advantage: high contrast is more of a problem than low contrast, and if the test exposure has an acceptable range, then the final picture will show enough detail. Use the table on page 108 to select a matching test film. Note that if *colour* does not need to be checked, black-and-white instant film is not only cheaper, but concentrates attention on the picture's tones. Colour can sometimes be a distraction when judging exposure.

Particularly in a studio or other small indoor location, it may be better to alter the lighting rather than the camera settings. In ordinary outdoor shooting, the answer to high contrast is likely to be nothing more than reducing the exposure to hold the highlights, or perhaps changing the camera position. Indoors, however, where the lighting can be controlled, the contrast in a scene can usually be altered by adding reflectors or secondary lights to lighten shadows. Sometimes it is easier to split the tests into two stages, first making a test for exposure, adjusting the camera settings or lamp output as necessary, and then making a second test for contrast.

Colour Accuracy

The main problem in photographing colours accurately, as they appear, is that the human eye is not the best judge. If the colour in a scene is a little off-balance, the eye will accommodate for this and 'read' the lighting as neutral. Film, however, cannot do this, and needs to be filtered to overcome colour shifts. The most common causes of such shifts are blue light from a clear sky on shaded scenes; a slight blue cast from cloudy skies; colour casts in reflectors or diffusers used in studios; orange casts from tungsten lamps; green casts from most fluorescent lamps; a bluish cast from mercury vapour lamps.

All of these can be checked with instant colour film. What cannot be checked is any colour cast *in* the conventional film, and if the instant colour film is being used in another camera; nor can the colour accuracy of the lens be checked.

The procedure is simple, bearing in mind that you will need to be certain of the colour balance of the instant film itself. Batches of film sometimes vary (a slight blue or green cast is not unusual), and bad storage conditions have an effect. You may find it necessary to use a filter to balance the instant film (see page 68).

The usual way of testing colour is to use a film that will fit in the regular camera—35mm Polachrome, for instance, or Polacolor in detachable film holders. Even integral colour film, however, can be used to check basic colour in a scene. Note that while 35mm Polachrome is very good for checking because of its high accuracy, it shows fluorescent light as less green than do most conventional colour films.

Depth-of-Field

The *only* way of judging depth-of-field in a photograph when the lens is stopped down to a small aperture is to look at a developed photograph. The reason is that depth-of-field is not an exact measurement; it is never possible to say that such-and-such a distance from a camera marks the boundary between sharpness and fuzziness. It is a matter of degree, and so inevitably of visual judgment. Unfortunately, even with an SLR camera, the view through a stopped-down lens is dark, which makes it difficult to see how much of the scene seems sharp. Depth-of-field scales and tables give an approximation, but this may not always be good enough, particularly if you want areas of the photograph to be unsharp to just the right degree. So, where depth-of-field must be judged exactly, instant film is often the only answer. If the speed of the instant film is not exactly the same as that of the conventional film, adjust the difference by means of the shutter speed, light intensity, or a neutral density filter—not with the lens aperture.

Shutter Speed

Just as there are pictures for which the aperture setting is important, so there are others that require capturing action in a certain way. Most common is the situation in which a moving image has to be frozen. Even if flash is being used, it may not always be fast enough to freeze the action completely. Instant film can provide an exact check.

As most actions are not precisely repeatable, however, you might occasionally need to check whether the final shot was satisfactory. For instance, if a drink or ice-cube is being splashed into a glass, the splashes and bubbles can never be repeated exactly. Clearly this is a strong argument for shooting finally on instant film (in black-and-white, Types 52 and 552 are perfect if flash is being used). If the shot *must* be on conventional film, two cameras placed side-by-side can give a simultaneous check. One method of synchronizing the cameras is to use a double cable-release, although for very fast movement it is only approximate. Another, more accurate, method is to use flash in a darkened room, opening both shutters, triggering the flash, and then closing the shutters.

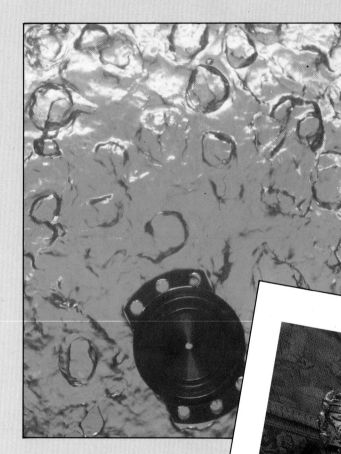

Left: Even under controlled studio conditions action may be unpredictable—at least in the exact visual effect. Here, a superconductor is shown being cooled in a bath of liquid nitrogen, bubbling furiously over the electronic flash beneath. The precise pattern of the bubbles, and the degree to which their movement would be stopped by the flash, could only be checked on film—here Type 59 Polacolor.

Below: Despite Polacolor's daylight colour balance, a long exposure under tungsten lighting can produce surprisingly accurate results *without* filtration. In this tungsten-lit interior, a 3-minute exposure at f32 on Type 59 film gives a very close approximation of the true appearance, as the blue-green reciprocity effect counters the redness of the lighting.

Checking lighting combinations The precise visual effect of electronic flash may not always be easy to see in advance; even with modelling lamps in the flash housing, the effect can be masked by ambient lighting. In this series of close-up shots of an art nouveau brooch, two lights were used, both flash. One side-light gave conventional illumination (above). A second, diffused flash unit underneath gave back-lighting through the leaf on which the brooch was resting (centre). The most reliable means of testing was to take a Polaroid of each light separately. Each could then be adjusted individually and precisely to give the final result (below). The tests were on Type 59 Polacolor, the final shot on 4 × 5-inch ISO 64 Ektachrome.

INSTANT FILMS FOR EXPOSURE CHECKS

Conventional film	Film size	ISO	Instant film
Kodachrome 25, Kodak Technical Pan 2415, Agfapan	35 mm	25	Polapan CT + ND 0.7
Kodak Panatomic X	35 mm	32	Polapan CT + ND 0.6
Agfachrome 50S and 50L, Ektachrome 50, Fujichrome 50, Ilford Pan F	35 mm	50	Polapan CT + ND 0.4
Kodachrome 64, Agfachrome 64, Fujichrome 64	35 mm	64	Polapan CT + ND 0.3 or Polachrome CS (with ND 0.2 on the conventional film)
Ektachrome 100, Agfachrome 100, Fujichrome 100, Ilfochrome 100, 3M Color Slide 100, Agfacolor XR100, Kodacolor VR100, Agfapan 100, Fujicolor HR100, Ilfocolor 100, 3M Color Print 100	35 mm	100	Polapan CT + ND 0.1 or Polachrome CS (with ND 0.4 on the conventional film)
Kodak Plus-X, Verichrome Pan, Ilford FP4	35 mm	125	Polapan CT, no filter
Ektachrome 160, Vericolor IIIS	35 mm	160	Polapan CT (with ND 0.1 on conventional film)
Agfachrome CT200, Ektachrome 200, Kodacolor VR200, Agfacolor XR200	35 mm	200	Polapan CT (with ND 0.2 on conventional film)
Ektachrome 400, Fujichrome 400, 3M Color Slide 400, Kodacolor VR400, Agfacolor XR400, Fujicolor HR400, 3M Color Print 400, Ilfocolor 400, Tri-X, Ilford HP5, Agfapan 400	35 mm	400	Polapan CT (with ND 0.5 on conventional film)
Agfapan 25	120	25	Type 665 + ND 0.9
Panatomic-X	120	32	Type 665 + ND 0.5
Agfachrome 50S and 50L, Ektachrome 50, Ilford Pan F	120	50	Type 665 + ND 0.1 or 0.2, or Types 669, 88 + ND 0.2 (Agfachrome 50S only)
Ektachrome 64	120	64	Type 665 + ND 0.1, or Types 669, 88 + ND 0.1
Agfachrome R100S, Ektachrome 100, Fujichrome 100, Agfacolor XR100, Fujicolor HR100, 3M Color Print 100, Agfacolor N100S, Vericolor IIL, Agfapan 100	120	100	Type 665 (with ND 0.1 on conventional film) or Types 669, 88 for all except Agfacolor N100S or Vericolor IIL (with ND 0.1 on conventional film)
Plus-X, Verichrome Pan, FP4	120	125	Type 665 (with ND 0.2 on conventional film)
Ektachrome 160, Vericolor IIIS	120	160	Types 107C, 664, 107, 084, 87 + ND 1.3
Ektachrome 200	120	200	Types 107C, 664, 107, 084, 87 + ND 1.2
Ektachrome 400, Fujicolor HR400, Tri-X, HP5, Agfapan 400	120	400	Types 107C, 664, 107, 084, 87 + ND 0.9
Royal-X Pan	120	1250	Types 107C, 664, 107, 084, 87 + ND 0.4
Kodak Technical Pan 2415, Agfapan 25	4 × 5	25	Type 55 + ND 0.3, or Types 52, 552 + ND 1.2
Panatomic-X	4 × 5	32	Type 55 + ND 0.2, or Types 52, 552 + ND 1.1
Agfachrome 50S and 50L, Ektachrome 6118*	4 + 5	50	Type 55 (no filter), Types 52, 552 + ND 0.9, or Types 59, 559 (+ ND 0.2 if using Agfachrome 50S, or with filtration as indicated if using the tungsten-balanced films in tungsten light)
Ektachrome 6117*, Fujichrome 64	4 × 5	64	Type 55 (no filter really necessary, but expect instant print to appear slightly darker than wanted), Types 52, 552 + ND 0.8, or Types 59, 559 + ND 0.1
Ektachrome 100, Fujichrome 100, Agfachrome R100S, Agfacolor N100S, Vericolor IIL	4 × 5	100	Types 52, 552 + ND 0.6, or Types 59, 559 (with ND 0.2 on conventional film)
Plus-X, FP4	4 × 5	125	Types 52, 552 + ND 0.5
Vericolor IIS	4 × 5	160	Types 52, 552 + ND 0.4
Ektachrome 200, Fujichrome 200, Agfapan 200	4 × 5	200	Types 52, 552 + ND 0.3, or Types 59, 559 (with ND 0.5 on conventional film)
Tri-X Professional	4 × 5	320	Types 52, 552 + 0.1
Various	8 × 10		Type 809 is rated at ISO 80, and so is suitable for the 8 × 10 versions of the emulsions listed above for 4 × 5—in theory. However, it is for most purposes too expensive a film to use for testing. A more usual solution is to have a 4 × 5 reducing back, and use the 4 × 5 instant films.

Note that variably rated films such as Ektachrome EES P800/1600, Ilford XP-1 and Agfa Vario XL should be tested with the instant film appropriate to the rating chosen.

Note also that the Polaroid 405 film holder, the Professional Camera Repair and Tekno 35mm backs allow 3¼ × 4¼ (and in some cases 3½ × 3⅜) pack films to be used in 4 × 5 and 35mm cameras respectively.

Nominal speed. Batches may vary. Affecting ND filter needed.

Composition and Layout

Although the design of a picture is more a personal and creative matter than a technical one, there are a few basics that need checking. These checks are particularly useful when using a view camera (the corners of the viewing screen are often difficult to see clearly), and when flash is being used without a modelling light (and so its effect has to be guessed). Checking is fairly straightforward with instant film, although it is important to remember the slight differences in format between some instant films and conventional films (4 × 5-inch single-pack films lose ¼ inch (6mm) at one end, for example).

Professionally, because many shots have to fit an exact layout designed by an art director, instant prints are often used as a base for sketching headlines, type and the like. This can be done on the ground glass screen of the camera, but is much easier on a print.

Special Applications

For all the reasons that instant film checks are valuable when taking regular, planned pictures, they are doubly useful in photography that relies heavily on technical accuracy.

Underwater Photography

Lighting and optical conditions under water are so different from those of ordinary scenes that special equipment and a fresh repertoire of skills are needed for photography. With these go greater risks of making mistakes, and as few diving sights are near processing laboratories, the results are usually seen only well after the pictures are shot. The most common technical problems and uncertainties include:

● exposure settings for natural light with a non-TTL metering camera;

● focus and framing with non-reflex cameras like the Nikonos, particularly at close distances;

● exposure settings for flash, particularly if the unit is held away from its usual on-camera positions;

● the amount of back-scatter visible from particles in the water;

● the colour cast at different depths and in different kinds of water;

● exposure settings for flash and natural light together.

The amount of physical handling in using peel-apart films makes them inconvenient for use in under-water camera housings, but a clear plastic housing is available for SX-70 and SLR 680 cameras in which ejected prints remain in a tray in front of the film door.

The revolution in checking the progress of under-water photography is the arrival of 35mm instant slide film. Most underwater photography is performed with 35mm cameras, and both Polapan CT and Polachrome CS can be used just as any conventional film. Not only do instant results after a dive give a feeling that all is going well, but they encourage experiments in techniques that many divers avoid because of uncertainty: for example, making exposures with mixed flash and natural lighting, or diffusing the flash head, or using the flash off-camera.

There are no special problems in using instant slide film during a dive that do not already apply to other films. Polaroid's Autoprocessor can be used perfectly well on a small dive boat, and only the usual precautions need to be taken: keep unprocessed film cassettes out of direct sunlight, keep everything dry, and before handling film or equipment thoroughly dry your hands and hair. Remembering that Polachrome slides are difficult to see and judge clearly just by holding them up to the light a small hand viewer is a great help, especially one that will accept a strip of film rather than individually cut slides. If any of the developed film is splashed with salt water, put it into fresh water until you have an opportunity to wash it, add a drop of Photo-Flo, and dry it. To this end, carry a plastic jar of fresh water.

Photomicrography

Photomicrography is especially dominated by equipment and technique, and there is plenty of room for error with even the most automated microscopes and camera systems. Technical problems that can easily be checked with instant film include:

● exposure, particularly when the magnification, lighting system and type of specimen are changed; and particularly under darkfield illumination when there is a small specimen against a large black background;

● flash exposure when it is not possible to preview the results with a modelling light;

● evenness of illumination;

● flatness of specimen, affecting sharpness of the picture;

● colour balance with an unfamiliar microscope;

● blue in time-exposures caused by vibration.

With instant film used to check progress, photography with a microscope is much easier than you might imagine, even without experience. The optics of the microscope are used exclusively, and there is no need for a camera lens, so that in principle the camera is used as little more than a box holding the film. Although there are special adapters sold by camera manufacturers to fit the body to the microscope, it is little more trouble to place the camera close to the eyepiece on a tripod. The gap between the two can be covered with a small piece of black cloth, or the photographs can be taken in a darkened room.

Because the image from the microscope's eyepiece is projected, it can, with a focus adjustment, be projected further back on to a larger format. As a demonstration of how easy this is, in the picture on page 110 a 4 × 5 view camera was set up over a regular microscope. Without instant film this would have been difficult with unfamiliar equipment, but by using Type 55 and Type 59 film to check exposure, alignment and colour balance, the system was checked out for shooting within half-an-hour. As well, the 4 × 5-inch prints were large enough for final use, as reproduced on these pages.

Polaroid produce a special kit for using an SX-70 camera with a microscope; unfortunately a similar system has not been made for the newer SLR 680. The 35mm instant slide films can, of course, be used directly in any 35mm camera, although an 80B filter will be needed to balance Kodachrome to conventional tungsten lighting. All the regular peel-apart films can be used, although Polacolor films need to be balanced for colour. Time exposures on 4 × 5-inch film tend to be long because the light from the eyepiece is projected further than usual, and Polacolor's infamous reciprocity failure paradoxically makes colour balance an easier matter. As explained previously, at exposures of longer than about 20 or 30 seconds, little filtration is needed to balance Polacolour to tungsten light. Needless to say, because of this, do not use Polacolour to check colour balance for conventional films.

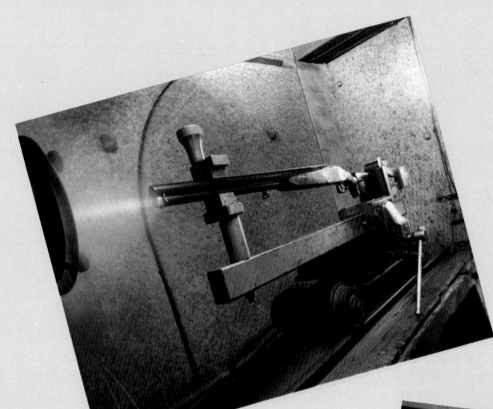

This ad-hoc arrangement of a 4 × 5 view camera was used for the two accompanying photomicrographs. Even with inexperience and with unfamiliar equipment, accurate results were possible by means of instant checking.

Unrepeatable shots This photograph of a test firing of a shotgun involved some complicated moves. The specially loaded charge gave a different effect each time, and the shot was difficult and time-consuming to set up. To add to the uncertainty, two exposures were needed on one piece of film: a lit exposure to show the gun and the room, and an open-shutter exposure in darkness to catch the muzzle flash. Moreover, all this had to be done by remote-control because of the risks involved. Here, for the security of knowing that the picture has been successful, a final photograph was done on Type 59 Polacolor.

A section of a natural pearl with unusual internal structure. Magnification X26 on to a 4 × 5-inch Type 59 Polacolor print.

A section of stained wood (*Aristolochia braziliensis*). Magnification X15 on to a 4 × 5-inch Type 59 Polacolor print.

Lighting conditions and flash performance underwater are frequently difficult to anticipate without constant diving experience. An initial dive with a roll of Polachrome, and bracketing exposures, is a valuable check at the beginning of a trip. The film can be processed immediately, on board the dive boat.

This stack of shelves too obviously truncated. Possibly a vertical format would be better.

Awkward space here.

Empty desk could possibly be improved by adding books.

Visually, these pages occupy too much of the picture. The only important name is that of Dr Johnson.

The ledger is now lower in the frame, but still shows the name 'Johnson' clearly.

Lens shade appears when the aperture is stopped down to its minimum. This kind of error is very difficult to see through the ground-glass screen of a view camera.

Books here help the depth of the shot.

The continuing downward line of the top of the pages takes the viewer's eye out of the picture unnecessarily.

Improving the Image

The technical checks just described are fairly straightforward: they are ways of making sure that the picture the photographer intends to take comes out accurately. Photography, however, would not be very interesting if it were completely predictable and simply a matter of working to plan; most photographs, even those taken under controlled conditions, owe something to chance. In constructing a still-life photograph, for example, you might find that the composition you had in mind creates problems of perspective or focus and does not work. Alternatively, different arrangements of objects may suggest themselves on the spot: reflections in surfaces, for instance, can help the design if the camera position is moved slightly.

Although much of this can be done through the viewfinder, nothing sharpens ideas about an image as much as a real picture. Apart from whether the exposure is right or if the shadow areas need lightening to show more detail, instant film tests give an opportunity to improve the design of a photograph. Making a test on instant film makes it possible to step back and assess the work critically.

Simple Improvements

Working up to a finished image by using instant film prints does not have to be elaborate or painstaking, although some of the examples shown in this section are quite complex. On a more straightforward level it can simply be a matter of taking full advantage of the immediate visual check that the first print gives.

The pairs and short sequences of pictures shown are typical of the kind of small improvements that can be made to the design of a photograph. Often, these one-step alterations are a way of making up for hurried picture decisions made at the moment of shooting. The fact that most of the compositional improvements seem to occur near the edges of the frame suggest that attention tends to concentrate in the centre of the camera's viewfinder.

Probably the worst way of using instant film is to look at the freshly produced print with a preconceived idea of how it *should* appear. Just as it is easy to ignore inconvenient design elements when looking through the viewfinder, so it is easy to 'see' what you would *like* to appear in the print. To get the full benefit it helps to concentrate as objectively as

This side of the ledger has been tilted up to anchor the bottom right of the composition.

The lens shade has been raised out of view.

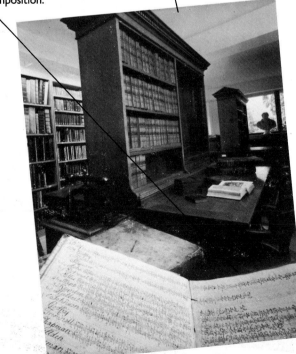

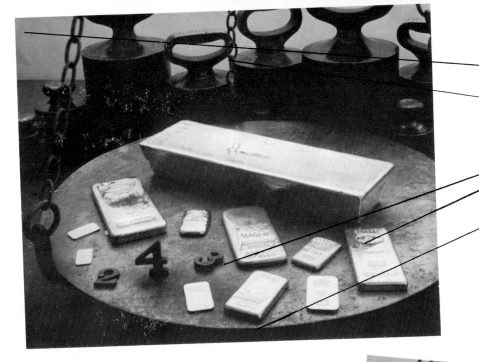

This empty corner is unnecessarily distracting.

This unevenness in the row of weights is too obvious.

With all the bars separated from each oher, the composition has a slightly contrived appearance.

The curve of the circular weighing tray is a little too close to the bottom edge of the frame.

Work in progress The sequence of Polacolor prints shown over the next few pages were used to construct various still-lifes, and are themselves a record of the photography's progress. The first shot, usually a long way from being satisfactory, is made to provide basic information on light levels and contrast—a preliminary technical check. It also can draw attention to obvious important design problems. Subsequent shots can be made to check the success of different design solutions, which cannot be judged by eye.

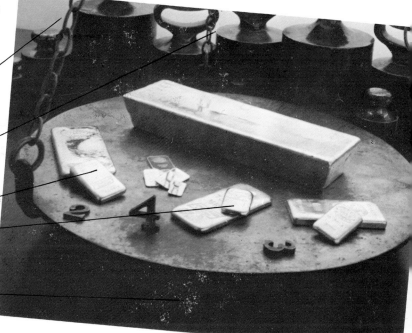

Lowering the camera fails to improve this distracting blank corner.

Lowering the camera helps the line of the weights.

The arrangement of the bars has been over-corrected; they now look cluttered.

Now slightly too much blank space at bottom of picture.

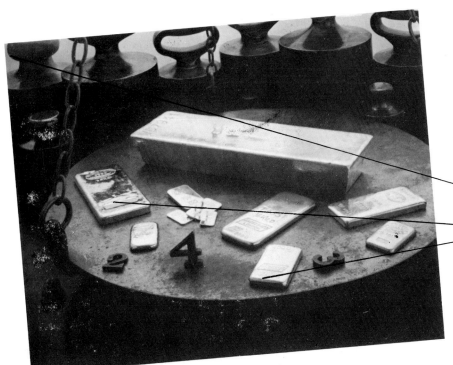

An extra weight fills the gap.

The rearrangement of bars now gives a compromise between a casual design and clarity.

113

Major problem is that all the lefthand pages are blank, giving an unavoidable white block somewhere in the picture—unless this part of the book is covered up.

Empty corner is distracting.

These empty corners either need additional objects to fill them, or the camera angle should be altered.

The line of the bookcase and floorboards is too nearly parallel to the top edge of the frame. It should be exactly in line, or definitely angled. Suggests a new camera angle.

Covering the white page with the other book is the right solution, but at this angle the shiny cover reflects too much light from the window.

Could do with a little more casualness—perhaps some other objects.

New camera angle gives better diagonal structure to the picture design, but leaves *this* corner empty.

Corner of a scrap of paper helps to loosen the composition.

Reflection on the cover still too bright. The entire left side of the picture is too light, taking attention away from the flowers.

Tassle fills the corner and helps to 'frame' the book.

Pulling out a third cloth-wrapped volume from the bookcase gives added interest and more texture.

Covering part of the window improves the design in two ways: by reducing reflections on the book cover, and by darkening these lefthand corners, so moving attention towards the centre.

The reflection is still a little too strong.

Raising the book tilts it away from the camera to make it seem less shiny.

More darkening at the window finally dulls the cover.

A very slight raising of the camera on its tripod tidies up the gap in the previous photograph.

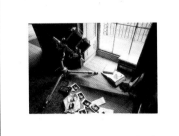

possible on the instant print for a short while. A two-stage examination may help: first, a close inspection of each area of the picture, paying particular attention to the edges and corners; second, a longer, cooler look from a distance, studying the image as a whole. Remove distractions by laying the print on a plain background, such as a sheet of paper.

If it seems difficult to identify precisely an area for improvement, think about the picture in these terms:

- Is there a sense of balance to the image? Is your eye drawn uncomfortably towards one particular area?

- Is there an area of the picture that seems empty?

- Are there any odd coincidences of line that look awkward? (This need not be something as obviously clumsy as a lamp-post appearing to stick out of someone's head.)

- Would the picture be improved by moving the camera up, down, left or right?

- Would a closer or longer view look better? (Use edges of scraps of paper or other prints to crop in on the picture and see what a closer view would look like).

- Would a different camera position help? Perhaps by moving around, or getting higher, or lower?

- Can anything in the picture be rearranged to advantage, particularly in the foreground?

Building Up a Still-Life
A still-life image is probably the ideal form for developing design ideas. The conditions are such that there is usually time to work through an idea thoroughly by adding or taking away objects, examining and changing their relationships, altering the viewpoint, the lighting, and so on.

This is, in fact, the normal process in still-life photography, with whatever kind of film. Instant film, however, has a special part to play: it can sharpen the design process by showing the actual results at any stage. Even in such controlled situations as a studio, there is a world of difference between examining the image through the camera's viewfinder and looking at an actual print. The viewfinder image is a window on to a three-dimensional scene, and bridging the gap between that and the finished picture is, of course, one of the fundamental skills in photography.

Technical matters aside, all kinds of perceptual quirks can make it difficult to 'see' how the image will look. A common effect, for example, is to concentrate on the centre of the viewfinder image at the expense of the edges; later, the rectangular borders of the print will draw attention, possibly highlighting sloppiness in the composition. Also, the real depth in the view through the camera can hide the graphic structure of the image: converging lines, for example, may look less like a pattern of diagonals in the real view than in the print.

Using instant film as the sequence shows not only shortens the gap between decision-making and pic-

tures, it makes it possible to act on the results as well. This does not have to be limited to checking the image at the point where the photographer thinks it complete. A progression of instant film prints can, as shown, be used as a part of the development of the still-life. An early exposure can be made, not with the expectation of it being nearly right, but as something to study. In this way instant film prints can help the photographer to be more objective about the work.

Major Operations
If simple compositional improvements are the most straightforward use of instant film feedback, the most complex is using it as a design plan for photographs that assemble different elements. While this is chiefly the province of professional photographers handling involved projects, the ways in which instant prints can simplify the operation should convince any photographer that complex shots are entirely manageable if taken step by step.

One common type of complicated photograph is an interior with mixed lighting. If, for instance, flash and continuous lighting are used together, there is no other way of visualizing the result. Taking a full range of light readings with a flash meter and a regular meter may make it possible to adjust the lighting *technically* (so that all areas, for example, are within the contrast range of the film), but judging the *appearance* without an instant print is at best a matter of informed guesswork. Add to this different sources of light that give different colour effects, such as fluorescent (green), tungsten (orange) and skylight on a clear day (blue), and the recipe is for a photographic headache.

The instant film answer to precision lighting with different sources is to check each one individually, and then adjustments can be made accordingly. For instance, in a room lit by tungsten and fluorescent lighting, separate testing will show the ideal exposures and filters for each. The complete exposure can then be made in two parts: with the camera on a tripod, one exposure is made with just the tungsten lights switched on, and then a second exposure with only the fluorescent strip-lighting. The aperture remains the same, but the exposure time is varied, while different filters are held over the lens for each exposure (say, a bluish filter for the tungsten exposure and a magenta filter for the fluorescent, to bring them more closely into balance).

In an even more complex type of photograph, several separate transparencies are copied together on to a single frame of film. This procedure, to make what is known as a photocomposite, often contains so many variables (the exposure and colour balance of each element, not to mention their exact positioning vis-à-vis each other) that first-time success would be fairly unlikely.

With instant film, a project that would otherwise be discouragingly complicated becomes reasonably straightforward. The principle is the one already described—checking each individual element first. As an extra aid, a useful technique is to cut up these initial instant pictures to make a rough assembly. The process is no less of a major operation, and not recommended for the photographer who prefers unadulterated images extracted from the real world, but with instant film it can be managed with no more than a simple duplicating machine and some kind of register system.

Building a difficult composite When executed accurately, special-effects photography can be extremely complex. In this representation of protons and neutrons forming into a nucleus, ten separate exposures were combined on the one sheet of 4×5-inch film—and three of these ten were themselves combinations. Even with layout sketches, this kind of image is sufficiently original to deliver surprises as it is being built up. Instant prints made at each stage of the combination serve not only as checks on the technical progress, but also make it possible to assess the visual effects and make improvements.

Breaking the Ice

The obvious kind of feedback from instant film involves comparing the photograph with the actual scene to make changes and improvements. But there is another, special, use. In travel and street photography instant film can actually help to change the *situation* in which pictures are being taken: few things give such immediate pleasure as the gift of a photograph, a discovery that many reportage photographers have put to good use to win over people they wish to photograph.

It is common practice for a professional photographer to promise his or her subject a copy of their picture, but the offer is usually a weak one, involving a delay of days or even weeks. Nevertheless, the gift of a portrait photograph is compelling: it is extremely personal, appeals to basic human vanity and, most important of all, it breaks no social mores and has no traps. It is the gentlest bribe you can offer someone whose cooperation you want; it has universal attraction, and neatly avoids any hint of payment (which

can be embarrassing for everyone concerned, and even counter-productive if it offends).

Instant film makes such a gift immediate currency, and it can work without lengthy persuasion or explanations. Indeed, if used in a certain way it can be a means of explaining what you want to photograph.

Basic Good Manners

At its simplest, the gift of an instant film print is a way of thanking someone for their permission to take their photograph. And, if you take and present their instant portrait first, you are in effect thanking them in advance. If you hope to take pictures over a period of hours, or even days, then gifts of instant prints spread across this period will always help.

Overcoming Resistance

There are many situations in which people are likely to be reluctant to have candid or semi-candid pictures taken. Photography without permission is, after all, a form of invasion of privacy, and whether this is offensive or not depends on the mood of the people, and on any cultural or religious objections they may have. In any case, you will have to use your own judgment to determine whether or not you can go ahead and take pictures with only a smile as preparation. If you sense wariness or hostility, however, the instant film gambit may save the day. The only hurdle is likely to be taking the first picture. It may be enough simply to ask someone if they would like a print for themselves, or it may require a more oblique approach, such as first photographing some-

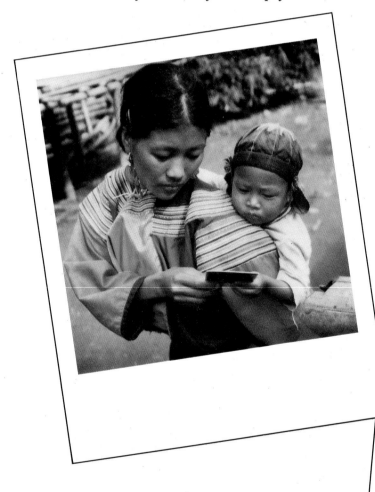

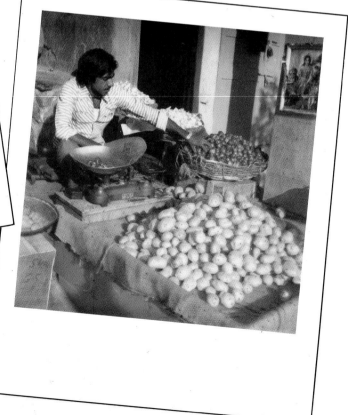

In remote communities, initial suspicions about a photographer's motives can disappear in a moment with the gift of an instant film print.

thing else, such as the person's house or some other possession. (In many situations it is easier to photograph a child before tackling the parent.)

Of course, if there is an inflexible reason why you should not take a picture—of women in strict Muslim societies, for instance—showing your intentions with a print is the worst thing you could do.

Crossing the Language Barrier
A variation of the 'reluctant subject' situation is when a photographer has to deal with a foreign language without an interpreter. In trying to shoot what you want, sign language with a camera is useful up to a point, but a refusal is not always easy to understand if you have no knowledge of the language. Moreover, the more exotic the location, the more likely you are to find different attitudes towards photographs and photographers.

Visual Explanation
If you want to photograph someone in a certain way, such as with a particular expression or against a certain background, the most direct explanation of what you require is in the form of a picture. This might mean taking an instant picture that is not quite as you would like it and then using it to show how it could be improved, or of taking a shot of just the setting and sketching in an outline of the person. If for a special shot you put someone to some trouble, you owe it to them to show how the result will be better. Moreover, the trouble *you* are obviously taking in making preparatory shots will communicate itself to other people.

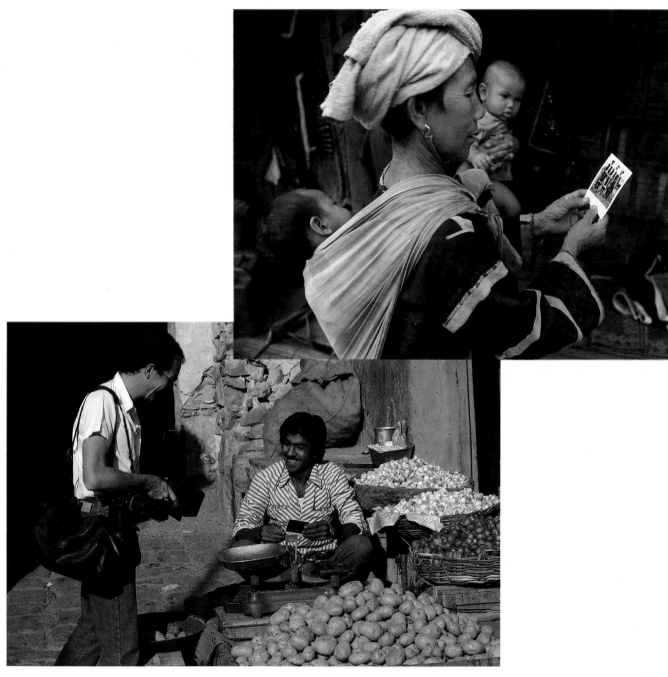

CREATIVE EXPERIMENTS

So far we have been looking at what are essentially 'straight' uses of instant cameras and film—finding the best ways of using the material in a conventional manner. Instant films, however, have encouraged many photographers—and non-photographers—to experiment, rather more so than conventional photographic processes. 'Experiment' in this sense means investigating what possibilities lie outside the bounds of the rectangular print border containing a normally seen view of real things. It includes such things as re-shaping the border—by tilting it, by adding several prints together, by cutting it up, and by playing illusionary tricks. It also includes distorting and manipulating the subject matter inside the borders—by cutting, scraping, painting over, chemical baths, multiple exposure, and a host of other unconventional treatments.

Why instant films attract these kinds of experiments is due to a number of reasons, not the least being the rapid delivery of the image, which helps to overcome the usual uncertainties of unusual treatment. One of the great pleasures of the ideas suggested on the following pages is the element of surprise—unexpected coincidences and the startling graphic effects that are achieved only through experimentation. Because with instant films results at all stages are available on the spot, avenues of experiment can be either rejected or followed up quickly.

Playing with unconventional techniques is also much easier if the material at hand does not seem too valuable. Photographs have a tendency to become more precious as time goes by; even though identical prints can be made from a conventional negative, most of us have reservations about desecrating a picture. An instant print fresh from the camera does not present this psychological barrier: another picture can be made immediately, and at any time.

The accessibility of instant film photography, with its immediate realization of the camera-user's ideas, attracts non-photographers. This has in turn encouraged different kinds of experimentation from people with no commitment to the traditions of photography. Certainly the instant-film works of the artists Lucas Samaras and David Hockney show a refreshing disregard for photographic convention. The field of instant creative experiment is open to anyone—and anyone is at liberty to judge the results.

Planning and Shooting a Composite

Building up an instant film composite from individual instant prints can be great fun, but unless money is no object, *too* free-wheeling an approach to shooting can use up more film than an idea might justify. A cost- and time-saving method is to think first about such basics as the area of the scene to be covered, and with how many prints. A thumbnail sketch often helps, and if the scene covers something like a normal angle of view, a single Polaroid can be used, as shown here.

One of the deciding factors as to the number of individual pictures needed is the scale of the important detail in the subject. If the print borders are to be left on—and there is little choice if integral prints

Treatment that is by any conventional standards perfectly wrong can sometimes give interesting results. This Type 55 Polaroid print of the Library of Congress in Washington D.C., shot originally as a test, was left uncoated through omission for more than five years. Not seen here, the original has an overall straw tint and ghostly semi-faded areas.

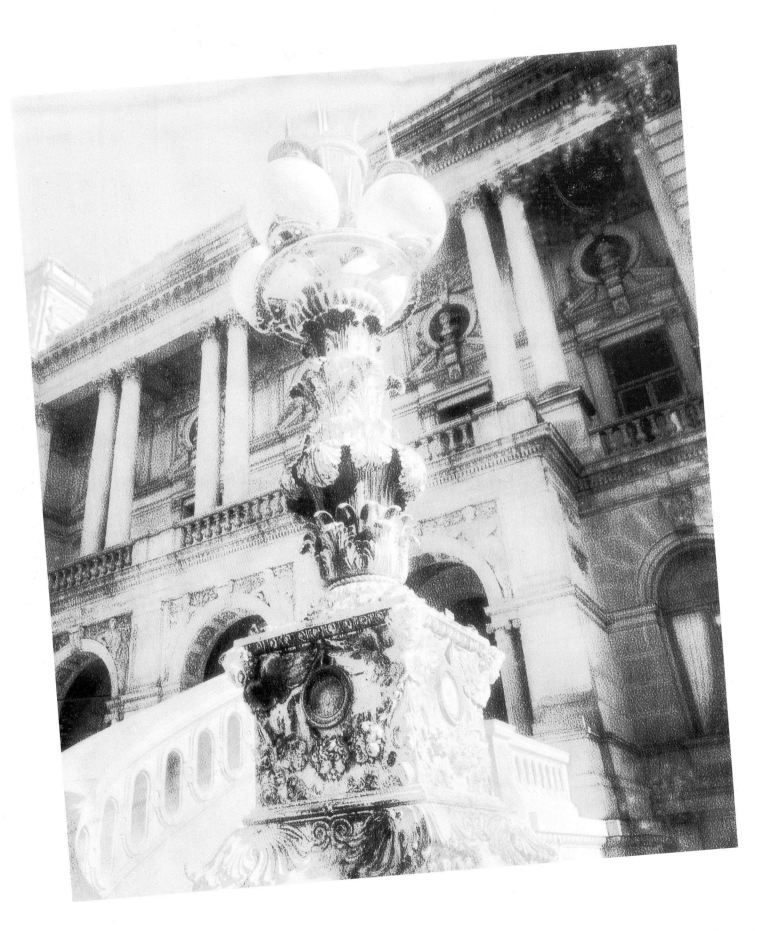

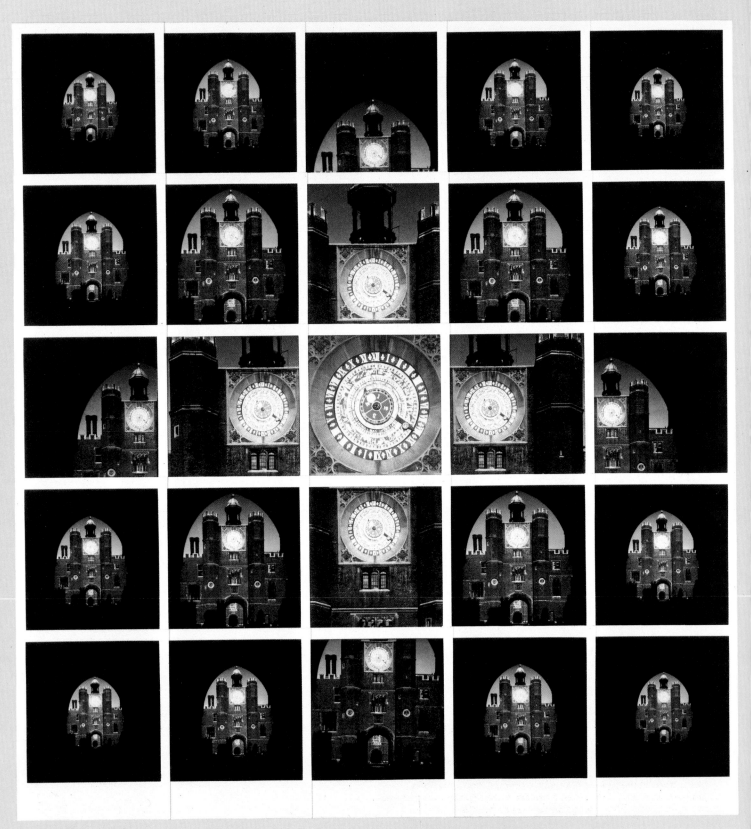

are used—there will be gaps that might possibly interfere with the legibility of the image. Another factor is the close-focusing ability of the camera. An SLR 680, for example, focuses no closer than 10¼ inches (26.4 cm), which sets a firm limit on scale. One of the things that makes composite shooting interesting is that the pictures must be taken from a relatively short distance, walking up to and around the subject. Although the tele-lens for the SX-70 narrows the angle of view, the newer SLR 680 can only be used with the standard fixed lens, so that from a fixed position it would take many shots to complete a full-circle panorama. As a result, virtually every composite subject photographed with this kind of camera must be shot from much closer than the anticipated overall view.

These fundamentals decided, shooting can begin. It helps to start with the important details, such as a face, that may need to be centred in one frame, and working out from these. Each shot must be exposed *not* for an average tone, but for what its particular section of the scene *should* look like. This calls for some judgment as to what are the average tones in the scene: the frames of these can be exposed without any adjustment to the lighten/darken control, but for white walls and dark shadows the control dial must be turned to 'lighten' and 'darken', respectively. As adjoining prints should match—at least in a composite that is intended to look realistic—there is plenty of opportunity to waste film. Perfection unfortunately costs money, and in tricky parts of the scene it may pay to move slowly, waiting the few minutes between shots until each print has developed fully and its tone can be judged.

The lighten/darken control on the SX-70 and SLR 680 cameras allows just one-and-a-half stops over and under exposure, and this may not always be enough. In practice, some flattening of contrast in a scene is usually an advantage, but where it is *not* wanted, a neutral density filter can be held over the sensor to lighten, or over the lens to darken.

With these technical matters under control, the real fun starts when the prints are butted up against each other. By laying them down on a flat surface, the progress of the shooting can be monitored as you work, and mistakes or bad fits can be spotted immediately. It may be tempting to try for an exactly squared-up arrangement, but again, be warned: perfection costs! Moreover, a rigid grid pattern is not necessarily the most interesting treatment, and departing from a single, predictable pattern gives you a chance to play with the design.

A composite of many prints will overlay the complete picture with a pattern. This pattern is emphasized by the white print borders (in the case of instant film prints), and with a little imagination these can be made to correspond to the picture or relate to it in some way. In this way composites can be vehicles for all kinds of experiments in design, such as:

Changing the scale within the picture. For example by including one print that covers the entire scene with other, detailed frames. This can be a way of showing two levels of perception within one image.

Photographed with a SLR 680, this view of Hampton Court was shot at different scales for a bulging effect in the middle and a formal, cross-like pattern. In the process of shooting a composite, design ideas gradually emerge, and it is often more productive to allow a treatment to suggest itself rather than rigidly following a set plan.

In contrast to the symmetrical, stylized treatment of the previous pages, this composite was shot in a deliberately loose, untidy way, partly following the structure of the scene with the print format. The massive scale-change in one print, which shows virtually the entire scene, introduces one more layer of viewing.

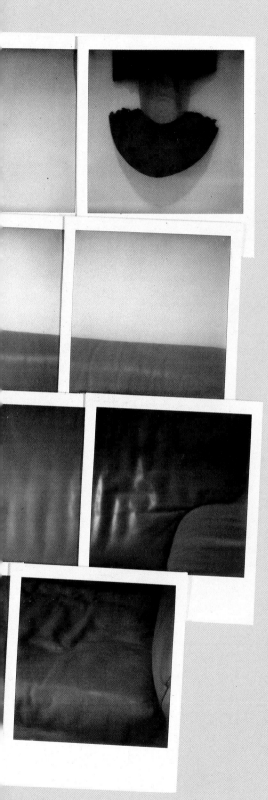

A partly planned, partly ad-hoc shooting method allows a compromise between a recognizable view and the interest of interlocking patterns of edges and corners. Note from the converging vertical lines that a view like this, although shot with the near-to-standard focal-length lens of the SLR 680, is very much a wide-angle picture. Aligning edges—the top of the sofa and the window frame, for example—can be tricky, but introduces some of the fun of doing a jigsaw in the process.

Breaking the pattern to draw attention to a part of the picture. In a regular, squared-up layout, for example, a point of central importance can be enhanced by tilting the camera when shooting to give an angled group of prints, or by shooting this part of the scene with strong overlap.

Matching the pattern to the flow of natural lines within the picture. A diagonal line, for example, could be shot with a tilted camera to align with the frame edges.

Stretching and squeezing. The horizontal and vertical proportions of the whole picture can be altered deliberately. This means either shooting with some overlap or leaving gaps, but then laying out the prints so they butt up to each other normally. This is less noticeable, and so more effective, where there are fairly nondescript areas in the scene, for example, grass, sky or a brick wall.

Spatial distortion. An example of this is to shoot the borders of the composite at one consistent scale (shooting at the same distance), and then moving in closer for the prints in the centre of the composite. If this is done progressively, and with some consideration for the lines and shapes within the image, the effect will be 'bulging' distortion. A less geometric type of distortion would be to favour the more important parts of the scene by shooting them from a little closer.

Viewpoint distortion. Instead of shooting only in one direction—the realistic way—an unusual alternative is to shoot one object from different angles, and then lay the prints out together. The Cubists used this technique of combining different viewpoints in one image. Another version of this would be to photograph in regular steps in an arc surrounding the object: the result would be an expanded view, as if the object had been peeled off and laid flat.

Displaying a Composite

Once the final layout of the completed prints has been decided, they must then be fixed in some way. The most straightforward method is to mount them on board for hanging, but even this offers a number of choices. Because the borders of the whole picture are likely to be irregular, some of the mounting board, if it is a plain rectangle, will show around the edges. The tone and the colour of the board will therefore have an effect on how the composite looks. If white, it will tend to absorb the white borders of the prints, and the composite may appear as a collection of squares rather than as a cohesive assembly. If the board is black, the overall shape of the entire composite will be emphasized. With grey board, the exact effect will depend on the tones of the image: a high-key composite will be dominated by the white borders much less than will a low-key picture. Another option is to use a colour of board that complements or contrasts the dominant colours in the composite.

There is also a way of avoiding the issue altogether by cutting the board carefully to the outline of the composite, and simply hanging it as an odd-shaped picture. This is probably the most effective way to emphasize the free-style shape of the composite, but not the easiest to carry out.

The simplest way to mount the prints is to use either adhesive or double-sided adhesive tape; if the composite is only intended to be displayed temporarily, these will cause no harm to the prints. If you are concerned with permanence, however, *any* kind of adhesive is to be avoided, which restricts the possibilities quite severely. Dry-mounting is one answer, provided there is no massive overlap of

A simple trick when shooting a composite is to step back from the scene and make one overall print. This can then be drawn over with a pen, and the pattern of the prints roughed out. This is not meant to regiment the shooting, but to give some idea of the number of prints that will be needed. It also helps to identify where certain key frames will have to be placed—in this instance, the single print that encloses the girl's head.

prints, and provided only peel-apart prints are used. Integral prints are too sensitive to heat to be put in a dry-mounting press. The only practical way of mounting such prints is to frame them, using the pressure of a sheet of glass to hold the prints.

Mosaics and Sequences

The qualities that make instant film prints so successful for constructing composite pictures also suggests other kinds of joined-up images. A single, large-scale picture is only one kind of possible effect. Alternative treatments—and there are many—include sequences of individual pictures, mosaic-like patterns made by juxtaposing and repeating prints, and dissected pictures. In all of these it is the ability to judge the effects on the spot, rearranging and adjusting as necessary, that is important.

One simple photograph arranged in a repeating pattern can be used as a graphic device to create an unusual mosaic. Take four identical prints and arrange them so they join at one common corner (effectively, this means rotating three of them). The type of picture that works best in this kind of mosaic has strong, simple shapes, tones and lines, and if the edges can be made to coincide where the prints join, the result is a new, larger shape.

A fair amount of experimenting is needed to find a suitable image, but one film-saving device is to use a mirror. Looking down at the print, hold a hand-mirror at right angles to the print, facing it towards the picture. The image will be reversed, which is not exactly how the mosaic will look, but it does give a useful general impression. Two tips when making a pattern from a single picture: a square format gives four different positions for the print instead of only two for a rectangular picture, and the four images will join up perfectly if the main shape occupies one corner, reaching up to the midpoints of two adjacent edges.

From this basic unit of four joined prints the mosaic can be extended by repetition. The more times it is repeated, the more pattern-like the overall picture becomes. Rather than take large numbers of individual instant prints for such a detailed mosaic, it is more convenient—and less expensive—to make a copy at each stage. In other words, re-photograph the first set of four pictures on to one print four times, then re-photograph this, and so on.

After this basic exercise of working with just one image, it is possible to construct more involved mosaics with slightly different prints. For instance, with a simple two-tone, single-edge subject, such as plants silhouetted against the sky, virtually any new, larger shape can be assembled, in as many prints as wanted.

An entirely different treatment when joining instant prints is to use a sequence of events—a set of individual images that make up a story. There are no special technical precautions to take, except that if the sequence is shot in one setting, it usually looks best if the camera is kept in the same position each time.

From two or three copies of one picture a distorted or altered version can be constructed by slicing up each print into sections and then re-assembling them. For example, if the prints are cut into parallel strips, parts of the picture can be 'stretched' by inserting extra strips from the second print. Alternatively, strips can be reversed, or pushed to one side or another to give an irregular frame to the picture.

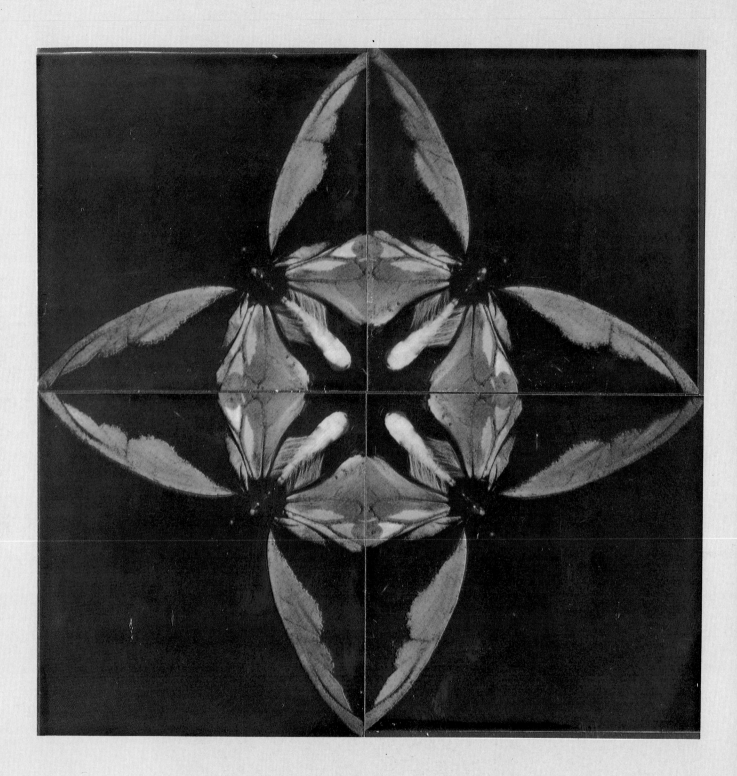

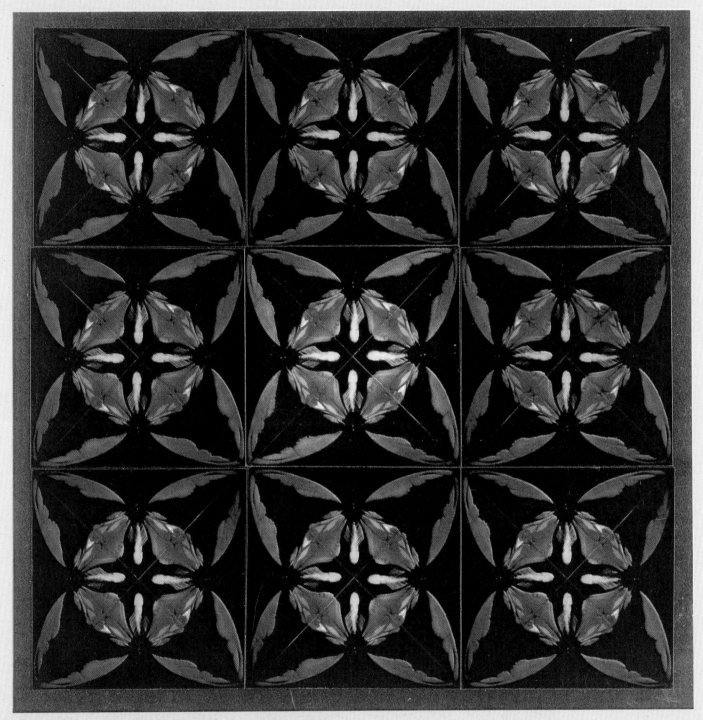

Step-and-repeat printing rapidly converts the original picture into an
entirely different image. Here, the initial shot is of a tropical butterfly,
deliberately framed into the diagonal of the picture area so that the
wing-tips would merge with each other. Note that, when employed as
a copy camera, the SLR 680 used here gives slightly darker edges and
corners, so there tends to be a build up of brightness in the centre of
the mosaic.

Diamond Compositions

Square and rectangular-shaped pictures are only conventions that can be ignored if the image is right. One way of defying convention with square-format integral prints is to tilt the camera to one side and shoot diamond frames. There are all kinds of subjects that seem tailor-made for this shape of picture. Some types of image that usually work well include:

- subjects with a strong, single vertical component, such as towers, trees or full-length portraits;

- views with otherwise boring corners, such as uninteresting areas of sky and foreground;

- cross shapes, with one main vertical and one main horizontal;

- triangles, such as single hills and mountains, gabled houses seen end-on, and pyramid arrangements of objects;

- triangles, as above, but with reflections that help to suggest diamond shapes: a mountain, for example, seen from across a still lake.

Apart from a single diamond composition, groups of diamonds make more interesting shapes than multiples of squares: four together, for instance, make a larger diagonal, and two or three overlapping in a sequence have a frieze-like effect.

There are no special precautions to take in shooting diamond frames, although accurate alignment is slightly more important than it is for most square images (the corners play a more prominent part in the design, and if the subject is composed centrally, the top and bottom corners are strong reference points). Because the SX-70 and SLR 680 cameras have to be held with upward-tilted bases even in 'level' photography, using them at an angle may at first be a little disorienting. Also, some allowance needs to be made for the difference between the viewfinder image and the recorded picture—a little more appears at the base of the print than is visible when shooting.

In display, the larger white border at the bottom of the print can be distracting, but can be covered with an overmat (see page 98).

Downtown Los Angeles.

Joshua Tree, Joshua Tree National Monument, California.

Sensoji Temple, Tokyo.

Wat Suandok, Chiangmai.

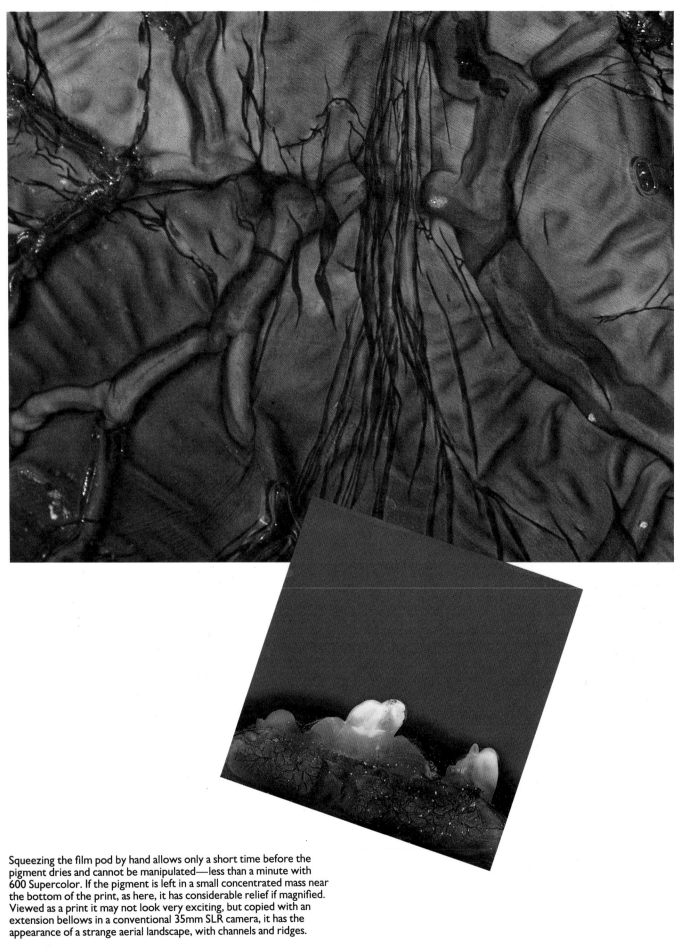

Squeezing the film pod by hand allows only a short time before the pigment dries and cannot be manipulated—less than a minute with 600 Supercolor. If the pigment is left in a small concentrated mass near the bottom of the print, as here, it has considerable relief if magnified. Viewed as a print it may not look very exciting, but copied with an extension bellows in a conventional 35mm SLR camera, it has the appearance of a strange aerial landscape, with channels and ridges.

A less extreme enlargement of part of a pod-squeezed integral print shows the combination of a real exposure and manipulated reagent.

Above, below: Intense colours can be created with Polachrome by the simple device—not recommended by Polaroid—of processing the film in Polagraph chemicals. This means using a 12-exposure Polachrome cassette. Of course, this will leave you with a roll of Polagraph film and Polachrome chemicals—but these combine interestingly to produce semi-contrasty black-and-whites.

Manipulating Integral Prints

Rearranging the Chemicals

Pressure manipulation soon after development is the simplest kind of manipulation of integral prints, and was once the most commonly practised. Left alone, the complex chemical reactions inside the film pack continue evenly (that is the reason for the motorized ejection—to break the pod and spread the reagent smoothly over the negative inside). Pressure applied after this point, until the contents are dry, will interfere with the normal progress of the image.

Pressing or rubbing the back of the print makes corresponding marks on the image, but with the new formulations of SX-70 and Type 600/779 film, there is very little time in which noticeable changes can be made. The image is fixed after a minute or so, and to have any worthwhile effect pressure should be applied within about the first 30 seconds, and quite strongly. Because of the improvement in the process since the original SX-70 film was launched, the results are, in any case, less spectacular than were first possible.

Pressure on the *front* of an integral print is not usually satisfactory because the clear polyester window is much thicker than the back covering, and is also liable to be scratched or buckled. For overall or random pressure patterns there are no problems in working on the back of the print, but if the marks are intended to follow some features in the image it is difficult to guess exactly where to press or rub. In this case, tape the print against a sheet of glass and hold it in front of a mirror. This will make it a little easier to see what is going on, but not a lot.

Pressure can also alter the image in peel-apart films, particularly with Polacolor (colour differences are more noticeable than changes in tone). A pressure mark on Polacolor appears as a dull orange; the print should be worked on through the outside of the film pack immediately after it has been pulled through the rollers.

Pod-Squeezing

A more drastic manipulation than applying pressure after development has begun is to spread the reagent *unevenly* by hand. Not surprisingly, rupturing the film pod by hand can produce unusual effects. This is very much an area for experiment, and almost any kind of subject can be used to push the fluid out. Closest to the roller mechanism is a squeegee rubber handroll, but other possibilities include the side of a pencil, the edge of a ruler, or even a finger.

If the film is exposed first, the image will lie beneath the blotchy or swirly patterns of the uneven development. If, on the other hand, the pod is ruptured on to an imageless film, the result will be completely abstract. The most suitable films for this are the single pack 4 × 5-inch sheets and integral films, although with the latter squeezing the pod in light will wipe out any previously exposed image.

These effects are more or less uncontrollable, and it may take a few trial runs to arrive at a satisfactory result. Colour film gives more interesting patterns, and with integral film the squeezing can be continued by inspection (sealed inside the film pack, the viscous mixture of reagent and titanium dioxide can be pushed around against the transparent window).

Often, only part of an abstract pattern is interesting, and viewed as a whole the frame is lopsided. One way of treating this is to re-photograph the design close up. At high magnifications, such as two times and greater, there is a three-dimensional effect visible in integral prints: pressed up against the polyester window, the thick mixture of chemicals forms bubbles and channels in relief.

Pod squeezing The pod containing reagent can be squeezed and spread by thumb and finger pressure (left), or, more evenly, by rolling the side of a pencil up across the back of the print (top). Working quickly, patterns and points of pressure can be applied with a burnisher (above), or other smooth, hard implements.

137

Separation Effects with Integral Film

SX-70 film acquired an early reputation for special effects. These mainly involved interfering with the chemicals behind the image by pressing through from the back of the print, or by opening up the package and stirring them around. To work effectively this kind of manipulation needs wet rather than dry chemicals, and the replacement of the early SX-70 film with an improved, fast-developing, quick-setting version has cramped the style of manipulation devotees. However, despite suggestions that the golden days of integral print manipulation are over, Polaroid's current versions, Time Zero 778 and high-speed Type 779, offer more possibilities for experiment and retouching than *any* other kind of photographic film.

To understand the reasons for this sweeping claim, it may help to think of integral film as a transparency sandwiched between a transparent window and a white backing. When the print is fully developed and dry inside, the transparent sheet of polyester that protects the image also supports it. This structure opens up various possibilities for working physically on the image from behind. As long as the chemicals, which are squeezed out of the pod when the print is ejected from the camera, are moist, they can be moved around. When dry, the image can be added to, inscribed, or even partly removed. No regular colour film, even in sheet sizes, offers the same possibilities, because its layers can not be separated physically.

From the manipulator's or retoucher's point of view, there are four important layers in the film, and each can be separated from the next: the transparent polyester cover, the gelatin layer, the thin coating of dyes that form the image and, finally, the brilliant white titanium dioxide that forms the background for viewing the picture. The range of possible manipulations varies according to the formulation of the processed film, and at least one product change in Polaroid integral films has already had a major effect on procedure: the entire gelatin-and-image layer could previously be lifted straight off the polyester window, but this is now impractical. The advantage of this formulation change is that the gelatin can now be cut into without risk of shrivelling out of shape. The lesson is that there may be other significant changes in the future, unannounced, which may invalidate some of the procedures.

Tone Separations

Polaroid's two high-contrast films—Type 51 prints and Polagraph 35mm slides—simplify images by reducing the number of tones. Even in normal use they separate the continuous range of tones in a scene into two distinct ones: black and white. By special re-copying, a more elaborate kind of separation is possible in which any regular image can be converted into a series of flat, poster-like tones.

The simplest of such tone separations is an image of black, white and one grey. For this, two high-contrast versions are needed of one original scene, one made with a short exposure, the other with a long exposure. The first will have extensive shadow areas, the second large areas of highlight. This pair is the starting point for experiment. The difference in exposure does not have to be exact, just significant. The two exposures can be made during live shooting, if the subject is static, or for more control by copying a continuous-tone original photograph. With an enlarger instead of a camera, negatives or slides can be enlarged directly on to Type 51 film. If copying, start by under-exposing the first contrast photograph by one stop, and over-exposing the second by the same amount.

The next step is to copy these two high-contrast photographs in register on the same frame of film. Where both high-contrast photographs show white, highlights will remain white, and where both record black shadows, these will stay black; where the tones overlap, however, there will appear grey.

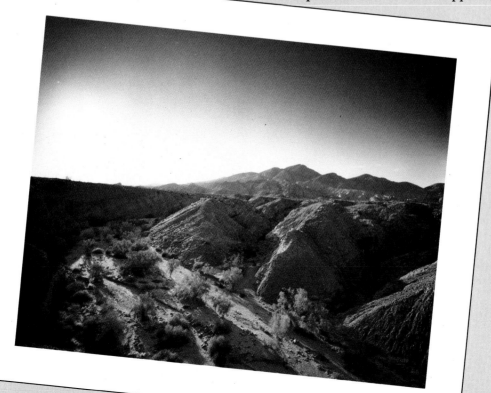

This barnstorming bi-plane on display in a museum makes an ideal subject for a special effects treatment. With the surroundings stripped away (see page 140); the aircraft can be made to 'fly' against any convincing background.

Opposite: A good landscape shot such as this can be used as a background to make an interesting combined image. Some further examples are shown on the opposite page.

Using conventional high-contrast films, tone separations like this are difficult to visualize before they are finished, but, once again, the rapid feedback of instant film comes to the rescue. With Type 51 film the two high-contrast prints can be sandwiched and viewed against a lightbox so both images and their overlap can be seen together. The two prints are positioned by eye so that the images register. They are then taped together at one end to form a hinge. Polagraph slides are smaller and so need more care in taping down; because they are denser than prints the slides underneath will not be visible *through* the top one, but the overlap area can be judged by quickly flipping the top slide up and down.

The final step is to photograph the two images. For this a Polaroid MP-4 camera is ideal, but the basic copying procedure described on page 92 will do perfectly well. An exposure is made of the top print; this is then folded back and the print underneath exposed. As with any double-exposure, set the lens for one stop less than normal.

The final result, on Type 51 or Polagraph, will be a three-tone image in black, grey and white. For more complex effects, start with three, or even four, high-contrast originals, each exposed differently. Also possible is a colour version, by making the final copy on colour film and using different coloured filters (the colours will appear richer if Polagraph slide separations are copied rather than Type 51 prints).

Combining Images

By far the most interesting family of manipulations offering the widest range of possibilities involves stripping away selected areas of the emulsion of integral prints. When done carefully this leaves a partial image on an otherwise completely transparent square of polyester. Anything placed or painted behind the print will then show through the stripped areas.

The potential for laying one image over another is virtually limitless. There are no restrictions, as in multiple exposures (see page 153), which need dark areas in one image to accept a second. The complete transparency of the polyester sheet on an instant print makes it possible to do things that are impossible on regular slide film. Better yet, all of this manipulation can also be done on dry prints—even those that are several years old.

It is important to first practise on a few unimportant prints. Integral films are not intended for such treatment, and consequently there are no manufacturers' recommendations for mistreating their contents. For instance, the original SX-70 film had a thick gelatin layer next to the polyester; the edges of this were liable to shrivel when wet, and once this shrivelling process had begun, say from the edge of a cut area, the image was likely to be ruined. Modern SX-70 Polaroid film and Types 600/779 behave quite differently: the edges do not pull away spontaneously from the polyester, making it easier to cut away precise areas; on the other hand, the emulsion itself damages quite easily.

Opening the Print

The pasty mix inside the film is caustic, and it is important not to touch it. If you do so, wash your hands immediately. The best precaution is to wear thin, disposable plastic gloves.

Lay the print flat, and with a sharp blade (a scalpel of the kind sold in art supplies stores is best) slice along the edges. Then peel the two halves apart.

Stripping the Emulsion

This procedure is described for Polaroid Type 600/779 *as it is manufactured now*. Improvements for regular use may alter its manipulability, and you cannot expect to be warned about this by Polaroid.

Continue wearing the gloves and work on a *dry* print (if the picture has just been taken, wait at least half-an-hour, and for about another half-an-hour after opening). Experiment should guide you towards the most appropriate tools for your own way of working. Mine is as follows:

1. Cut lightly around the area to be retained with a sharp-pointed scalpel blade.

2. Moisten up to this edge with water and a soft sable artist's brush.

3. Gently scrape away the emulsion. The knife blade is good for working close up to the edge, but runs the risk of scratching the polyester. A dampened wooden toothpick or cocktail stick is useful, as are cotton buds. For large areas, a fingernail is probably as good a tool as any. Keep the emulsion moist, but the image area that is *not* being removed should be left dry. Keep tissues at hand to dab off excess moisture; a small hair dryer is an optional accessory.

Replacing Lost White Backing

In opening the film package, the white titanium dioxide may be pulled away unevenly from the image. In this case, replace it over the image area that remains with an opaque white paint, such as white acrylic (titanium white contains the same substance—titanium dioxide—that is in the film pack). Precision is not essential; apply the coating until the image looks even when seen from the front.

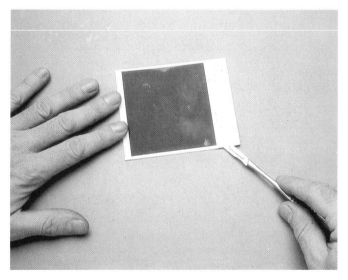

To make the basic separation of an integral film print, use a very sharp blade, such as a surgical scalpel of the type sold in art supply shops. Make an incision away from the picture area—around the bottom of the pack—and then work carefully around the edges. Do not enter the pack deeply, or the picture will be spoiled. For all subsequent stages, wear plastic gloves.

Adding a New Background

There are no restrictions of choice at this point. Experiment by laying the stripped image against different backgrounds—plain colours, other instant film prints or regular photographic prints, patterned paper, mylar, and so on. Alternatively, turn the print face-down and paint or draw on the back (taking care with the remaining emulsion). A few ideas are shown here and on the next few pages.

Retouching Polacolor Prints

Although it is always better to avoid the need for retouching any photographic print, it is useful to be able to fall back on this as an emergency technique to save a picture. Retouching can involve as little as spotting, to fill in a small white 'hole', or can involve actually changing the image. What is possible depends largely on your own skill and experience, so it is best to practice first on discarded prints.

Polacolor is as retouchable as any conventional photographic print, and in some respects easier. The range of techniques is as follows:

Bleaching: The easiest solution to use is a mixture of ordinary household bleach and water, normally 1 part bleach to 5 parts water (but you can experiment with different strengths). As the treated part becomes lighter, the colour balance will change. The magenta will go first, followed by cyan, with yellow last. Use sparingly, and monitor the effect. This bleach is easy to use as the effects take place gradually as you apply it. Another bleach—a 2% solution of acetic acid in water—will give a purer white, but its effect happens suddenly.

Dyeing: Dyes have the advantage of integrating with the image, and they lock firmly into the print. Use standard retouching dyes, mixing the colour needed from a basic set. Always build up to the effect you want slowly, in several applications—if you apply too much, it may be impossible to remove satisfactorily.

Spotting: Retouching pencils can be used for this; a black pencil will do well for white spots in a relatively colourless area. Otherwise, use a fine brush and dilute the dye.

Opaque colours: These colours are available for conventional prints in the form of cakes that must first be moistened. These do *not* integrate with the image, and always remain obvious. In particular, they destroy the gloss of the print surface. Use them for special effects, but not for naturalistic retouching.

Photograms

Photograms are 'shadow pictures' of objects placed directly on to sensitive film. With conventional emulsions this is normally performed in a dark room so that the paper, or sheet-film, can be processed directly. Instant film photograms, however, can be made conveniently in any room that can be darkened. All that is needed is a pack of film, the means for processing each sheet (a holder or camera), and a light source that can be switched on and off quickly. An ordinary room light is perfectly adequate, a typical exposure for most instant films being a fast flick of the switch—about as fast as the fingers can manage.

Precision is not usually a feature of photograms; trial-and-error is the normal method of working out the best exposure, position of the object, and even the basic form of the image. This suits instant film admirably, as photograms can be judged and re-done in short order.

What makes a successful photogram is not always easy to predict. Solid, opaque objects will show just their outlines and appear just as silhouettes; holding them up to a window gives a good idea of how they will appear. Often more interesting are transparent and translucent objects—a glass bottle, for instance. One object can give two or three different photograms according to how it is placed on the film. Flexible things can be bent or crumpled to give different shapes.

As well as the object itself, filters can be held above to give various effects, although this calls for the services of an enlarger. The film and object are placed on the enlarger baseboard, and by using an empty pack for setting up, as described on page 96 the effects of partial filters can be worked out in advance. An easy and potentially interesting variation is to use two or more coloured filters in sequence, moving the object between each exposure, creating an overlap of different colours.

In a special class of their own are objects that produce light. Very few are suitable, because the amount of light emitted needs to be very small indeed to avoid over-exposing the film. Anything phosphorescent, such as a watch face, works well, as do light-emitting diodes.

A lamp filament exposed under an enlarger fitted with a 25 red filter.

Above: An antique perfume bottle, conveniently of just the right dimensions.

Opposite: Not quite what it looks like—a wristwatch with a fluorescent dial, exposed face-down.

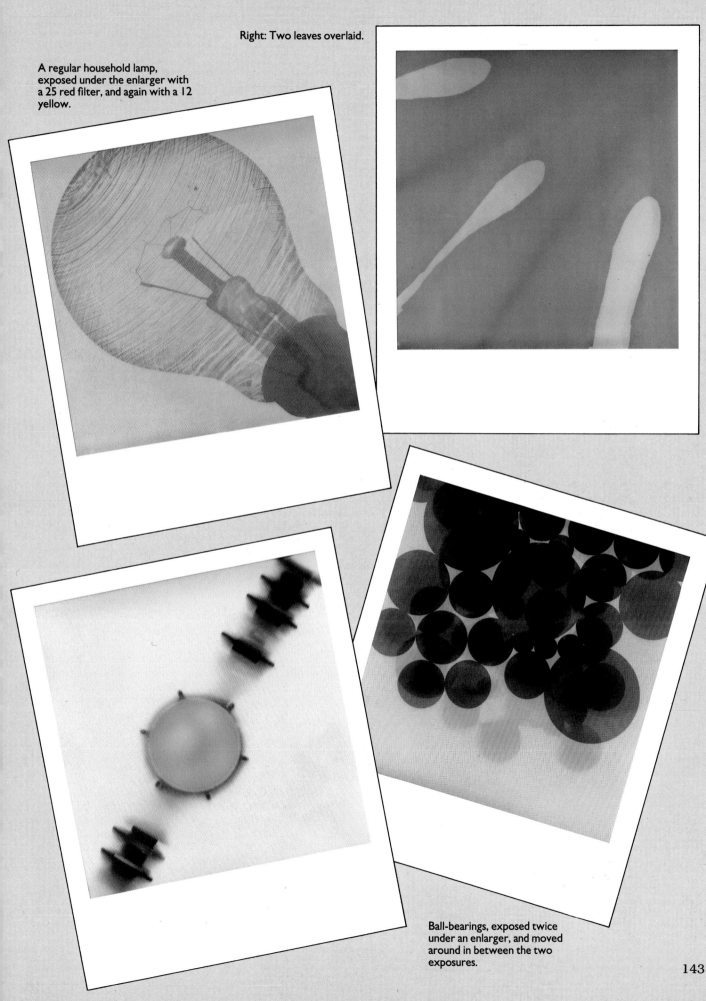

Right: Two leaves overlaid.

A regular household lamp, exposed under the enlarger with a 25 red filter, and again with a 12 yellow.

Ball-bearings, exposed twice under an enlarger, and moved around in between the two exposures.

Experiments with an Enlarger

Making straight copies of slides, as described on page 92, is a useful basic technique to learn, but apart from its obvious uses, it is also a jumping-off point for a wide range of special effects. While an enlarger is more versatile than a purpose-built slide copier, some of the suggestions that follow are applicable to both.

Using Filters

While filters can be used as a means of correcting colour-balance, they can also be used for effect, and straight, unmanipulated slides can be used as the basis for a variety of different images. Coloured filters can be used to give an overall cast or, if held over just a part of the projected image, to give a transitional effect. Coloured gels or acetate can be cut into shapes to tint particular areas of the picture, although at the small apertures that are usually necessary with fast instant film the edges usually appear rather hard (to soften these edges, place a strong neutral-density filter in the enlarger's filter-holder and open the aperture accordingly).

Close-up of bivalve made with a Sinar 4 × 5 view camera and 150mm lens.

Softening and diffusing filters of all kinds can also be used, as can graduated filters, both neutral and coloured, as well as the gamut of trick filters, such as prisms, defraction screens, and so on. Neutral graduated filters are generally more useful in adjusting contrast and tones than the traditional shading and printing in, using hands or dodging tools, because typical exposures are very short with fast instant films. Printing controls can be used, however, by using neutral density filters as just described.

All of this is no more than can be done with conventional colour printing and most ordinary slide copiers. Instant film, however, makes the results immediately available and repeatable without the inconvenience of mixing chemicals. For instant film photography, and in particular the one-step integral process, the darkroom and enlarger offer freedom to use all the filters anyone could wish for.

Instant Film in Other Cameras

For photographers who admire the image qualities of integral print film but feel frustrated by the no-frills, simple-lens cameras in which they must be used, there is a way of broadening the scope of activities. It is admittedly a little laborious, and requires the services of a view camera, but in the studio, at least, it is practical.

Basically, all that needs to be done is to load the conventional sheet-film holders used in view-camera photography with an integral film instead of the normal, wet-process film. Although thicker, and not the same size as any standard sheet film, it is fairly simple to load.

A print is extracted from its pack, and then placed *upside-down* inside the film holder. This is, naturally, a darkroom operation, although it can be performed with little extra trouble in a changing bag.

The print must be located in a known position in order to be able to compose the shot properly, if the view camera has good lateral and vertical shift movements, the off-centre position is no problem. For ease of viewing and composing, the position can be marked on the ground-glass screen, or else a sheet of plastic card can be cut to shape to fit in the back of the ground-glass screen as a frame mask.

The next problem is to fix the print temporarily—securely enough to stop it slipping out of position in the slide holder, but not so well as to damage it. One easy method is to place four small pieces of sticky putty at the corners of the back of the print. The slide is then replaced, and the holder is as ready for use as if it were normally loaded.

After the exposure the integral film is unloaded—in the dark—and slid back into the top of its pack, which is then simply pushed back into its proper instant camera. As with enlarger use, closing the door ejects the film through the rollers, and the image is developed.

Although all of this takes a little space to describe, it is with practice simplicity itself. Even so, why go to the trouble? With a straight shot through a standard lens, no reason at all. But for close-ups—the natural province of an extendable-bellows view camera—it makes possible an entirely new area of photography. Multiple exposures immediately become as simple as they can ever be. The spectacular front-to-back sharpness possible with the swings of a view camera can now be recorded on Type 600/770 film and its companions.

Another odd combination that can be performed either under an enlarger or more simply with a slide duplicator, is to copy conventional negatives on to Polagraph slide film. The base density of a conventional black-and-white negative, which gives it its foggy appearance, disappears under the contrast-enhancing effect of the Polagraph. The effect is of close-to-normal tones, but all of them reversed.

A 'projectogram' of a snakeskin. The skin was simply loaded into the negative carrier and printed as if it were a normal transparency.

Here, a wire frame model of a man was photographed on high-contrast film (conventional line film in this case, but the negative Polalith transparency film would do perfectly). In these two versions, different filters were used in the enlarger, and a second, short, blue exposure was given to one for a coloured background.

Double exposure of a sunrise stock-shot and a watch, both 2¼ × 2¼-inch transparencies. To blend the two together, the lower half of the watch exposure was 'soft-masked'—a dark card was held above the film pack to give a soft edge.

Multiple Exposures

The classic method of combining two or more images in one is by the use of multiple exposure. Technically this is simply a matter of making different exposures of different subjects on the same piece of film, but to do it well, so that the images blend or at least fit comfortably together, requires a good eye. In a double exposure, for example, to get a full, richly coloured image of each subject there should be a corresponding dark background. Two subjects, both photographed against black but in different positions in the frame, will combine perfectly. If lighter tones are superimposed, however, the image will appear ghost-like, which may well be desirable. This may sound a little complicated, but visually it is straightforward.

For a number of reasons multiple exposure is easier to do by copying than with original photography. With an enlarger, images can be positioned exactly, by making a trace, if necessary. Moreover, fine adjustments to position and exposure are important to the success of a combined photograph, and because a certain amount of guesswork is involved, instant results are especially valuable. In original photography, only 4 × 5-inch single film packs can be removed unprocessed for the later addition of another shot, and the design of integral print cameras, such as the SLR 680, offer few possibilities of multiple exposure.

The mechanics of multiple exposure in the darkroom are simple. Using Types 600/779 film, the film pack is placed under the enlarger in darkness with an unexposed sheet face-up; the first exposure is made and the pack is then slipped into a light-tight box. The second slide is put in the enlarger and focused, the light turned out, and the film pack returned for a second exposure. Finally, the pack is placed, still in darkness, in the camera, which processes and ejects the print as normal.

For this simple combination, a high-contrast silhouette of the two men was first shot on Polagraph and then sandwiched with a landscape shot. The slight diffuse haze in an integral print does a good job of blending the two images.

148

A refinement for accurate positioning is to fit a small sheet of paper into the empty film pack used for processing and to trace the outline of the first image on to this; the trace then serves as a guide when the second slide is focused.

A useful way of blending two or more images together is to shade them off. This can be done with a simple soft mask: a piece of card cut approximately to shape and held, or taped, under the enlarger lens. The wider open the aperture, the softer the edges of the mask will appear.

Blending Images

If two images are each shaded off in opposite directions, they can be made to blend without overlap in a double exposure. The simplest method is to hold the straight edge of a card under the lens to shade off one-half of the picture area for the first slide, and then for the second slide to shade off the other half. For more sophisticated blending, take a piece of card that will just cover the picture area at whatever height it is held, then cut it in two in any shape; whatever the two shapes, they will match. Use one shape to mask the first slide, the other to mask the second.

Slide Sandwiches

Two slightly over-exposed slides sandwiched together can be copied as easily as one, and with some imagination can make interesting combinations. Over-exposure helps because, unlike a multiple exposure, the density of the two images is *added*, and this tends to flatten the contrast severely.

A specially effective type of sandwich is the mixture of a regular colour transparency and a high-contrast transparency: if the colour slide is back-lit, a high-contrast silhouette can usually be combined with it very realistically, and copying helps to blend the two. Polagraph HC is ideal for this, particularly if retouched.

Projectograms

Treading close on the heels of photograms, is a type of special effect that comes from placing objects rather than slides in the negative carrier of an enlarger. Instant photograms, fun though they are, are limited by the size of instant print film: the object has to fit, or be made to look like a workable composition.

For the photogram enthusiast who has exhausted the serendipity and wants some control, the answer is to place the object on a sheet of glass in the enlarger's negative holder. This makes it possible to enlarge the projected outline, and to control the focus. At full aperture, different parts of a solid object

can be focused, or the lens can be stopped down for greater depth-of-field.

With a large-format enlarger, all that needs to be done is to fit a sheet of glass in a negative holder, but with enlargers designed for 35mm film only, it is better to remove the carrier entirely and fit a sheet of glass in its place.

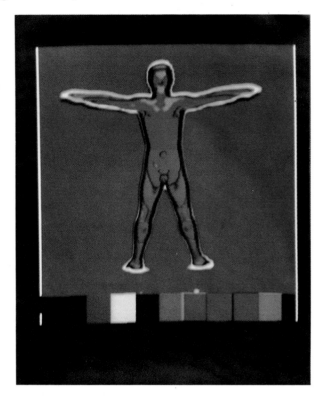

Thermographic image of a man. No lighting. The colour differences represent temperature variations in the skin, and are recorded separately off a black-and-white video monitor, each with a different coloured Wratten filter.

Also a thermographic image—this time of a lit lantern. Only the temperature is recorded, not the illumination.

Video Imagery

Although there are now a number of specialized instant systems for recording computer graphic displays (Polaroid's Palette is one), the straightforward recording of images from a television monitor is extremely simple—and rewarding, as these pictures show. Provided that the effect you want is purely pictorial and does not have to meet any particular technical standards, all of the regular instant films and their cameras or holders can be used. The examples on these pages were taken with Polaroid 600 Supercolor in a SLR 680, and with Type 59 in a 545 film holder on a 4 × 5 view camera.

The procedure for setting up is the same as for a conventional film and camera. The difference is that the odd quirks that video images display in photographs can be spotted and dealt with right away. In particular, neither 'banding' nor colour casts should be a problem.

For preparation:

1. Wipe the screen clean of dust and marks.

2. Set up the camera on a tripod at a distance that gives a frame-filling view of the screen. This is the ideal arrangement, but not strictly necessary with 600 Supercolor, which is a sufficiently fast film to be hand-held (although an armchair makes a better support).

3. Darken the room. This is important, to reduce reflections from the glass of the screen.

4. Fit a CC30 red and CC20 yellow filter over the camera lens (and over the sensor window in an automatic camera). These are the standard corrective filters for most video images, but after the first shot, wait a few minutes for the colours in the instant print to settle down, and make your own judgment.

5. Set the television's brightness control to about average. If high, the image will be less sharp.

There is essentially no more to it than this. If you are using an automatic camera, there are no exposure calculations to be made; the lens will be wide open (making it important that the camera is aligned accurately to the face of the screen). If you are using instant film in a conventional camera, as in a film holder, f5.6 at $\frac{1}{15}$ second or an equivalent exposure is a reasonable starting point for ISO 125 film.

Catching still, sharp images from a television transmission takes a little practice, but if you watch any programme carefully for a few minutes it is usually quite easy to anticipate the moments when either the subjects or the camera are moving, and the still moments. Also, study and try to anticipate the editing of the programme—an exposure that takes place just as one scene cuts to another will give a jumbled image. Of course, such moving effects can themselves make interesting pictures. With the Polaroid SX-70 and SLR 680, remember that there is a slight pause between pressing the button and the actual exposure.

Video-enhanced images photographed directly off a conventional monitor (settings are as given in the text).

151

Multiple Exposure

Making more than one exposure on a single sheet of film is the basis of many standard special effects in all kinds of photography. Unlike physical manipulation of the emulsion, multiple exposure is essentially a naturalistic effect—or at least it can be if the separate images are properly matched and positioned. Like all special effects, multiple exposure must first be imagined, and the final effect cannot usually be predicted down to the last detail. Hence instant film has a special place in multiple exposure, as results can be checked in time to do something about them.

The principles of multiple exposure apply equally to conventional and instant film photography, and are not complicated. For good saturation, and so realism, in all the different images exposed on to the one piece of film, the bright areas of each should coincide with dark areas in the others. The easiest of all kinds of realistic multiple exposure is the combination of isolated subjects on black backgrounds. If this is done carefully there need be no evidence that the images have been recorded separately.

This is only one method, however, and for more individualistic, and often more interesting, combinations, the separate images can be arranged so that they overlap. The result is a kind of 'ghosting' that can be used effectively in several ways. Trial-and-error is a normal part of making such multiple exposures, and instant results are obviously a great help. If the areas of overlap are large in the picture, it may be necessary to reduce each exposure to keep the tone average. Exposure is, of course, cumulative, and adding one on top of another lightens the image.

These are the basic principles of multiple exposure and are not unique to instant film photography. With peel-apart and slide films used in manually operated cameras, there are no special technical problems—the shutter is simply re-cocked after each exposure. Integral film, however, poses a problem because the cameras in which it is used are highly automated. With simpler models results are not likely to be satisfactory, but sometimes can be done with the SX-70, the SLR 680 and the Kodak Fastback.

The problem with both the SX-70 and the SLR 680 is that once the button has been depressed the sequence of exposure and ejection is automatic. The only way of halting this process in the middle without risking damage to the camera is to open the film door just after the exposure has been made to break the circuit. You will need a short delay in the exposure to be able to open the film door before ejection starts, and this means making a long exposure (the shutters on both cameras will stay open up to 14 seconds if the lighting is dim enough). The easiest solution is to work in a darkened room. Press the shutter release and then immediately press the release for the film door at the side of the camera. Once the film door is open, *everything* is halted, and the shutter remains open, so that the most convenient lighting to use is flash. Because the camera's meter measured only darkness, the lens will be open at full aperture, so the flash exposure should be calculated for f8. This can be adjusted either by reducing the flash *output* (diffusing or filtering the flash head or using the controls on a studio flash unit), or by using neutral density filters over the lens.

All shooting must take place in a darkened room, or else the lens must be tightly covered. With the shutter open, there is no way of viewing, so that the subjects must be arranged beforehand; a tripod helps.

This arrangement of circular objects (a test print for a dictionary of science) was multiply-exposed to bring each one to the required size. Because of the different dimensions, the composition was first sketched out and then photographed in four groups. The dish culture, tape, tablet and wheel were shot together at one scale, and their positions drawn on the ground-glass screen of the 4 × 5 view camera. Then the film in its holder was removed and the barometer arranged in place. After this second exposure the process was repeated for the third shot—the watch gears—and finally the fourth—the record label. As each exposure was made against a background of black velvet, each subsequent image was recorded against an unexposed area of film.

Trompe l'Oeil

Trompe l'Oeil is a kind of pictorial illusion in which the eye is tricked into believing that what is shown is not two-dimensional at all, but real. Most photographs give an impression of depth; indeed, it is hard to avoid making natural-looking pictures with a camera. Even so, such straight photographs are never seen as anything other than skilled representations. To create a genuine illusion, the picture must seem to be a part of the physical world.

In painting, trompe l'oeil featured during periods when naturalism was popular, such as classical Greek art and the Italian Renaissance. Its success depended on the artist's skill to render things as realistically as possible. One popular use was in interior design, where, for example, murals might be painted to look like real doorways or architectural details, such as columns.

In photography trompe l'oeil differs from that used by the artist because camera and film produce realistic pictures as a matter of course; there is nothing particularly clever about making a natural-looking photograph. To work well, photographic illusion needs to go further: however well crafted, the illusion must be based on an idea. A painter can, on a large scale, really fool the eye, but any photographic

trick must appear within the borders of a print. Therefore, one of the commonest types of photographic illusion is of a picture within a picture, in which the photograph can be shown to be a close substitute for reality.

The examples shown here are simple and effective and, with instant film, easy to make. This kind of illusion depends on near-perfect matching—not only of the dimensions and perspective of the image, but of the tone, contrast and colour balance—and is only practical with instant photography. The advantages of feedback are obvious here.

To construct this illusory image of a collection of tribal jewellery, the camera was first set at exactly life-size magnification by focusing on a ruler and checking that 1 inch as imaged actually measured 1 inch on the viewing screen. The first print was then made, of a section of the jewellery. When this had developed fully, it was placed in exactly the right position and simply re-photographed from further away. This kind of trick has its strongest effect if clear, obvious lines cross from the actual setting into the print—in this case, the circle of the Indian silver bracelet catches the eye.

BIBLIOGRAPHY

Adams, Ansel, *Polaroid Land Photography*, New York Graphic Society, Boston, 1983.

Adams, Ansel, *Singular Images*, New York Graphic Society, Boston, 1974.

Andrews, Weston and Miller, David L., 'Instant Pictures', a regular feature in *Modern Photography* magazine, ABC Leisure Magazine Inc, New York.

Sealfon, Peggy, *The Magic of Instant Photography*, CBI Publishing, New York, 1983.

SX-70 Art, Lustrum Press, New York, 1979.

INDEX

CREDITS
Polaroid Corporation: 4, 10–11, 12–
13, 16, 21, 28–29, 56, 57, 72, 127
Kodak: 23, 24
Contax: 26
Konica: 27